God's Gym

GOD'S GYM

DIVINE MALE BODIES
OF THE BIBLE

Stephen D. Moore

Routledge
New York & London

Published in 1996 by
Routledge
29 West 35 Street
New York, NY 10001

Routledge
11 New Fetter Lane
London EC4P 4EE

Copyright © 1996 by Routledge

Printed in the United States of America.

Library of Congress Cataloguing-in-Publication Data

Moore, Stephen D., 1954–
 God's gym : divine male bodies of the Bible / Stephen D.
Moore.
 p. cm.
Includes bibliographical references and index.
ISBN 0-415-91756-5. — ISBN 0-415-91757-3

 1. Masculinity of God. 2. Christianity and culture—History—
20th century. 3. Bible. N.T.—Criticism, interpretation, etc.
4. Torture—Religious aspects—Christianity. 5. Punishment—
Religious aspects—Christianity. 6. Body, Human—Religious
aspects—Christianity. 7. Bodybuilding—Religious aspects—
Christianity. 8. Jesus Christ—Crucifixion.
9. Atonement. 10. Foucault, Michel—Influence. I. Title.

BT153.F3M66 1996 95-44257
220.6—dc20 CIP

Dedicated to my beloved sister, Nessa.
It's getting harder and harder to show you my work;
can it be that I'm beginning to tell the truth?

contents

figures

preface
A PHOBIA AND
TWO FASCINATIONS

This is an intensely personal book. Its three chapters (really, three essays) spring from a phobia and two fascinations, each of which has shadowed me since childhood. The first is a morbid fear of physical torture. The second is a morbid fascination with depth anatomy: how that which is most calculated to appall me—everything this thin, skin coating conceals—is also that which is nearest to me. And the third is a frank fascination with surface anatomy, specifically the male physique.

To translate these three obsessions into biblical exegesis (for the New Testament is what I am paid to obsess about) proved surprisingly easy. Actually it was less a case of translating a preoccupation with anatomy, torture, and the male body into biblical criticism than of demonstrating how the latter is already deeply preoccupied with all three. For how do biblical critics examine the corpus (cadaver?) of Scripture except by dissecting it—opening it up and peering inside, probing as deep as their instruments allow? And what is the New Testament about (to the extent that it is about any one thing) if not the death by torture of Jesus of Nazareth and the subsequent perfection of his (male) body? And what is the essential message of the New Testament (to the extent that there is any one message) if not that *you too* can have a body like his, if only you are willing to pay the price?

The first essay, "Torture: The Divine Butcher," picks up where my previous book, *Poststructuralism and the New Testament: Derrida and Foucault at the Foot of the Cross*, left off, listening in further to the heated argument that had erupted at the place of execution. Foucault, Paul, and certain of Paul's supporters, notably Bultmann, disagree over the real meaning of Jesus' physical agony, their raised voices almost drowning out his groans.

"Dissection: How Jesus' Risen Body Became a Cadaver," the second essay, stages an experiment. A row of anatomy books is placed upon a dissecting table opposite a row of biblical scholarly books. Each book is open and stands upright, so that it can read and be read by its fellows. Flat on its back between the two rows is an open copy of the Fourth Gospel. Understandably it is nervous; for the real purpose of this reciprocal reading lesson, which at any moment could turn into an anatomy lesson, is to determine whether a critical reading of a biblical text must always be performed with a scalpel.

Having explored biblical criticism as metaphoric dissection in the second

essay, I go on in the final essay, "Resurrection: Horrible Pain, Glorious Gain," to explore divine power as metaphoric muscle. In order to sketch the shapely contours of this third essay, which accounts for almost half the book, I shall have to hazard some sweeping brushstrokes. The God of the Hebrew Bible is, for the most part, corporeal, "perfect," and male; it follows, therefore, that this God is a physically perfect male. To behold this paragon of male perfection would be heaven, at least for the author of the book of Revelation, for whom heaven consists precisely in the vision of this divinely perfect male. Is there a contemporary cultural analogue to this adoring apotheosis of the perfect male as the ultimate object of vision? Yes, the bodybuilding posing exhibition. Using contemporary testaments to male narcissism, therefore, and bodybuilding magazines in particular, I attempt to decipher ancient testaments to male narcissism—the "Old" and "New" Testaments. If Revelation can be viewed as a bodybuilding posing exhibition, however, the canonical Gospels can be read as bodybuilding training manuals. Note in particular the striking homology between a central assertion of the Gospels—that there can be no resurrection without crucifixion—and the fundamental syllogism of bodybuilding philosophy: No pain, no gain.

A recent piece in *The Chronicle of Higher Education* tells how two professors of anthropology, preparing to write a book on Arnold Schwarzenegger, decided to begin working out to get over feeling self-conscious about their "squishy academic bodies."[1] Similar concerns drove me into the darkest recesses of my garage as I prepared to write this book. There I was soon joined by Harold Veeser, who not only assisted my own self-torture in this dingy dungeon but allowed me to read his as yet unpublished paper "No Pain, No Gain: The Political Economy of Bodybuilding." This book owes much of its meager strength to Harold, and also to Stuart Lasine, who, although he did not work out with me, nevertheless worked through much of the manuscript in its earliest stages (that, undoubtedly, was torture enough). At a later stage, Daniel Boyarin subjected what I had prematurely taken to be the finished product to a penetrating critique. The book also owes much to him, and would owe even more had I had the ability to act on his most far-reaching recommendations. Many others, too, along the way (and the way was long) supplied insightful suggestions or crucial encouragement, notably Andrew Adam, Janice Capel Anderson, Pat Anderson, Roger Berger, Robert Brawley, Fred Burnett, David Clines, Laura Donaldson, Cynthia Eller, Cheryl Exum, Debbie Gordon, David Gunn, Jane Hurwitz, David Jasper, Edgar McKnight, Chris Parr, Debbie Parr, Gary Phillips, Regina Schwartz, Francis Watson—but above all John Ashton. To Beth Simon, my erstwhile research assistant, I owe a special debt of gratitude;

1 Heller, "Bodies on Stage," A9.

this book would be an even thinner specimen without her tireless efforts on its behalf. Special thanks are also due to Bill Germano, Editorial Director at Routledge, who accosted the manuscript as it emerged from the dungeon, dizzy and disoriented, and generously offered to provide it with a stage. In the wings many members of his capable staff waited, notably Neill Bogan, Matthew DeBord and Jonathan Korzen, ready to massage the manuscript, strip it down, and oil it up for display.

Feed a book and watch it grow. The principal texts that the present book ingested are regurgitated for inspection at the end. Four others should also be acknowledged: the 27th edition of the *Novum Testamentum Graece*; the 4th edition of the *Biblia Hebraica Stuttgartensia*; Rahlfs's *Septuaginta*; and above all the New Revised Standard Version of the Bible, the English translation most often favored below.

An underdeveloped version of the first essay appeared in my *Post-structuralism and the New Testament* (Minneapolis: Fortress Press, 1994), as stated above. A pencilnecked version of the second essay likewise appeared in *The New Literary Criticism and the New Testament*, edited by Edgar V. McKnight and Elizabeth Struthers Malbon (Sheffield, U.K.: Sheffield Academic Press, 1994). And by the time the present book makes its début, portions of the third essay will have appeared in *The Journal for the Study of the Old Testament* under the title "Gigantic God," and in *The Journal for the Study of the New Testament* under the title "The Beatific Vision as a Posing Exhibition" (both journals are also published by Sheffield Academic Press). I am grateful to Fortress and Sheffield for permission to develop and reprint this material. I am also grateful to Fortress for permission to reproduce Figure 7, to Cornell University Press for permission to reproduce Figure 6, to Williams & Wilkins for permission to reproduce Figures 8 and 14, and to William D. Edwards for permission to reproduce Figures 2, 9 and 10.

torture
THE DIVINE BUTCHER

This is my body which is broken for you.

— 1 CORINTHIANS 11:24 (textual variant)

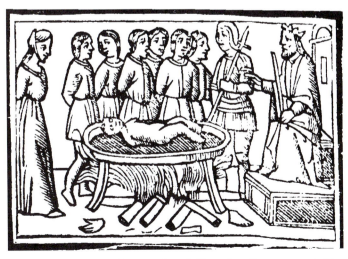

Figure 1: Dismembered martyr from 2 *Maccabees* 7 as represented in an Italian Bible of 1525.

Opening Confession
"My Father Was a Butcher"

> "Father, save me from this hour. . . ."
>
> —JOHN 12:27
>
> "Father,...remove this cup from me. . . ."
>
> —MARK 14:36
>
> "Father, don't you see I'm burning?"
>
> —SIGMUND FREUD, *The Interpretation of Dreams*[1]

I begin with a confession, although it is not yet my own. "Now my soul is trou-
bled [*nun hē psychē mou tetaraktai*]," confesses the Johannine Jesus in an
uncharacteristic moment of uncertainty as the hour of his flogging and cru-
cifixion draws near. "And what shall I say? 'Father, save me from this hour?'"
All too quickly he collects himself: "No, it is for this reason that I have come
to this hour. Father, glorify your name" (John 12:27–28). As it happens, the
Father has something quite exquisite up his sleeve. He will arrange for his
Son to be condemned to death around noon on the day of preparation for the
Passover (19:13–16)—the precise hour when the slaughter of the passover
lambs will begin in the temple precincts nearby (cf. 19:29, 36; Exod. 12:22,
46; Num. 9:12; 1 Cor. 5:7).[2] In truth, however, Jesus' throat was cut from the
moment that he first strayed, bleating, into this Gospel: "Here is the Lamb of
God who takes away the sin of the world!" exclaims John the Baptist upon
first spotting him (1:29). The next day, Jesus staggers by again, still bleed-
ing profusely (cf. Rev. 5:6). "Look, here is the Lamb of God!" John again
exclaims (1:36; cf. Acts 8:32ff.; 1 Pet. 1:18–19; Rev. 5:6–13). Two of the Baptist's
disciples set off hungrily after Jesus (1:37), following a trail of blood. The
trail leads straight to the cross, which is also a spit, for it is as *roast* lamb
that Jesus must fulfill his destiny (cf. 6:52–57: "'How can this man give us his
flesh to eat?'..."). Justin Martyr saw this more clearly than most: "[T]hat

1 This question forms the climax of a dream that was reported third-hand to Freud, a dream
 that seems to have affected him deeply, as it does me (see *The Interpretation of Dreams*,
 5:509–11; cf. 533–34, 542, 550, 571).

2 Colossal quantities of passover lambs, if Philo is to be believed (*On the Special Laws* 2.27.145).
 Most of the major commentators on the Fourth Gospel note in passing the connection between
 the commencement of the slaughter and Jesus' sentencing. Raymond E. Brown is more
 loquacious than most; see *The Gospel According to John XII–XXI*, 883, and *The Death of the
 Messiah*, 1:847–48.

[passover] lamb which was commanded to be wholly roasted [Exod. 12:8–9] was a symbol of the suffering of the cross which Christ would undergo. For the lamb, which is roasted, is roasted and dressed up in the form of the cross. For one spit is transfixed right through the lower parts up to the head, and one across the back, to which are attached the legs of the lamb."[3]

My own father too was a butcher, and a lover of lamb with mint sauce. As a child, the inner geographical boundaries of my world extended from the massive granite bulk of the Redemptorist church squatting at one end of our street to the butcher shop guarding the other end. Redemption, expiation, sacrifice, slaughter.... There was no city abattoir in Limerick in those days; each butcher did his own slaughtering. I recall the hooks, the knives, the cleavers; the terror in the eyes of the victim; my own fear that I was afraid to show; the crude stun-gun slick with grease; the stunned victim collapsing to its knees; the slitting of the throat; the filling of the basins with blood; the skinning and evisceration of the carcass; the wooden barrels overflowing with entrails; the crimson floor littered with hooves.

I also recall a Good Friday sermon by a Redemptorist preacher that recounted at remarkable length the atrocious agony felt by our sensitive Saviour as the spikes were driven through his wrists and feet. Crucifixion, crucifixation, crucasphyxiation.... Strange to say, it was this somber recital, and not the other spectacle, that finally caused me to faint. Helped outside by my father, I vomited gratefully on the steps of the church.

Mors turpissima crucis

> Then they will hand you over to be tortured. . . .
> —MATTHEW 24:9

The central symbol of Christianity is the figure of a tortured man. Attending an exhibition of instruments of torture in Rome, Page duBois reports: "I gazed uneasily at the others visiting this spot.... I tried to imagine what brought them there. Was it a historical curiosity about the Middle Ages, or the same desire that brings people to horror movies, or sexual desire invested in bondage and discipline? I was there too."[4] Such unease would be almost unimaginable in a Sunday service, and yet the central spectacle is not altogether dissimilar. The Gospels do nothing to disturb the bland equanimity with which the average Christian views this grisly spec-

3 Justin Martyr, *Dialogue with Trypho* 40.3 (trans. from Roberts and Donaldson, eds., *The Ante-Nicene Fathers*).

4 DuBois, *Torture and Truth*, 2.

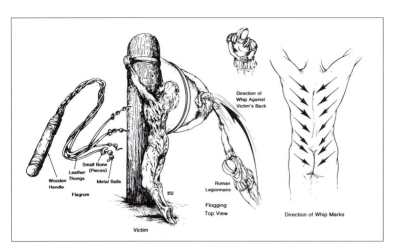

Figure 2: A Roman flogging as reconstructed by W .D. Edwards, W. J. Gabel, and F. E. Hosmer (*Journal of the American Medical Association*, 1986).

tacle. The evangelists seem smitten with verbal conspitation as they describe the scourging and crucifixion of Jesus.[5] Tersely John tells us that "Pilate took Jesus and flogged him [*elabon ho Pilatos ton Iēsoun kai emastigōsen*]" (19:1). Mark and Matthew relegate the scourging to a subordinate clause: "and after flogging Jesus, he handed him over to be crucified [*kai paredōken ton Iēsoun phragellōsas hina staurōthē*]" (Mark 15:15; cf. Matt. 27:26). Luke has Jesus publicize his flogging well in advance (18:33), but passes over the event itself in silence (although see 23:16, 22). What none of the evangelists find it necessary to say is that the scourging would almost certainly have been administered with a short *flagrum* composed of several single or braided leather thongs, each adorned with jagged fragments of bone, or weighted with metal balls, or both (see Figure 2); or that the severity of the flogging, when it was a prelude to crucifixion, was commonly calculated to bring the condemned to the forecourt, if not the threshold, of the grave, thereby shortening his sojourn on the cross (cf. Mark 15:44; John 19:33).[6] Contrast Josephus, who telling of the flogging of a different Jesus before a different Roman procurator, cannot resist throwing in a graphic detail: "he was scourged till his bones were laid bare [*mastixi mechri osteōn xainomenos*]"[7] This pales, however, beside Josephus's earlier claim that he himself had certain of his Galilean enemies "scourged

5 Scourging was a frequent prelude to crucifixion in the Roman world; see, most recently, Crossan, *Who Killed Jesus?*, 118–19.

6 Complete details can be found in Leclercq, "Flagellation (Supplice de la)," and Blinzler, *The Trial of Jesus*, 222–35 passim.

7 Josephus, *Jewish War* 6.5.3 §304 (my trans.). The Jesus in question is Jesus son of Ananias, and the procurator is Albinus.

until the entrails of all of them were exposed [...*emastigōsen, mechri pan-tōn ta splagchna gymnōsai*]."[8]

The restraint exercised by the evangelists in their accounts of Jesus' flagellation is only matched by the restraint exercised in their accounts of his crucifixion. "They crucify him [*staurousin auton*]" is all that Mark will say (15:24). Luke is no less tight-lipped—"they crucified him [*estaurōsan auton*]" is all he tells us (23:33)—while Matthew and John actually bundle the event into a subordinate clause: "And when they had crucified him [*staurōsantes de auton*], they divided his clothes..." (Matt. 27:35); "and carrying the cross by himself, he went out to what is called The Place of the Skull,...where they crucified him [*hopou auton estaurōsan*]..." (John 19:18). The noncanonical *Gospel of Peter* drains the scene still further of its horror: "And they brought two criminals and crucified the Lord between them. But he himself remained silent, as if in no pain" (4.1)[9].

It would not be difficult, however, to imagine the crucifixion of Jesus retold in the merciless manner of another contemporary work, *4 Maccabees*, which recounts in unsparing detail the execution by torture of an elderly Jew, Eleazar, under the baleful glare of the Syrian tyrant Antiochus IV Epiphanes—an execution, which, as it happens, also commences with a flogging (6:3–7):

> After they had tied his arms on each side they cut him with whips [*mastixin katē-kizon*], while a herald who faced him cried out, "Obey the king's commands!" But the courageous and noble man, like a true Eleazar, was unmoved, as though being tortured [*basanizomenos*] in a dream; yet while the old man's eyes were raised to heaven, his flesh was being torn by scourges, his blood flowing, and his sides were being cut to pieces [*anexaineto tais mastixin tas sarkas...kai katerreito tō haimati kai ta pleura katetitrōsketo*]. Although he fell to the ground because his body could not endure the agonies, he kept his reason upright and unswerving.[10]

After this, Eleazar is led away to be subjected to more elaborate agonies,

8 Ibid. 2.21.5 §612 (my trans.). We find a rather different, but even more gruesome, account of the incident in Josephus's *Life* (30.147).

9 Translation from Miller, ed., *The Complete Gospels*. This statement is often said to express a gnostic or docetic christology. The *Apocalypse of Peter* (incontestably gnostic) goes one better, "Peter" being vouchsafed an ebullient vision of what really transpired on Golgotha: "He whom you saw on the tree, glad and laughing, this is the living Jesus. But this one into whose hands and feet they drive the nails is his fleshly part, which is the substitute being put to shame, the one who came into being in his likeness" (81.15–23, trans. from Robinson, ed., *The Nag Hammadi Library*; cf. *Acts of John* 99, 101).

10 NRSV translation, modified (quotations from *4 Macc.* throughout this book will be based on the NRSV). Cf. *Ascension of Isaiah* 5:14: "And while Isaiah was being sawed in half, he did not cry out, or weep, but his mouth spoke with the Holy Spirit until he was sawed in two" (trans. from Charlesworth, ed., *The Old Testament Pseudepigrapha*).

although his entire ordeal is merely a warm-up for the slow butchering and broiling of seven brothers, witnessed by their mother, which follows (8:10–12:19; cf. 2 *Macc.* 6:18–7:42; *Testament of Moses* 8).[11]

Martin Hengel has written what amounts to a Maccabean elaboration of the stark statement, "they crucified him." When I tracked down Hengel's *Crucifixion in the Ancient World* in the college library I was surprised to find that it was not shelved in the religion section, as I had expected, but in a dusty corner of the history section devoted to torture. Hengel's theological monograph (for that is what it is) was flanked by lavishly illustrated treatises on medieval torture, on the one hand, and Amnesty International reports, on the other.

The burden of Hengel's book is to show, through extensive appeal to ancient sources, why crucifixion was regarded as the most horrific form of punishment in the ancient world. The original German edition of the work bore the Latin title *Mors turpissima crucis*, "the utterly vile death of the cross," a quotation from Origen.[12] Josephus similarly deemed crucifixion "the most wretched of deaths," while Cicero called it "that most cruel and disgusting penalty," and "the ultimate punishment."[13] According to Hengel, far from being a dispassionate execution of justice, "crucifixion satisfied the primitive lust for revenge and the sadistic cruelty of individual rulers and of the masses."[14]

Even in the Roman empire, where there might be said to be some kind of "norm" for the course of the execution (it included a flogging beforehand, and the victim often carried the beam to the place of execution, where he was nailed to it with outstretched arms, raised up and seated on a small wooden peg), the form of execution could vary considerably: crucifixion was a punishment in which the caprice and sadism of the executioners were given full rein. All attempts to give a perfect description of *the* crucifixion in archaeological terms are therefore in vain; there were too many different possibilities for the executioner.[15]

11 *4 Maccabees* appears to date roughly from the second quarter of the first century C.E.; see Bickerman, "The Date of Fourth Maccabees," and Hadas, *The Third and Fourth Books of Maccabees*, 95–99.

12 Origen, *Commentary on Matthew* 27.22.

13 Josephus, *Jewish War* 7.6.4 §203; Cicero, *Verrine Orations* 2.5.165, 168. See also Cicero, *On Behalf of Rabirus* 5.16 (even the term "cross" should be far from the eyes, ears and thoughts of a Roman citizen); Seneca, *Epistle* 101.14 (the cross is an "accursed tree"); Justinian, *Digest* 48.19 (crucifixion is "the supreme punishment"); Augustine, *City of God* 19.23 (crucifixion is "the worst of deaths, a death bound with iron"); along with 1 Cor. 1:18, 23; Gal. 3:13; Heb. 12:2. Crucifixion was also dubbed "the slave's punishment," as we shall see.

14 Hengel, *Crucifixion in the Ancient World*, 87.

15 Ibid., 25, his emphasis. The specimen texts here include Josephus, *Jewish War* 5.11.1 §451, and Seneca, *To Marcia on Consolation* 20.3. The latter reports: "I see crosses there, not just

The implication, of course, is that the bald statement, "they crucified him," may still retain some of its secrets even when the historians and archaeologists are through interrogating it. In a chapter unambiguously titled, "Crucifixion as a 'Barbaric' Form of Execution of Utmost Cruelty," Hengel documents some of the possibilities open to the executioner.[16]

Spectacle and Surveillance

> . . . the crowds who had gathered there for the
> spectacle. . . .
>
> —LUKE 23:48

> . . . they will be tormented with fire and sulfur
> in the presence of the holy angels and in the
> presence of the Lamb. And the smoke of their
> torment goes up forever and ever.
>
> —REVELATION 14:10–11

Seventeen-hundred years later we find the executioners exploring other possibilities. Michel Foucault's *Discipline and Punish* opens with the following scene:

> On 2 March 1757 Damiens the regicide was condemned "to make the *amende honorable* before the main door of the Church of Paris," where he was to be "taken and conveyed in a cart, wearing nothing but a shirt, holding a torch of burning wax weighing two pounds"; then, "in the said cart, to the Place de Grève, where, on a scaffold that will be erected there, the flesh will be torn from his breasts, arms, thighs and calves with red-hot pincers, his right hand, holding the knife with which he committed the said parricide, burnt with sulphur, and, on those places where the flesh will be torn away, poured molten lead, boiling oil, burning resin, wax and sulphur melted together and then his body drawn and quartered

of one kind but fashioned in many different ways: some have their victims with head down toward the ground; some impale their private parts; others stretch out their arms on the crossbeam" (Brown's trans.; see *Death of the Messiah*, 2:948).

16 Hengel, *Crucifixion in the Ancient World*, 22–32; cf. Kuhn, "Die Kreuzesstrafe während der frühen Kaiserzeit," 751–58. Hengel and Kuhn each conclude with bibliographies on ancient crucifixion (*Crucifixion*, 91–93; "Die Kreuzesstrafe," 775–80). For a more recent bibliography, see Brown, *The Death of the Messiah*, 2:885–87; and for Brown's own investigation of the practice, see esp. 2:945–53, 1088–92, 1176–78. Gerard S. Sloyan's *The Crucifixion of Jesus*, a significant contribution to this body of scholarship, unfortunately appeared too late to use.

by four horses and his limbs and body consumed by fire, reduced to ashes and his ashes thrown to the winds."[17]

According to witnesses, the execution was badly botched; the quartering went on interminably, two more horses had to be brought in, "and when that did not suffice, they were forced, in order to cut off the wretch's thighs, to sever the sinews and hack at the joints...."[18] The victim, meanwhile, forgave his executioners, Jesus-like, and begged them not to swear as they struggled to dismember him.

In time, as Foucault reports, the ritual of public torture became intolerable. "Protests against the public executions proliferated in the second half of the eighteenth century: among the philosophers and theoreticians of the law; among lawyers and *parlementaires*; in popular petitions and among the legislators of the assemblies."[19] The more spectacular forms of public execution gradually ceased, and judicial punishment was reestablished on a more "humane" foundation. "In the worst of murderers, there is one thing, at least, to be respected when one punishes: his 'humanity.' The day was to come, in the nineteenth century, when this 'man,' discovered in the criminal, would become the target of penal intervention, the object that it claimed to correct and transform, the domain of a whole series of 'criminological' sciences...."[20] No longer could judicial punishment be justified as the rightful vengeance of a sovereign on a rebellious subject.

A giant step forward in the history of judicial practice? Foucault does not think so, which is what makes *Discipline and Punish* remarkable. For Foucault, the feudal "society of the spectacle" was succeeded in the modern period by something altogether more sinister. The fearful spectacle of brutal punishment being publicly exacted on the body of a condemned criminal had at least the advantage of being open and direct. The degree of covert control over the individual that modern "disciplinary societies" aspire to would have been unimaginable under the old regimes. In particular, for Foucault, the prison reforms of the nineteenth century concealed an iron fist of totalitarianism in a velvet glove of humanitarianism. "In the totally ordered, hierocratized space of the nineteenth-century prison, the prisoner is put under constant surveillance, discipline, and education in order to transform him into what power as now organized in society demands that

17 Foucault, *Discipline and Punish*, 3, quoting from the *Pièces originales et procédures du procès fait à Robert-François Damiens* (1757).

18 Ibid.

19 Ibid., 73.

20 Ibid., 74. This terrain is further excavated in Foucault, ed., *I, Pierre Rivière....*

everyone become: docile, productive, hard-working, self-regulating, conscience-ridden, in a word, 'normal' in every way."[21]

In a 1978 interview Foucault remarked: "I'm delighted that historians found no major error in *Surveiller et punir* [*Discipline and Punish*] and that, at the same time, prisoners read it in their cells."[22] Recently, however, Page duBois has questioned the story that *Discipline and Punish* tells. She notes that the tripartite structure of the book shows "Torture" (the subject matter of Part One) yielding first to "Punishment" (Part Two) and then to "Discipline" (Part Three), the implication being that state-sanctioned atrocities such as the execution by torture of transgressors have now receded into history, "that we are all so throughly disciplined now, have so deeply internalized our own policing, that we no longer need the spectacle of punishment."[23] Foucault states confidently: "We are now far away from the country of tortures, dotted with wheels, gibbets, gallows, pillories."[24] "Tell it to the El Salvadorans," replies duBois.[25] In other words, the narrative of *Discipline and Punish* "is resolutely Eurocentric"; Foucault's "description of the transition from spectacular torture and execution to internalized discipline remains a local analysis."[26] His narrative is further undermined by the fact that whereas state-sanctioned torture does indeed seem to be the exception rather than the rule today in Western Europe and North America, the substantial role that certain Western democracies have played in propping up regimes that routinely employ torture to enforce public order suggests a disturbing, symbiotic relationship between the "societies of the spectacle" and the "disciplinary societies," one that the serene, seductive chronology of *Discipline and Punish* obscures.[27] These are serious criticisms. At the very least, they caution us that if we are to use *Discipline and Punish* as an analogical tool for a reconsideration of the relationship between violent punish-

21 White, "Michel Foucault," 106; cf. Miller, *The Passion of Michel Foucault*, 212. Didier Eribon claims that Foucault's "entire oeuvre can be read as a revolt against the powers of 'normalization'" (*Michel Foucault*, x). This is not the place for a general introduction to Foucault, however. Among the innumerable introductions available, at least three relate his work to biblical studies; see the Bible and Culture Collective, *The Postmodern Bible*, 138–44; Castelli, *Imitating Paul*, 35–58; and Moore, *Poststructuralism and the New Testament*, 85–94.

22 Foucault, "On Power," 101. Further on the reception of *Discipline and Punish* in the prisons, see Macey, *The Lives of Michel Foucault*, 335.

23 DuBois, *Torture and Truth*, 153.

24 Foucault, *Discipline and Punish*, 307.

25 DuBois, *Torture and Truth*, 154.

26 Ibid. Foucault himself was not unaware of this: "I could perfectly well call my subject [in *Discipline and Punish*] the history of penal policy in France—alone" ("Questions on Geography," 67).

27 Cf. DuBois, *Torture and Truth*, 154–57; also, Sáez, "Torture," 128ff.

ment and internalized self-policing in the New Testament (I shall be focusing mainly on the letters of Paul), we must allow for the possibility that the relationship may be symbiotic or parasitic.

"His Mighty and Annihilating Reaction"

> And Samuel hewed Agag in pieces before the
> Lord in Gilgal.
>
> —1 SAMUEL 15:33

> For the wrath of God is revealed from heaven
> against all ungodliness and wickedness. . . .
>
> —ROMANS 1:18

> I . . . give up body and life...to bring to an end
> the wrath of the Almighty. . . .
>
> —2 *Maccabees* 7:37–38

Let us begin with Hengel's conclusion, which is that "the earliest Christian message of the crucified messiah demonstrated the 'solidarity' of the love of God with the unspeakable suffering of those who were tortured and put to death by human cruelty...."[28] This is a poignant interpretation of the crucifixion. It is also an interpretation that one encounters repeatedly in the writings of liberation theologians. For example, introducing *The Scandal of a Crucified World: Perspectives on the Cross and Suffering*, editor Yacob Tesfai strikes a note that resounds through all nine contributions to this collection, the contributors hailing from such geographically disparate locales as Brazil, Cameroun, Germany, Guyana, Indonesia, South Africa, Taiwan, and the United States: "The crucifixion of Jesus is not an event in the past that happened to one person only. On the contrary, it is a cruel chastisement being meted out to all those who suffered and suffer still in various ways because of unjust and inhuman activities of people and the structures and systems created and sustained by them. Contemporary sufferers see in Jesus their own proper suffering."[29] To descend from the general to the particular, in *Passion of Christ, Passion of the World* by the Brazilian liberation theologian Leonardo Boff we read about Carlos Alberto, a Roman Catholic priest who became convinced that his ministry to his peasant parishioners necessitated "the promotion of their socio-political liberation," and was

28 Hengel, *Crucifixion in the Ancient World*, 88.
29 Tesfai, "Introduction," 11.

arrested and interrogated as a result.[30] "Father Carlos Alberto was barbarously tortured and taken back to his cell. With what strength he had left he read the passion of our Lord Jesus Christ according to Saint John, and realized that he was identified with Christ in a glorious suffering."[31] And yet a troubling question arises, one that Boff himself does not address, nor any of the contributors to *Scandal of a Crucified World*.[32] Hengel too can ill-afford to to address it, having argued that crucifixion "is a manifestation of trans-subjective evil, a form of execution which manifests the demonic character of human cruelty and bestiality."[33] The question is a deceptively simple one: Who inflicted the punishment of crucifixion on Jesus? Was it the procurator of Judea, acting on behalf of the Roman Emperor? Or was it an even higher power, acting through the Roman authorities—which is how several of the New Testament authors understood it (see Acts 2:23; 4:27–28; 1 Cor. 2:6–8; cf. John 19:11; Rom. 13:1–4; 1 Pet. 2:13–14)?[34]

Certain feminist theologians have taken this question with the utmost seriousness. "Is it any wonder that there is so much abuse in modern society," Joanne Carlson Brown and Rebecca Parker write, "when the predominant image or theology of the culture is of 'divine child abuse'—God the Father demanding and carrying out the suffering and death of his own son? If Christianity is to be liberating for the oppressed it must itself be liberated from this theology."[35] After centuries of exquisitely subtle pronouncements and propositions by theological courtiers and diplomats, designed to finesse the dubious divine desire that eventually issued in the crucifixion, such statements have a refreshingly direct ring.[36] What if the divine Emperor were still in a state of undress despite the most determined efforts of his theological tailors? Most embarrassing of all, what if the denuded Emperor were even discovered to be in a state of arousal as he allows the soldiers to violate the naked body of his Son?

30 Boff, *Passion of Christ, Passion of the World*, 118.

31 Ibid., 123.

32 Moltmann-Wendel ("Is There a Feminist Theology of the Cross?," 90) and Song ("Christian Mission toward Abolition of the Cross," 142) come closest, although ultimately they both skirt it.

33 Hengel, *Crucifixion in the Ancient World*, 87.

34 Whether "the rulers of this age" in 1 Cor. 2:8 are to be understood as human authorities, supernatural authorities (cf. Col. 2:15), or a combination of both does not substantially affect the issue.

35 Brown and Parker, "For God So Loved the World?," 26. For discussions of this and other feminist perspectives on the theology of the cross, see Schüssler Fiorenza, *Jesus*, 98–107, and the Bible and Culture Collective, *The Postmodern Bible*, 300–301.

36 Cf. Mark 14:36 (par. Matt. 26:39, 42; Luke 22:42): "Abba, Father, for you all things are possible [*panta dunata soi*]; remove this cup from me; yet, not what I want, but what you want [*all' ou ti egō thelō alla ti su*]." Gundry remarks: "That God *can* take away the cup—an ability emphasized by the ellipsis of 'are' between 'all things' and 'possible for you'—shows all the more that Jesus' crucifixion will be God's will" (*Mark*, 855, his emphasis).

To interpret the Son's torture and execution as a spectacle staged by the Father is to move within the ambit of the doctrine of *atonement*, a term which, as John McIntyre observes, "has so established itself as to have become the generic name for the doctrine of the death of Christ," enfolding all the other names within its embrace ("reconciliation," "redemption," "expiation," "propitiation," "substitution," "ransom," and so on).[37] The doctrine of atonement continues to exercise enormous popular appeal, even, or especially, in its propitiatory form, the form most calculated to cause contemporary theologians to squirm uncomfortably or become hot under the collar, clerical or otherwise.[38] "Jesus was nailed to the cross instead of me. He took the punishment that was due to me on account of my sins"—these are sentiments that I, at any rate, encounter with remarkable regularity in student essays.

Although it had a rich patristic history,[39] the doctrine of atonement came fully into its own only with Saint Anselm's *Cur Deus homo* (1097–98), where it was formulated as a "theory of satisfaction." The Anselmian form of the doctrine has generally been accepted by Roman Catholic theologians since the Middle Ages.[40] Moreover, as Gustaf Aulén notes, it has long been argued "that a continuous line may be traced from Anselm, through medieval scholasticism, and through the Reformation, to the Protestant 'Orthodoxy' of the seventeenth century."[41] This is not to say, continues Aulén, that Anselm's teaching was merely regurgitated by his successors, "for differences of view are noted in Thomas Aquinas and in the Nominalists, and the post-Reformation statements of the doctrine have a character of their own; nevertheless, there is a continuity of tradition, and the basis of it is that which Anselm laid."[42] What Anselm laid was a new foundation for the slaughterhouse of Christian soteriology. Its plan can be sketched as follows:

> Sin is an offence against the majesty of God. In spite of his goodness, God cannot pardon sin without compounding with honor and justice. On the other hand, he cannot revenge himself on man for his offended honor; for sin is an offence of infinite degree, and therefore demands infinite satisfaction; which means that he

37 McIntyre, *The Shape of Soteriology*, 39.

38 The term "propitiation" carries the implication that Jesus' death appeased the divine wrath called forth by sin.

39 See Daly, *Christian Sacrifice*, 309–490, and Young, *The Use of Sacrificial Ideas in Greek Christian Writers*, esp. 137–217.

40 It has been adopted by the Roman Catholic magisterium, although "not actually defined" (Rahner and Vorgrimler, *Dictionary of Theology*, 463; cf. anon., *Catechism of the Catholic Church*, 615).

41 Aulén, *Christus Victor*, 18.

42 Ibid., 18–19. Salient statements of the Reformers on the atonement are collected in Grelot, *Péché originel et rédemption*, 205ff. See also McGrath, *Luther's Theology of the Cross*, esp. 148–75.

must either destroy humanity or inflict upon it the eternal punishments of hell.... There is but one way for God to escape this dilemma without affecting his honor, and that is to arrange for some kind of *satisfaction*. He must have infinite satisfaction because the offense is immeasurable.... Hence, the necessity of the *incarnation*. God becomes man in Christ; Christ suffers and dies in our stead....[43]

It is, of course, no coincidence that Anselm's interpretation of the crucifixion bears a marked resemblance to the feudal conception of judicial punishment as outlined in the opening chapters of *Discipline and Punish*.[44] Under the feudal regime, "the law...represented the will of the sovereign; he who violated it must answer to the wrath of the king.... Thus, the power and integrity of the law were reasserted; the affront was righted. This excessive power found its form in the ritual of atrocity."[45] The term "ritual" is highly appropriate here. "Under this type of regime the notion of crime is still not fully distinguished from that of sacrilege, so that punishment takes the form of a ritual intended not to 'reform' the offender but to express and restore the sanctity of the law which has been broken."[46]

In *The Doctrine of Reconciliation*, the fourth and final volume of his *Church Dogmatics*,[47] Karl Barth reiterates Anselm's assertion that sin is an infinite affront to the divine majesty, requiring infinite restitution.[48] The fact that God put forward his own Son as the means of atonement "makes it plain what human guilt is," how horrendous it is.[49] Any other means "would be quite inadequate...even the severest punishment which might come upon us.... Even if he were eternally cast into hell, would not man still be the sinner that he is? What help would this punishment be?"[50] Instead, "the judgment of God" is "executed in the death of Jesus Christ." Negatively put,

43 From Alfred Weber's introduction to *Cur Deus Homo* (see Anselm, *Basic Writings*, viii, Weber's emphasis).

44 Beyond such generalizations, the precise extent of Anselm's dependence upon Roman public and private law (via Tertullian), Teutonic legal concepts (such as the practice of Wergild), and the early medieval penance system has long been debated. See McIntyre, *St. Anselm and His Critics*, esp. 82–95.

45 Dreyfus and Rabinow, *Michel Foucault*, 145.

46 Sarup, *Post-Structuralism and Postmodernism*, 67, paraphrasing Foucault. Foucault himself uses language such as the following: "[T]orture forms part of a ritual. It is an element in the liturgy of punishment" (*Discipline and Punishment*, 34).

47 The German title of the volume, *Die Lehre von der Versöhnung*, could just as easily be translated *The Doctrine of the Atonement*.

48 "The way in which it is put by Anselm of Canterbury...is very accurate and complete" (Barth, *The Doctrine of Reconciliation*, 1:485; cf. 1:407, 412; also 257, 273). In other respects, Barth is (mildly) critical of Anselm (e.g., 1:253, 486). Also see Barth's *Anselm*, which, however, concentrates on Anselm's ontological argument for the existence of God rather than his theory of satisfaction, even though the book arose out of a seminar on *Cur Deus homo* (7).

49 Barth, *The Doctrine of Reconciliation*, 1:491; cf. 412, 533ff.

50 Ibid., 1:491; cf. 540, 553.

this judgment, this sentence, is "the burning, the consuming fire, the blinding light of His wrath" on "corrupt and sinful man."[51] This judgment and sentence is "that I am the man of sin, and that this man of sin and therefore I myself am nailed to the cross and crucified (in the power of the sacrifice and obedience of Jesus Christ in my place), that I am therefore destroyed and replaced, that as the one who has turned to nothingness I am done away in the death of Jesus Christ."[52] For it was Jesus himself who, in "lowly obedience," "undertook to withstand the wrath of God in our place on the cross."[53]

The language of wrath and punishment applied to the crucifixion is by no means defunct even among contemporary critical exegetes. In his massive commentary on Romans, for example, Douglas Moo has recently defended the traditional attribution to Paul of a doctrine of divine wrath and retribution.[54] What distinguishes Moo from other critical commentators on Romans is his austere refusal to dilute the doctrine of divine wrath to make it more palatable to modern tastes. "God's wrath is necessary to the biblical conception of God," he insists. "The OT constantly pictures God as responding to sin with wrath"—Moo's examples include Exodus 4:14; 15:7; 32:10–12; Numbers 11:1; Jeremiah 21:3–7—and "Paul clearly works with this same conception of God's wrath."[55] Moo singles out C. H. Dodd as representative of the apologetic school of thought to which he is so sternly opposed.[56]

Dodd's concluding comment in his discussion of the wrath of God in Romans 1:18 is really his point of departure: "In the long run we cannot think with full consistency of God in terms of the highest ideals of personality and yet attribute to Him the irrational passion of anger."[57] C. E. B. Cranfield also objects to Dodd's mild-mannered God.[58] God *is* capable of anger, insists Cranfield, although God doesn't foam at the mouth, tear the telephone out of the wall, say things he will regret in the morning, or return to the office with an assault rifle and a case of ammunition. On the contrary, "even the very highest and purest human wrath can at the best afford but a

51 Ibid., 1:514; cf. 3:461–78 passim.

52 Ibid., 1:515; cf. 2:378–403 passim. See also Barth, *The Epistle to the Romans*, 193–94, 199.

53 Barth, *The Doctrine of Reconciliation*, 1:559; cf. 2:487ff.; *The Epistle to the Romans*, 105–6.

54 Moo, *Romans 1–8*, 94–97.

55 Ibid., 94–95. For Moo, however, Paul stresses even more strongly "than the OT the working and effects of God's wrath" (95).

56 See Dodd, *The Epistle of Paul to the Romans*, esp. 20–24.

57 Ibid., 24. Cf. Käsemann, *Commentary on Romans*, 37, who claims that the wrath of God in Rom. 1:18 "is not to be viewed as an emotion," nor is "psychologizing language about holy indignation" applicable to it. Christian qualms about attributing anger to God go back at least to Clement of Alexandria (e.g., *The Instructor* 1.9) and Origen (e.g., *Against Celsus* 4.13; *On the Principles* 3.1 passim).

58 Cranfield, *The Epistle to the Romans*, 1:108–9.

distorted and twisted reflection of the wrath of God, since the wrath of men (our Lord alone excepted) is always more or less compromised by the presence of sin in the one who is wroth, whereas the wrath of God is the wrath of Him who is perfectly loving, perfectly good."[59] For James D. G. Dunn also, Paul's conception of God's wrath is an exquisitely nuanced affair, transcending the commonplace notions of "divine indignation" and "judicial anger against evil," not to mention divine vengeance.[60] Yet Dunn, like Cranfield, would stop well short of Dodd's contention that "the wrath of God" (an "archaic phrase" that "suits a thoroughly archaic idea") is retained by Paul "not to describe the attitude of God to man, but to describe an inevitable process of cause and effect in a moral universe...."[61] Joseph A. Fitzmyer, however, whose own outsized commentary on Romans ranks alongside those of Cranfield, Dunn, and Moo, comes perilously close to echoing Dodd's pernicious doctrine (Moo couples Dodd with the heresiarch Marcion, who also tinkered with Romans 1:18) when he writes: "When Paul speaks of God's wrath being revealed against the godlessness and wickedness of pagans, it is his inherited way of expressing the inevitability of evil finding its own retribution."[62]

Barth, too, was sternly critical of the Pauline apologists of his own day:

> The critics of the term "wrath of God"...were quite wrong when they said that "wrath" is not a quality or activity or attitude which can be...brought into harmony with [God's] love and grace. In reply to this criticism we have to say plainly that the grace of God would not be grace if it were separated from the holiness in which God causes only His own...will to prevail and be done, holding aloof from and opposing everything that is contrary to it, judging and excluding and destroying everything that resists it.[63]

And later: "For wrong is an outrage and abomination to God. It has to perish. The right of God confronts it with such majesty. It cannot exist before it. It is taken up and burnt and destroyed...."[64] And so the perpetrator of wrong

59 Ibid., 1:109; cf. 216. Indeed, Cranfield's God can express his anger only by driving his fist into his own face: "God, because in His mercy He willed to forgive sinful men and, being truly merciful, willed to forgive them righteously, that is, without in any way condoning their sin, purported to direct against His own very Self in the person of His Son the full weight of that righteous wrath which they deserved" (1:217).

60 Dunn, *Romans 1–8*, 54–55, 70–71.

61 Dodd, *Romans*, 23; cf. 29, 77, 200, 204. This is also the position of Hanson, *The Wrath of the Lamb*; see esp. 69, 84–85, 89. Käsemann distances himself from this view (*Commentary on Romans*, 37, 138).

62 Fitzmyer, *Romans*, 272; cf. 108. It is not to Dodd that Fitzmyer appeals for support, however, but to J. A. T. Robinson (see *Wrestling with Romans*, 18).

63 Barth, *The Doctrine of Reconciliation*, 1:490; cf. *The Epistle to the Romans*, 42–43, 358–59.

64 Barth, *The Doctrine of Reconciliation*, 1:539.

is "intolerable before God," and "cannot remain in His presence but can only disappear. It is his existence which is untenable. It is he who is confronted by the majestic right of God. It is he who must perish," who must "be repaid, and repaid according to his works. This man has to die." Upon him the judgment of God must fall "in all its inescapable...strictness."[65] Barth would undoubtedly approve of Moo, then, who himself applauds Anders Nygren's paraphrase of Romans 1:18: "As long as God is God, He cannot behold with indifference that His creation is destroyed and His holy will trodden underfoot. Therefore He meets sin with His mighty and annihilating reaction."[66] Here we are not far from the world of Anselm, nor from the world of Paul. We can almost hear the bones cracking on the wheel as the might of the offended sovereign bears down upon the body of the condemned (cf. *4 Macc.* 9:12ff.; 10:8; 11:9–10, 17–18).

"What a Primitive Mythology"

> . . . Christ Jesus, whom God put forward as a
> sacrifice of atonement by his blood. . . .
>
> —ROMANS 3:24–25

> . . . now that we have been justified by his blood,
> will we be saved through him from the wrath of
> God.
>
> —ROMANS 5:9

Not surprisingly, the doctrine of atonement has been an acute embarrassment for many other twentieth-century exegetes. Rudolf Bultmann is exemplary in this regard, turning pink, then crimson, then apoplectic purple as he confronts it.[67] Traditionally the doctrine has been laid at the feet of Paul, where it lies in a slow-spreading pool of blood. For Bultmann, as for the majority of critical scholars, Paul does not altogether deserve this dubious honor.[68] (Turning to leave, Paul slips on the blood and lands flat on his back

65 Ibid., 1:539–40; cf. 280; 2:400.

66 Nygren, *Commentary on Romans*, 98, quoted in Moo, *Romans 1–8*, 94.

67 Xavier Léon-Dufour's embarrassment is only slightly less agonized; I shall consider his *Life and Death in the New Testament* below. Other studies are decidedly less embarrassed in tone; see, e.g., Taylor, *The Atonement in New Testament Teaching*; Hengel, *The Atonement*; Grayston, *Dying, We Live*; Tambasco, *A Theology of Atonement*; G. Barth, *Der Tod Jesu Christi*; and Sloyan, *The Crucifixion of Jesus*. Defiantly unapologetic is H. D. McDonald; see, most recently, his *New Testament Concept of the Atonement*.

68 The following discussion is indebted to Gundry's critique of Bultmann in his *Sōma in Biblical Theology* (see esp. 206–209).

in the doctrine. Horrified, Bultmann rushes over to help the Apostle to his feet. Apologizing profusely, Bultmann attempts to wipe the sacrificial blood of Jesus from the Apostle's robe with his handkerchief.)

Paul's thought regarding sin contains two distinct strands, according to Bultmann, and these strands "are not harmonized with each other."[69] Most significant for us is the strand that Bultmann regards as least important (it turns out to be a stray strand of intestine from the butchered body of a sacrificed animal, as we shall see). Bultmann reluctantly concedes that there is in Paul a "juristic conception of death as the punishment for sin."[70] This Paul inherited from "the Old Testament-Jewish tradition."[71] Bultmann continues:

> *Death is the punishment for the sin a man has committed*; sinners are "worthy of death" (Rom. 1:32 KJ), they have "earned" death. So Paul can also say that…the sinner by his death pays his debt, atones for his sin (Rom. 6:7). In such statements, death, we must recognize, is first thought of as the death which is natural dying, as Rom. 5:12ff. shows, according to which death as the punishment for sin was brought into the world by Adam's sin. Nevertheless, they also presuppose that this death will be confirmed—made final, so to say—by the verdict condemning them to "destruction" which God will pronounce over sinners on the judgment day (Rom. 2:6–11).[72]

Faced with this glum prospect, the sinner is in urgent need of justification through the blood of Jesus Christ, "a propitiatory sacrifice by which forgiveness of sins is brought about; which is to say: by which the guilt contracted by sins is canceled."[73] Closely bound up with the idea of propitiatory sacrifice, moreover, is the idea of vicarious sacrifice, "which likewise has its origin in the field of cultic-juristic thinking."[74] "The same phrase (*hyper hēmōn*) that is translated 'for us' can also express this idea, meaning now: 'instead of us,' 'in place of us.'"[75] Bultmann detects a vicarious theology in Galatians 3:13 ("Christ redeemed us from the curse of the law by becoming a curse for us—for it is written 'Cursed is everyone who hangs on a tree'") and 2 Corinthians 5:21 ("For our sake, he made him to be sin who knew no sin…"; cf. Rom. 8:3), and argues that both ideas, vicarious and propitiatory

69 Bultmann, *Theology of the New Testament*, 1:249.
70 Ibid.
71 Ibid., 1:246. Compare Bultmann's deprecation of Revelation as "weakly Christianized Judaism" (ibid., 2:175).
72 Ibid., his emphasis.
73 Ibid., 1:295. According to Bultmann, this view underlies the following Pauline passages: Rom. 3:25ff.; 5:9; 1 Cor. 11:24ff.; 1 Cor. 11:24 ff; 15:3; 2 Cor. 5:14; cf. Rom. 4:25; 5:6, 8; 8:32; 14:15; Gal. 1:4; 2:20; I Thess. 5:10.
74 Ibid., 1:296.
75 Ibid.

sacrifice, merge in 2 Corinthians 5:14ff ("we are convinced that one has died for all; therefore all have died.... [I]n Christ God was reconciling the world to himself, not counting their trespasses against them...").[76]

Bultmann himself bristles at such ideas. "How can the guilt of one man be expiated by the death of another who is sinless—if indeed one may speak of a sinless man at all?" he splutters in "New Testament and Mythology." "What primitive notions of guilt and righteousness does this imply? And what primitive idea of God?... What a primitive mythology it is, that a divine Being should...atone for the sins of men through his own blood!"[77] The sacrificial hypothesis entails a *sacrificium intellectus* that Bultmann is determined to avoid. He has no desire to see his own brain laid upon the sacrificial altar, quivering under the upraised knife.

In his *Theology of the New Testament*, therefore, Bultmann is careful to highlight those passages in which Paul appears to interpret Jesus' crucifixion as potential deliverance from the *power of sin*, and to gloss over passages in which Paul appears to interpret the crucifixion as sacrificial atonement for *actual sins committed*. The latter passages do "not contain Paul's characteristic view."[78] For Paul, "Christ's death is not merely a sacrifice which cancels the guilt of sin (i.e., the punishment contracted by sinning), but is also *the means of release from the powers of this age: Law, Sin, and Death*."[79] Like the judicial reformers of the eighteenth century, then, Bultmann finds the idea of a vengeful sovereign, one capable of inflicting brutal physical punishment on his rebellious subjects, to be intolerable. Such primitive ideas "make the Christian faith unintelligible and unacceptable to the modern world."[80]

"Once you suppress the idea of vengeance," writes Madan Sarup, "punishment can only have a meaning within a technology of reform"[81]—or a *theology* of reform, as here. The doctrine of atonement, in its classic medieval form, amounts to an interpretion of Jesus' death as public execution by torture for transgression, the righting of an affront to the sovereign power—the injured party not being the Roman Emperor, however (as those who administer the punishment unwittingly suppose), but the Divine Majesty Himself. Uncomfortable with such primitive notions, Bultmann prefers to attribute to Paul—the "real" Paul—an interpretation of Jesus' death as a potential

76 Ibid. Sanders objects: "Expiation, propitiation and substitution may be theoretically distinguished, but it is not clear that such distinctions were made in the first century or are relevant for Paul." Sanders prefers "to speak of all the sacrificial passages as referring simply to atonement for past transgressions" (*Paul and Palestinian Judaism*, 465).

77 Bultmann, "New Testament and Mythology," 7.

78 Bultmann, *Theology of the New Testament*, 1:296; cf. 46–47, 287.

79 Ibid, 1:297–98, his emphasis; cf. 287.

80 Bultmann, "New Testament and Mythology," 5.

81 Sarup, *Post-Structuralism and Postmodernism*, 67–68, paraphrasing Foucault.

reform, a unique opportunity for the transgressor to be utterly transformed from within. The event of the cross promises freedom from sin. "But this freedom is not a static quality: it is freedom *to obey*. The indicative implies an imperative."[82] A horrific act of violence, then, execution by public torture, gives birth to an altogether different order in which obedient action springs spontaneously from within and no longer from any external coercion. This is also the transition that *Discipline and Punish* describes.

Bultmann's insistence that the crucifixion be understood in terms of inner transformation recalls the "subjective" doctrine of the atonement, commonly associated with the twelfth-century philosopher and theologian, Peter Abelard, and distinguished from Anselm's "objective" doctrine. Abelard interpreted the atonement "as consisting essentially in a change taking place in men rather than a changed attitude on the part of God."[83] The subjective doctrine only came into its own during the Enlightenment, however, when, as we have seen, the practice of public execution by torture was being questioned: "A 'more humane' idea of the Atonement was propounded.... The doctrine of retributive punishment was scouted, for punishment could only be ameliorative."[84] Around the same time, moreover, an aspect of the traditional doctrine of hell, one defended by such theological colossi as Augustine and Aquinas, and by lesser luminaries such as Tertullian and Peter of Lombardy, became an embarrassment in certain quarters. This was the idea that part of the happiness of the blessed consists in contemplating the torments of the damned (cf. Luke 16:23–26; Rev. 14:9–10; Isa. 66:24),[85] a spectacle calculated to fill them with grim satisfaction, or outright delight, since it manifests the Divine Sovereign's impartial justice and implacable hatred of sin.[86] "Forgive me, my God! Forgive me, Lord!" screams Foucault's Damiens "at each torment,...as the damned in hell are supposed to cry out...."[87]

Of course, Bultmann is far from being the only modern New Testament scholar to ascribe a theology, or technology, of reform to Paul—he is simply the most passionate. In *Paul and Palestinian Judaism*, the most admired book on Paul in recent decades, E. P. Sanders extends Bultmann's gesture, taking the Apostle firmly by the elbow and leading him even farther away from the altar of sacrifice. (Paul is insisting that the altar is dripping with

82 Bultmann, "New Testament and Mythology," 32, his emphasis. This sentiment is a commonplace of Pauline studies.

83 Aulén, *Christus Victor*, 18.

84 Ibid., 150.

85 Also *1 Enoch* 27:3–4; 48:9; 90:26–27; *4 Ezra* 7:36; *Apocalypse of Paul* 20.5–22.10.

86 See Walker, *The Decline of Hell*, 29–32, and Almond, *Heaven and Hell in Enlightenment England*, 97–100. Cf. Bernstein, *The Formation of Hell*, 331–32.

87 Foucault, *Discipline and Punish*, 4 (I have modified Sheridan's translation here).

the blood of a crucified man. Drs. Bultmann and Sanders briskly assure him that it is not.) "It is not clear...that all the references to Christ's dying 'for us' [e.g., Rom. 4:24–25; 5:6–9; 1 Cor. 15:3] should be taken as referring to his *sacrificial death for past transgressions*," Sanders states in opposition to Bultmann.[88]

> On the contrary, Paul often gives quite a different significance to the death of Christ. Thus II Cor. 5.14f.: "For the love of Christ controls us, because we are convinced that one has died for all; therefore all have died. And he died for all, that those who live might live no longer for themselves but for him who for their sake died and was raised." Here the significance of Christ's death "for all," *hyper pantōn*, is not primarily that it is expiatory. We note here the ease with which Paul uses categories of participation to explain his meaning: "therefore all have died," not "therefore all have had their sins expiated." It is true that in 5.19 Paul says that God did not count former trespasses, but it is equally true that the meaning of 5.14 cannot be restricted simply to this "overlooking" of former trespasses. Rather, in Christ, one dies to the *power* of sin, and does not just have trespasses atoned for.[89]

Here Sanders is finishing what Bultmann began, picking up several of the problematic Pauline passages that Bultmann had precipitously consigned to the "cultic-juristic" trash heap and dusting them off. Sanders is now ready to endorse Bultmann's view of Paul's "characteristic" view of Jesus' demise: "I agree completely with Bultmann and most other scholars that what is distinctive in Paul is not the repetition of the traditional sacrificial view...."[90] In support, Sanders cites his distinguished teacher W. D. Davies and Bultmann's distinguished student Ernst Käsemann (New Testament scholarship is largely a father-and-son business). Käsemann wrote: "But for Paul, salvation does not primarily mean...the forgiving cancellation of former guilt. It is, according to Rom. 5.9f.; 8.2, freedom from the power of sin, death and the divine wrath; that is to say, it is the possibility of a new life."[91]

For Käsemann, of course, it is not a matter of an eleventh-hour pardon, a telephone call from the divine Governor as the sweating sinner is being strapped into the electric chair—a "cancellation of former guilt"—followed by a successful program of rehabilitation leading to "the possibility of a new life." Instead the lever is pulled, the sinner is mystically electrocuted—and then goes on to lead a productive life. For Sanders's Paul also, the crucial

88 Sanders, *Paul and Palestinian Judaism*, 464, his emphasis, referring to Bultmann, *Theology of the New Testament*, 1:296.
89 Sanders, *Paul and Palestinian Judaism*, 464–65, his emphasis. He proceeds to read Gal. 1:14, Rom. 14:8–9, and 1 Thess. 5:10 in this light.
90 Ibid., 465.
91 Käsemann, "The Saving Significance of the Death of Jesus," 41, quoted in Sanders, *Paul and Palestinian Judaism*, 466; cf. Davies, *Paul and Rabbinic Judaism*, 242. See further Käsemann, *Commentary on Romans*, 158–86.

thing is "the Christian's *death with Christ*."[92] "[B]y *sharing* in Christ's death, one dies to the *power* of sin...with the result that one *belongs to God*.... The transfer takes place by *participation* in Christ's death.... One is free from the power of sin (or the law) and free to live for God."[93] One is free from the law precisely because one has incurred the full penalty of the law: one has joined Jesus in the chair. The attending physician declared him dead, but God managed to resuscitate him. As a result one can now walk free with him. Barth puts it memorably: "His innocence, the innocence in which He bore and bore away our sin, the innocence which was manifested in His resurrection, was and is our innocence...."[94] And again: "By virtue of his resurrection from the dead,...we have a future and hope, the door has been opened, and we cross the threshold from wrong to right, and therefore from death to life."[95] Pauline soteriology as pulp fiction? Reading Barth or Bultmann, or even Sanders, one frequently finds oneself in the midst of a theological crime thriller, a nail-biting prison drama in which the innocent hero has elected to go to the chair in place of his guilty brother, only to cheat the executioner unexpectedly and march through the prison gates arm in arm with the now reformed brother into the mandatory sunset and the apocalyptic announcement of "The End."

God's Own (Pri)son

> Are they servants of Christ? . . . I am a better
> one: with far greater labors, far more imprison-
> ments, with countless floggings. . . .
>
> —2 CORINTHIANS 11:23–25

> Now I begin to be a disciple.... Let fire and the
> cross; let the crowds of wild beasts; let tearings,
> breakings, and dislocations of bones; let cutting
> off of members; let shatterings of the whole body;
> and let all the dreadful torments of the devil come
> upon me. . . .
>
> —IGNATIUS OF ANTIOCH, *Epistle to the Romans* 5[96]

92 Sanders, *Paul and Palestinian Judaism*, 466, his emphasis.
93 Ibid., 467–68, his emphasis.
94 Barth, *The Doctrine of Reconciliation*, 1:556.
95 Ibid., 1:557. Appropriately enough, Barth's next section is entitled "The Pardon of Man" (568–608).
96 Translation from Roberts and Donaldson, eds., *The Ante-Nicene Fathers*.

One would be hard-pressed to find a Protestant New Testament scholar more squeamish about the blood of Jesus than Bultmann. One would be equally hard-pressed to find a Roman Catholic New Testament scholar more squeamish about it than Xavier Léon-Dufour. Léon-Dufour's *Life and Death in the New Testament* returns obsessively to the motifs of sacrifice, expiation, and atonement. For Bultmann, the bloodstains on Paul's letters are an unfortunate residue of the "Old Testament-Jewish tradition."[97] Fighting down a wave of nausea, Léon-Dufour also analyzes these bloodstains—and discovers a blood type so rare (so pure?) as to be in a class all of its own. "We must carefully refrain from regarding this 'blood' from the perspective of the bloody sacrifices in other religions, or even within the framework of Jewish sacrifices," he cautions.[98] "To give expression to Christ's death there is no need now to refer to the sacrifices of the Old Testament, except to note their end, their disappearance...."[99]

Léon-Dufour is especially pained by a common tendency among Christians, loosely based on a sacrificial reading of Paul,[100] to speak "of sin's 'offense' against God and of God's intention to punish and to chastize," on the one hand, and "of 'reparation,' of 'satisfaction,' and of 'merit' by which the human Jesus 'satisfied' divine justice," on the other hand.[101] This leads to a "distressing attribution" to God of "inadmissible dispositions."[102] Although Léon-Dufour does not say so explicitly, the dispositions in question are those of a cruel despot who keeps his fearful subjects in check through the threat of frightful physical punishment—the sort of despot who features

97 In his reconstruction of the Pauline interpretation of Jesus' crucifixion, Bultmann attempts to eradicate the "Jewish sacrificial" element from Paul's theology, as we have seen. This gives rise to some troubling questions. Is it possible to isolate Bultmann's statements on Paul in "New Testament and Mythology" (1941, later elaborated in his *Theology of the New Testament*, 1948–53) from the Nazi solution to the Jewish question, which was being implemented even as Bultmann wrote? What is Bultmann really doing in these statements? Excising an undesirable Jewish influence from Paul's thought? Inadvertently furthering the ethnic cleansing everywhere underway around him? In response to such questions, is it enough simply to cite Bultmann's public criticism of Nazi policy in his 1933 lecture at Marburg (see "The Task of Theology in the Present Situation," esp. 165), courageous and commendable though that criticism was? Did the anti-Judaic elements common in German theology of the period, including Bultmann's own, not contribute to the very phenomenon he was attacking? These are questions that have often been debated; see esp. Schwan, *Geschichtstheologie Konstitution*, a book-length comparison of Bultmann's theology and that of his National Socialist colleague Friedrich Gogarten. Also see the comments of Georgi, "*Theology of the New Testament* Revisited," 82ff.; Jones, *Bultmann*, 200–208 passim (cf. 175–92 passim); and Boyarin, *A Radical Jew*, 209–14 (who focuses on Käsemann more than Bultmann, although what he has to say about the former also applies to the latter).

98 Léon-Dufour, *Life and Death in the New Testament*, 189.

99 Ibid., 190.

100 A "Paul" who is also the author of Hebrews (as the historical Paul was not).

101 Ibid., 192.

102 Ibid.

prominently in the early chapters of *Discipline and Punish*. Interestingly, the public executions by torture in eighteenth-century France led to the precise phenomenon that Léon-Dufour deplores, an attribution to the sovereign of "inadmissible dispositions." Foucault writes: "It was as if the punishment was thought to equal, if not to exceed, in savagery the crime itself, to accustom the spectators to a ferocity from which one wished to divert them,...to make the executioner resemble a criminal, judges murderers...."[103] Léon-Dufour's God is not given to theatrical displays of power. A "healthy understanding of Jesus' death" would emphasize instead its transformative potential, how it is "active" in the believer through baptism and the eucharist "so that it exercises its influence in ordinary life."[104] Once again, as in the eighteenth-century rhetoric of judicial reform, the recommended shift of emphasis is from corporal punishment ("painful to a more or less horrible degree," as one contemporary glossed it) to internal reform leading to a transformation of everyday behaviour.[105]

What the transformational interpretation of the crucifixion attempts to exclude, however, is the issue of *power*, an issue all too close to the surface in the punitive interpretation, the power of one person over the body of another, a power never more evident than in the relationship of the torturer to the victim—and never more disturbing, perhaps, than when the torturer is God and the victim his Son.[106] But what if the transformation of the believer were merely a more efficient exercise of power, still exercised on the body but now reaching into the psyche as well to fashion acceptable thoughts and attitudes yielding acceptable behavior, of power absolutized to a degree unimaginable even in a situation of extreme physical torture? This, above all, is the question that *Discipline and Punish* prompts us to ask.

Let us rephrase the question: What if the crucified Jesus, as interpreted by Paul, were actually God's own (pri)son? The prison would contain a courtyard, and the courtyard would be dominated by a scaffold. Needless to say, Paul's gospel of reform cannot simply be equated with the judicial reforms of the eighteenth century. For the latter, the punitive liturgy of public torture had to be consigned once and for all to history. But for Paul, discipline remains indissolubly bound up with atrocity. Each believer must be subjected to public execution by torture: "Do you not know that all of us who

103 Foucault, *Discipline and Punish*, 9.

104 Léon-Dufour, *Life and Death in the New Testament*, 192. Compare Dunn on Rom. 6:4: "We should note at once how quickly Paul jumps from a deep theological concept (union with Christ in his death) to talk of daily conduct. For Paul, evidently, *the character of daily conduct is actually determined by these deeper realities...*" (*Romans 1–8*, 330, his emphasis).

105 The quote is from Foucault, *Discipline and Punish*, 33.

106 For a penetrating analysis of the torturer-victim relationship, see Scarry, *The Body in Pain*, 27–59. Also insightful in this regard is Greenblatt, *Learning to Curse*, 11ff.

have been baptized into Christ Jesus were baptized into his death?" (Rom. 6:3). Paul refuses to separate torture from reform (cf. 1 Cor. 1:18ff.; Gal. 2:19–21). Unless the believer is tortured to death in the (pri)son, he or she cannot be rehabilitated: "We know that our old self was crucified with him so that the sinful body might be destroyed [*hina katargēthe to sōma tēs hamartias*]" (Rom. 6:6; cf. Gal. 5:24).

Of course, Christian discipline is also bound up with power: "[T]he kingdom of God does not consist in talk but in power [*en dynamei*]" (1 Cor. 4:20). How is this power exercised and who is entitled to exercise it? Foucault's views on power may be pertinent here. "In thinking of the mechanisms of power," he explains, "I am thinking...of its capillary forms of existence, the point where power reaches into the very grain of individuals, touches their bodies...."[107] For Foucault, "nothing is more material, physical, corporal than the exercise of power"—and for Paul too, seemingly.[108] As Elizabeth A. Castelli has remarked of 1 Corinthians, "the human body provides a central series of images and themes for this text.... Food practices and sexuality occupy fully half of the letter's content.... It is also the case that explicit language about authority and power is used most frequently in the discussion of bodily practices...."[109]

Discipline has only one purpose, according to Foucault: the production of "docile bodies."[110] "A body is docile that may be subjected, used, transformed and improved," says Foucault.[111] "I punish my body and enslave [*doulagōgō*] it," says Paul (1 Cor. 9:27). Indeed, the docility engendered by discipline is precisely that of the slave. Crucifixion in the Roman world was, above all, "the slave's punishment."[112] Through Jesus' crucifixion, then, the Christian slave is disciplined and kept in line (cf. Phil. 2:5–8). "Whoever was free when called is a slave [*doulos*] of Christ," says Paul (1 Cor. 7:22; cf. Rom. 6:16–19), he himself being no exception (Rom. 1:1; cf. Phil. 1:1). Of course, there are slaves and "slaves" (cf. 1 Cor. 7:21–24; Phlm. 15–16), and Paul is in the parenthesized category.[113] Even among "slaves," moreover, a strict hier-

107 Foucault, "Prison Talk," 39. Foucault's most detailed and most frequently cited statement on power, however, occurs in *The History of Sexuality*, 1:92–97. For a brilliantly incisive elucidation of this controversial statement, see Halperin, *Saint Foucault*, 16ff.
108 Foucault, "Body/Power," 57–58.
109 Castelli, "Interpretations of Power in 1 Corinthians," 209; cf. Brown, *The Body and Society*, 51–57; Meeks, *The Origins of Christian Morality*, 131–35. Above all see Martin, *The Corinthian Body*, which appeared too late to be incorporated into my discussion.
110 Cf. Foucault, *Discipline and Punish*, 135–69.
111 Ibid., 136.
112 See, e.g., Cicero, *Verrine Orations* 2.5.169; Valerius Maximus, *Deeds and Sayings* 2.7.12; Tacitus, *Histories* 2.72.2; 4.11.3. For discussion see Hengel, *Crucifixion in the Ancient World*, 51–63, and Kuhn, "Die Kreuzesstrafe während der frühen Kaiserzeit," 719–23.
113 Here Paul is deploying the rhetorical topos of the "enslaved leader" (see Martin, *Slavery as Salvation*, 86–135).

archy is observed; the man is the "head" [*kephalē*] of the woman, for example, even as Christ is the "head" of the man (1 Cor. 11:3; 14:34). Christ himself is also a subject: "When all things are subjected to him, then the Son himself will also be subjected to the one who put all things in subjection under him" (1 Cor. 15:28; cf. 11:3).

Given this hierarchy of subjection and submission, it is no wonder that Paul can define his apostleship, his mission, as as that of bringing about "the obedience of faith" (*hypakoē pisteōs*—Rom. 1:5)—that is, the faith that manifests itself as obedience, or alternatively the obedience that stems from faith.[114] As Dunn has argued, that "the obedience of faith" is "a crucial and central theme" of Paul's preeminent surviving letter, (i.e., Romans), "structurally important in understanding the thrust of the letter," is indicated by its reappearance in the letter's concluding sentence (16:26), thereby framing it, and by the prominence of *hypakoē* ("obedience") and its cognate, *hypakouō* ("I obey"), in the letter as a whole (5:19; 6:12, 16–17; 10:16; 15:18; 16:19; cf. 10:30–31).[115]

Indeed, throughout all of Paul's letters, the issue of obedience is crucial to his interpretation of Jesus' crucifixion, as David Seeley has recently demonstrated in *The Noble Death*. For Seeley, as for several other sleuths, the trail of blood sprinkled across Paul's letters leads not to the Old Testament altar of sacrifice, nor to Isaiah 53 (where the Servant of Yahweh suffers silently), nor to Mount Moriah (where Abraham has raised his knife to slit his son's throat), nor to the secret chambers where Hellenistic mystery rites were practiced, but to the torture chamber of Antiochus IV Epiphanes.[116] In other words, Paul's interpretation of Jesus' crucifixion is primarily, although not exclusively, a martyrological one, and a blood relative of the interpretations of the Maccabean martyrs' deaths lightly sketched out in *2 Maccabees* and given detail and (garish) color in *4 Maccabees* (a free expansion of *2 Macc.* 6:12–7:42).[117]

Now, the heroic example set by the Maccabean martyrs is precisely the example of *obedience*. They embrace God's will, expressed in his law, no matter how horrific the cost. The martyrs are models, moreover, for the audiences of these books, who are implicitly urged to imitate their obedi-

114 The first if the genitive in *hypakoē pisteōs* is epexegetical or appositional, the second if it is a genitive of source (see Fitzmyer, *Romans*, 237).

115 Dunn, *Romans 1–8*, 17–18; cf. Cranfield, *Epistle to the Romans*, 1:66–67.

116 Here Seeley is following in the footsteps of Eduard Lohse (*Märtyrer und Gottesknecht*; see esp. 149–54), although Seeley's stride tends to be more sure-footed than Lohse's.

117 E.J. Bickerman's arguments in favor of a date for *4 Maccabees* no earlier than 19 C.E. and no later than 54 ("The Date of Fourth Maccabees," first publ. 1945) are now widely accepted. *2 Maccabees* is more difficult to date. Jonathan A. Goldstein argues that it achieved its present form between 78/77 and 63 B.C.E (*II Maccabees*, 71–83), although many other specialists assign it to the late second century B.C.E.

ence. Eleazar, for example, a man "advanced in age" (*2 Macc.* 6:18; cf. 6.24), on his way to the rack "of his own accord" rather than eat "things that it is not right to taste" (6:19–20), but pausing repeatedly en route to express various stirring sentiments, declaims: "Therefore, by bravely giving up my life now, I will...leave to the young a noble example [*hypodeigma gennaion*] of how to die a good death willingly and nobly for the revered and holy laws" (6:27–28). Lest the reader miss the point, the narrator adds at Eleazar's expiration: "So in this way he died, leaving in his death an example of nobility and a memorial of courage [*hypodeigma gennaiotētos kai mnēmosynon aretēs*], not only to the young but to the great body of his nation" (6:31).

The young in question are, first and foremost, the seven brothers, who are patiently awaiting their turn. In *4 Maccabees* this is made explicit: The seven brothers, also refusing "the defiling food" (pork), berate the tyrant "with one voice together, as from one mind" (8:29), resolving to despise his "coercive tortures," which their "aged instructor [*paideutēs gerōn*]" has so admirably endured (9:6). Subsequently, as Seeley observes, "the brothers serve as models for one another."[118] "Imitate me, brothers [*mimnēsasthe me, adelphoi*]," cries the first (9:23), the wheel on which he is being broken being "completely smeared with blood," and the coals over which he is simultaneously being roasted "being quenched by the drippings of gore, and pieces of flesh...falling off the axles of the machine" (9:20). "I do not desert the excellent example of my brothers [*ouk apautomolō tēs tōn adelphōn mou aristeias*]," cries the seventh when his turn finally comes (12:16; cf. 10:13, 16; 11:14–15; 13:8–18). This mimetic chain, slick with blood, snakes out of the text and seeks to coil itself around the audience. Through his lingering, almost loving descriptions of these unspeakable deaths, the author seeks to inspire heroic obedience in his audience just as each martyr's slaughter inspires renewed obedience in his fellow martyrs.[119]

"Be imitators of me [*mimētai mou ginesthe*], as I am of Christ," Paul similarly urges (1 Cor. 11:1; cf. 4:16; Phil. 3:17; 1 Thess. 1:6; also Gal. 4:12).[120] Again, a mimetic chain reaches out of the text and seeks to wrap itself around the audience. Jesus' death, as Paul interprets it, was an utterly obedient death (Rom. 5:19; Phil. 2:8). Absolutely obedient to the will of his Father, and hence sinless (cf. 2 Cor. 5:21), Jesus alone has quashed the rebellion of the flesh, even under extreme torture, and resisted the savage coer-

118 Seeley, *The Noble Death*, 92.

119 Cf. ibid., 94.

120 Oddly enough, Seeley fails to connect these Pauline injunctions to imitation with those in the Maccabean literature. I have benefited from Castelli's searching analysis of Pauline mimesis in *Imitating Paul* (see esp. 89–117). She, however, does not adduce the Maccabean parallels, even though she deals extensively with "discourses of mimesis" in antiquity (59–87).

cion of the cruel tyrant, Sin.[121] In order to emerge triumphant from the tomb, Jesus had first to emerge triumphant from the torture chamber. What does this mean for the believer? "Do you not know that all of us who have been baptized into Christ Jesus were baptized into his death?" inquires Paul in Romans 6:3. When you imitate a martyr's death, going to the rack or cross with the same obedient abandon, you triumph over the tyrant who would compel you to sin. Similarly, when you "die with" Christ, even though you do not literally die, you reap the objective benefits that accrue from the literal reenactment of a martyr's death: you gain a victory over the wicked tyrant (Sin), and reap the rewards of absolute obedience, as though you really had remained faithful under terrible torture, as though you really had died horribly rather than renounce God's will. Seeley hits the nail on the head: Paul has "coalesced the two categories of literal and imaginative re-enactment."[122] Each Christian emerges from the baptismal water a bloodless martyr, with the heroic obedience of Jesus attributed to him or her, but without his stripes or stigmata.

Of course, the Christian is then ready for *real* floggings, and even real crucifixion. "Are they servants [*diakonoi*] of Christ?" Paul asks contemptuously of his Corinthian opponents. "I am a better one," he boasts, baring his hideously scarred back, "with far greater labors, far more imprisonments, with countless floggings [*en plēgais hyperballontōs*], and often near death. Five times I have received from the Jews the forty lashes minus one. Three times I was beaten with rods. Once I received a stoning" (2 Cor. 11:23–25; cf. 6:4–5; Heb. 11:32–38). Concluding his letter to the Galatians he utters a grim, if cryptic, warning: "From now on, let no one make trouble for me, for I carry the marks of Jesus branded on my body [*egō gar ta stigmata tou Iēsou en tō sōmati mou bastazō*]" (6:17). Despite the reader's polite protests, Paul is stripping off his shirt once again as he says this, exposing the map of his missionary journeys that has been cut into his back. (Significantly, the term *stigmata* was also common in the ancient world for the brands of slaves or prisoners, for a slave of Christ is what Paul claims to be, as we saw earlier.)[123]

But Paul also wants his converts to have their own war wounds to show off. To the Thessalonians he writes: "And you became imitators [*mimētai*] of us and of the Lord, for in spite of persecution you received the word with joy [*dexamenoi ton logon en thlipsei pollē*] inspired by the Holy Spirit, so that

121 Cf. Seeley, *The Noble Death*, 148–49. Robinson, *The Body* (esp. 40), is also very good on this.

122 Ibid., 148. Seeley's claim is not that Paul consciously mined the Maccabean literature, but merely that he internalized a notion—that of the Noble Death—"available to anyone who breathed the intellectual atmosphere of the Hellenistic Kingdoms and the early Roman Empire" (150).

123 See Betz, "Stigma," 657ff., and Longenecker, *Galatians*, 299–300 (also on *stigmata*).

you became an example to all the believers in Macedonia and Achaia" (1 Thess. 1:6–7). In submitting obediently to the word of proclamation, even in the face of persecution (cf. 2:14; 3:3–4), the Thessalonians successfully imitated Paul's own obedient imitation of Jesus' exemplary obedience (cf. 2:2, 15–16), and themselves became examples of obedience to be imitated by all the believers in the region. Again, the mimetic chain wends its way toward an audience that Paul never envisioned (you and I), but first it must pass through the ankle cuffs of a chain gang whose principal overseer is Paul himself, namely the Thessalonian "imitators [*mimētai*] of the churches of God in Christ Jesus that are in Judea" (2:14), similarly "in Christ," similarly in(mates of) God's own (pri)son.[124]

"You received the word with joy inspired by the Holy Spirit…." The crucial role played by the Holy Spirit in all of this should not be overlooked. The imaginative reenactment of Jesus' death-torture, especially through the ritual of baptism, has objective effects precisely because it results in the Holy Spirit setting up a command post within the believer: "the Spirit of God dwells in you [*pneuma theou oikei en hymin*]" (Rom. 8:9; also 8:11; 1 Cor. 3:16; 6:19; 12:13; 2 Cor. 1:22; Gal. 4:6; cf. 2 Tim. 1:14). You are no longer regulated from without, as formerly, but from within (Rom. 8:5, 14; 2 Cor. 3:3; Gal. 5:16–18, 25; cf. Eph. 3:16). No longer must you police your own thoughts, desires, and emotions; they are now overseen by an inner sentinel (cf. 2 Cor. 10:5b) whose relationship to you is one of permanent penetration and absolute possession (cf. Rom. 8:9b; 1 Cor. 6:19; 2 Cor. 10:7), closer than the most intimate act of love, closer than the most exquisite act of torture (cf. 1 Cor. 2:10b; 6:17). The Spirit is *in* you, filling your every orifice (cf. Rom. 5:5; also Eph. 5:18), insinuating itself between you and your self. Its fingers uncoil within you and extend outward until everything you once thought you were is but a tight glove adorning its open hand, always about to become a clenched fist (cf. 1 Cor. 5:3–5, 11; 16:22; 2 Cor. 10:6; Gal. 6:1).[125] But the Spirit is also God's phallus, a (rigid) extention of his power. It penetrates you, it invades you, it annihilates you, causing you to "groan inwardly," to expel "sighs too deep for words" (Rom. 8:23, 26).

In Galatians 5:19–23 Paul lists "the works of the flesh" ("fornication, impurity, licentiousness…"), contrasting them with "the fruit of the Spirit" ("love, joy, peace…"). The *work* of the Spirit, however, is discipline, for the Spirit is God's rod (cf. Prov. 13:24; 23:13–14). ("Shall I come to you with a rod

124 Some have tried to brand 1 Thess. 2:13–16 as an interpolation. Donfried skillfully deflects the branding iron in "1 Thessalonians 2:13–16 as a Test Case."

125 James T. South, concluding his *Disciplinary Practices in Pauline Texts*, notes that Paul's letters contain no formal disciplinary code, but naively attributes this to Paul's "gospel of freedom" (185–86), failing to recognize that the internal self-policing made possible by the Holy Spirit renders all such codes crude and redundant.

[*en rabdō*]...?" Paul threatens his Corinthian "children," fondling the instrument lovingly as he speaks—1 Cor. 4:21; cf. 4:14–15.)[126] Like Aaron's rod, moreover (Num. 17:8; cf. Heb. 9:4), God's rod puts forth blossoms and fruit. The blossom of discipline is obedience, and the fruit of obedience—Christ's obedience, and the consequent obedience of the believer—is righteousness (Rom. 5:19; 6:16–19; cf. 2:13), the supreme Pauline fetish. Obedience to whom? Ostensibly obedience to God, for even when Jesus' crucifixion is interpreted as a means toward internalized discipline rather than as retributive punishment for sin (and Paul is not uncomfortable with the latter interpretation, as we have seen), absolute power continues to be attributed to a monarchical God. But the question that inevitably arises is this: Who really stands to benefit from this attribution? And the answer that immediately suggests itself is, Paul.[127] To appeal to one's own exemplary subjection to a conveniently absent authority in order to legitimate the subjection of others (cf. Rom. 1:5; 15:18; 16:26; 1 Cor. 14:37–38; 2 Cor. 13:3) is a strategy as ancient as it is suspect. "Be imitators of me, as I am of Christ," urges Paul. Above all, imitate my obedience by obeying me (cf. 1 Cor. 11:16; 2 Cor. 2:9; 10:6; Philem. 21; also 2 Thess. 3:14).

The Dark Twins

> . . . if you confess...you will be saved.
>
> —ROMANS 10:9

> I deemed it...necessary to extract by torture a confession of the truth from two female slaves. . . .
>
> —PLINY THE YOUNGER, *Letters* 10.96[128]

"It has often been said that Christianity brought into being a code of ethics fundamentally different from that of the ancient world," writes Foucault, adding that what is less often noted is that Christianity "spread new power

126 Throughout his magisterial tome on the Holy Spirit in the Pauline letters, Gordon D. Fee strives valiantly, but unsuccessfully, to dispel the impression that being "led" by the Spirit confers a passive role on the Christian. On Galatians 5:22–23, for example, he remarks: "Paul's point, of course, is that when the Galatians properly use their freedom, by serving one another through love, they are empowered to do so by the Spirit, who produces such 'fruit' in/among them. But they are not passive; they must walk, live, conform to the Spirit" (*God's Empowering Presence*, 444; cf. 881–82). In other words, they must strive actively to submit passively.

127 Cf. Castelli, *Imitating Paul*, 112–13.

128 My translation. Writing to the emperor Trajan around 112 C.E., Pliny, governor of Bithynia, is detailing his handling of certain individuals denounced to him as Christians.

relations throughout the ancient world."[129] This new form of power Foucault terms "pastoral power." It "is not merely a form of power which commands; it must also be prepared to sacrifice itself for the life and salvation of the flock. Therefore, it is different from royal power, which demands a sacrifice from its subjects to save the throne."[130] Ultimately, for Foucault, "this form of power cannot be exercised without knowing the inside of people's minds, without exploring their souls, without making them reveal their innermost secrets. It implies a knowledge of the conscience and an ability to direct it."[131] Foucault is thinking particularly of the sacrament of penance here,[132] which assumed the status of a Christian obligation only after the Fourth Lateran Council in 1215 C.E., but which is deeply rooted in the ancient Jewish conception of an all-seeing God who "searches" and "tests" the human heart, exposing its innermost secrets (cf. 1 Sam. 16:7; 1 Kgs. 8:39; 1 Chron. 28:9; Job 34:21–22; Pss. 17:3; 26:2; 44:21; 90:8; 139:1–2, 23; Prov. 5:21; 15:11; Jer. 11:20; 12:3; 17:10; *Sirach* 15:18–19; 17:15–20; 23:18–20; 39:19–20; 42:18–20).[133]

Although this tradition does not achieve anything like its full flowering in Paul—that will have to await the institution of private confession—Paul does allude to it frequently (e.g., Rom. 2:16, 29; 8:27; 1 Cor. 4:5; 14:25). In time, Paul's ecclesiastical descendents will appropriate for themselves the divine privilege of laying bare the human soul. "Since the Middle Ages at least, Western societies have established the confession as one of the main rituals we rely on for the production of truth...."[134] But this form of discipline, too, will be closely bound up with atrocity, for at least two reasons. First, it is the crucifixion of Jesus, interpreted as atonement for sin, that makes the sacrament of penance efficacious.[135] God's forgiveness is extended to the sinner over the mutilated body of his Son (e.g., Rom. 5:8–11; 2 Cor. 5:18–21). Second, as Foucault notes, "[o]ne confesses—or is forced to confess. When it is not spontaneous or dictated by some internal imperative, the confession is wrung from a person by violence or threat; it is driven from its hiding place in the soul, or extracted from the body. Since the Middle Ages, torture has accompanied it like a shadow, and supported it when it could go no further: the dark twins."[136]

129 Foucault, "The Subject and Power," 214.
130 Ibid.
131 Ibid. Further on pastoral power, see Foucault, "Politics and Reason," 60ff.
132 This is clear from Foucault, "Technologies of the Self," 40–41.
133 See further Marmorstein, *The Old Rabbinic Doctrine of God*, 1:153–60.
134 Foucault, *The History of Sexuality*, 1:58.
135 See Denzinger et al., *Enchiridion symbolorum*, 1668ff.; cf. anon., *Catechism of the Catholic Church*, 1449.
136 Foucault, *The History of Sexuality*, 1:59.

Eventually, Foucault argues, this coercive obsession with the state of the soul becomes the soul of the modern state. His hypothesis is that "the modern Western state has integrated in a new political shape, an old power technique," namely, pastoral power, with its investment in the regulation of the individual's inner existence.[137] This power technique, "which over centuries—for more than a millenium—had been linked to a defined religious institution, suddenly spread out into the whole social body; it found support in a multitude of institutions."[138]

As it happens, these are the same institutions of surveillance and control that Foucault repeatedly attacked in his writings. Of course, they are not necessarily the institutions that ordinarily leap to mind in this connection—the CIA, the KGB, and so on. Power is at its most insidious and efficient, for Foucault, precisely when its workings are effaced—when its brow is furrowed with humanitarian concern, when its voice is warm with Christian compassion, when its menace is masked even, or especially, from itself. The institutions, or practices, at which Foucault took aim in his writings, therefore, are particularly those in which power wears a white coat and a professional smile.[139] They include psychiatry, the secular sacrament of penance, and the subject of *Madness and Civilization*;[140] modern medicine, which exposes the innermost secrets of the human body to the scientific gaze, and the target of *The Birth of the Clinic*; the social sciences, which likewise turn the human subject into an object of scientific scrutiny, and the target of *The Order of Things*;[141] modern methods of dealing with delinquency and criminality, the subject of *Discipline and Punish*; and the modern policing of sexual "normality," the subject of the first volume of his *History of Sexuality*.[142]

137 Foucault, "The Subject and Power," 213; cf. his "Governmentality," 87–88, 94–95, 104. The symbol of the modern state, for Foucault, or better, of the "disciplinary society," is the *Panopticon*, Jeremy Bentham's utilitarian design for the perfect disciplinary institution. In the Panopticon, the inmates would be totally and permanently visible to supervisors who themselves would ordinarily be invisible (*Discipline and Punish*, 195–228). Foucault's reflections on the Panopticon provide a rich resource for defamiliarizing the all-seeing God of Judaism and Christianity (see Moore, *Mark and Luke in Poststructuralist Perspectives*, 129–44).

138 Foucault, "The Subject and Power," 213.

139 He himself preferred the term "practices" to "institutions" (see "Questions of Method," 75).

140 Psychiatry was also the subject of Foucault's little-known first book, *Maladie mentale et personalité*.

141 "At this point there emerges an enterprise of which my earlier books...were a very imperfect sketch," explains Foucault in *The Archaeology of Knowledge* (14–15; cf. 16). This enterprise is the *Archaeology* itself. Substituting a wide-angle lens for the zoom lens used in the earlier books, it attempts to expose the rules that determine the conditions in which knowledge itself (psychiatric, medical, etc.) becomes possible.

142 The two succeeding volumes, *The Use of Pleasure* and *The Care of the Self*, push the investigation of sexuality back into Greek and Roman antiquity, respectively. A projected fourth volume, devoted to Christianity and entitled *Les Aveux de la chair* (The confessions of the flesh),

Foucault once confessed in an interview: "A nightmare has pursued me since childhood: I have under my eyes a text that I can't read, or of which only a tiny part can be deciphered; I pretend to read it, but I know that I'm inventing...."[143] Foucault tempts us to invent in our turn, to write preludes and sequels to his own surreal historical narrative, one in which the melancholy murmur of a medieval penitential liturgy is heard echoing through the contemporary halls of science, of medicine, and of justice—the public dismemberment of the body of the deviant having been displaced by strategies of social control that seem to grow ever lighter the deeper they extend into each of us.[144]

Closing Confession: "Bless Me, Father...."

> Then Ura'el, one of the holy angels who was with me, . . . said to me, "Enoch, why are you afraid like this?" I answered and said, "I am frightened because of this terrible place and the spectacle of this painful thing."
>
> —*1 Enoch* 21:9–10[145]

> Let this be enough, then, about the...extreme tortures.
>
> —*2 Maccabees* 7:42

I recall that each ornate confessional in the Redemptorist church displayed, deep in its sombre interior, the effigy of a tortured man, and that the column of confessionals was itself flanked by the fourteen Stations of the Cross, each one ornate and imposing, the spectacle of atrocity being inseparable, as I now realize, from the spectacle of docility. "Bless me, Father, for I have sinned...."

My own father was a warm, compassionate man. But he was also a butcher. Foucault's father too was a butcher of sorts, as I learned upon reading *The Passion of Michel Foucault*:

remained unfinished at Foucault's death in 1984. In his latter years, Foucault was also beginning to take aim at an institution or practice in which power wears a dark suit, namely government; see esp. Foucault, "Governmentality."

143 Foucault, "The Discourse of History," 25.

144 Its touch is lightest of all in the case of television, a "disciplinary technology" that Foucault never examined. The obverse of Paul's panoptic God, television's single blind eye polices and controls, not by being all-seeing, but by being seen by all.

145 Translation from Charlesworth, ed., *The Old Testament Pseudepigrapha.*

These, then, are the images that Foucault apparently shared on his deathbed with [Hervé] Guibert: the sunken continent of childhood revealed;...the philosopher's most singular truths confessed....

The first of the "terrible dioramas," writes Guibert, "shows the philosopher-child, led by his father, who was a surgeon, into an operating room in the hospital at Poitiers, to witness the amputation of a man's leg—this was to steel the boy's virility...."

[This] first story, of being forced by his father to witness an amputation, Foucault told to at least one other person before he died. This, of course, does not mean that the story is "true," in the sense of accurately representing an event that actually occurred. The recollection of primal scenes from childhood, as Freud has taught us, often produces elaborations, omissions, strange and telltale ellipses, and fabrications....

The image, certainly, has all the ingredients of a recurrent nightmare: the sadistic father, the impotent child, the knife slicing into flesh, the body cut to the bone, the demand to acknowledge the sovereign power of the patriarch, and the inexpressible humiliation of the son, having his manliness put to the test.[146]

All of which brings us back to where we began: "Father, spare me from this hour...."

I received a postcard from Paris the other day, sent to me by my sister, who had just read an earlier draft of "The Divine Butcher." She writes of being put off her food for an entire day (truly a disservice to a tourist in Paris) remembering "the blood, entrails, and passion dramas" of that street "flanked by the two places of sacrifice," then adding, "although I must admit I remember the slaughterhouse in Adare much more vividly."

We moved from Limerick to Adare, "the prettiest village in Ireland," when I was seven and my sister five. The children's Bible used in the Christian Brothers' school that I attended there contained a slaughterhouse even more terrible than my father's—that of Antiochus IV Epiphanes in *2 Maccabees* 7, site of the scalping, dismemberment, and barbecuing of the seven hapless brothers, watched by their helpless mother, a Pietà to the power of seven. ("Do not fear this butcher," she cries [7:29], as her youngest son is about to be dismembered.) The story held a horrible fascination for me. It seemed the very soul of this Bible, a soul racked with an agony that the anemic Jesus on the jacket, suffering the little children to come unto him, could never quite conceal—a Jesus who would soon be summoned to the torture chamber to take the place of the seventh brother, under the wrathful glare of his Father and the anguished gaze of his mother: "The king fell into a rage, and handled him even worse than the others..." (7:39).

146 Miller, *The Passion of Michel Foucault*, 365–66, his emphasis. He continues: "Like debris from a shipwreck, fragments of this scene keep bobbing up throughout Foucault's life and work."

dissection
HOW JESUS' RISEN BODY
BECAME A CADAVER

You will skin the whole area in the manner of a
butcher, incising in one line from chest to pubic
bone...and cutting away.

—ANDREAS VESALIUS, *De humani corporis fabrica*

[B]eware of those who mutilate the flesh!

—PHILIPPIANS 3:2

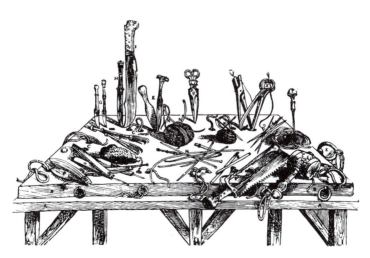

Figure 3: Anatomical instruments and dissecting table from
Andreas Vesalius, *De humani corporis fabrica* (1543).

Prologue

How Jesus' Corpse Became a Book

In the beginning was the Word, and the Word was in a book, and the Word was the book.

There was a book sent from God, whose name was John. It came as a witness to testify to the light, so that all might believe through it. It was not the light, but it came to bear witness to the light.

And the Word became flesh—human flesh at first, then eventually animal flesh, parchment, processed sheepskin, or goatskin. Later still it became paper, processed wood pulp, the blood-drenched wood of a Roman cross.

Why did the Word become flesh, according to John? In order to reveal his "glory" (*doxa*; cf. 1:14), the glory bestowed on him by the Father (8:54; 13:31–32; 17:1, 5, 22, 24). How did the Word reveal his glory? By means of the "signs" (*sēmeia*) that he performed (2:1–11; 4:46–53; 5:2–9; 6:1–13, 16–21; 9:1–12; 11:1–44; cf. 2:18–19; 20:30). He "manifested his glory, and his disciples believed in him [*episteusan eis auton*]" (2:11; cf. 2:23; 4:48; 6:14, 30; 11:18; 12:37).

Why did the Word become writing, according to John? For precisely the same reason that the Word performed signs: so that his audience might come to believe, and believing "have life in his name" (20:31; cf. 19:35; 21:24). Each time the book is read, Jesus reenacts his signs. The book extends Jesus' mission beyond the tomb. As such, the book is Jesus' risen body.

Here is how the book was found:

> Peter and the other disciple set out and went toward the tomb. The two were running together but the other disciple outran Peter and reached the tomb first. He bent down to look in and saw the linen wrappings [*ta othonia*] lying there, covered with writing, but he did not go in. Then Simon Peter came, following him, and went into the tomb. He saw the linen wrappings lying there, and the cloth [*to soudarion*] that had been on Jesus' head, not lying with the linen wrappings but rolled up in a place by itself, and likewise covered with writing. Then the other disciple, who reached the tomb first, also went in, and he saw and believed; for as yet they did not understand that, as scripture, he must rise from the dead. (20:3–9; NRSV, augmented)

Tenderly, the Beloved Disciple gathered the linen wrappings and the *soudarion*, burying his tear-streaked face in them, and inhaling the scent of death that still clung to them (cf. 19:39–40). He slept in the linen wrappings for many years, the *soudarion* under his head.[1] Finally, when the writing had begun to fade, he reluctantly cut the moldering grave cloths into crude rectangular sheets, stacked them roughly in order, folded them in two, and stitched them along the crease, thereby producing the first Christian codex.[2]

"Read me," urges the book, "that you may have life." "Eat me," urges the Word, in the book; "whoever eats me [*ho trōgōn me*] will live because of me" (6:57). Eat me, drink me (cf. 6:53–56), ingest me, digest me! With impeccable logic, therefore, Augustine has the Beloved Disciple (whom he mistakes both for the apostle John and the author of the Fourth Gospel) suckle from Jesus' breast at the Last Supper:

> [I]t has been very lately read to you, how that this St. John the Evangelist lay in the Lord's Bosom [13:23–25]. And wishing to explain this clearly, he says, "On the Lord's Breast"; that we might understand what he meant by "in the Lord's bosom." For what, think we, did he drink in who was lying on the Lord's Breast? Nay, let us not think, but drink, for we too just now heard what we may drink in.[3]

That Jesus' breast milk was a superb source of nourishment for the Beloved Disciple is the message of an apocryphal Irish text of uncertain origin, *Beatha Eoin Bruinne* (The Life of John of the [Lord's] Breast), which portrays the blissful disciple as a paragon of healthful good looks:

> Fresh, angelic Eoin,
> Sedate, with beautiful hair,
> Bright, with blue eyes,

1 What was the original purpose of the *soudarion* (which was also part of Lazarus's burial garb—11:44)? "Probably it passed under the chin and was was tied on the top of the head, to prevent the dead man's mouth from falling open" (Brown, *The Gospel According to John XIII–XXI*, 986; cf. *m. Šabbat* 23:5). Somewhere there is a corpse whose mouth is hanging open—but only because he hasn't finished speaking.

2 The codex, or leaf book, is the ancestor of the modern book. Although not a Christian invention, it quickly became the medium of choice among early Christians, displacing the scroll (see Gamble, *Books and Readers in the Early Church*, 49–66). Scholars date this development to the early second century, "or perhaps even...the close of the first century" (Metzger, *The Text of the New Testament*, 6)—soon after the appearance of the Fourth Gospel?

3 Augustine, Sermon 69 (trans. from Schaff and Wace, eds., *Nicene and Post-Nicene Fathers*), quoted in Culpepper, *John, the Son of Zebedee*, 166–67. Augustine recycles the topic in Sermon 70: "he [John] drank in from the Lord's breast...." Jesus is also described as a mother in the writings of Clement of Alexandria, Origen, Irenaeus, Chrysostom, and Ambrose, and in the *Odes of Solomon* and the *Acts of Peter* (so Bynum, *Jesus as Mother*, 126, 128). Later, Jesus will nurse assorted Christian mystics, notably Catherine of Siena (see Bynum, "The Female Body and Religious Practice," 176–79). How did Jesus acquire his breasts? This will be explained in due course.

Red-cheeked, with a beautiful face,
With bright teeth and brown brows,
Red-lipped with a bright throat,
Skilful, bright-handed,
Long-fingered, fresh-complexioned....[4]

The second-century *Acts of Paul* implies that the Apostle also feasted on Jesus' breast milk, indeed that he was sodden with the blessed beverage long before he lost his head. Preparing for his execution, Paul prayed fervently, we are told, imbibing one last long draught, after which "he stretched out his neck without speaking further. But when the executioner struck off his head, milk spurted upon the soldier's clothing."[5]

What of the biblical scholar? Is Jesus also the complete food, or even the main course, for him or her? I shall presume only to speak for myself. For seventeen years I have aspired to be a biblical scholar. By the end of my first year I had learned to use a knife, although not a table knife. I had learned not to devour the book, nor even the Word, to internalize them, to become one with them. Instead I had learned to dissect the book and the Word.

As a biblical scholar I have learned to be doubting Thomas's doubly dubious twin. Invited to subject the Risen Body to a physical examination, Thomas declines, and for the same reason that so many of the faithful decline to subject the Word to a critical examination. Fearful that the Word is of God, Thomas refuses to put his finger in the mark of the nib in its hands, or place his hand in the tear in its side (20:27–28). Nevertheless, Jesus rebukes Thomas for his reliance on the empirical method: "Have you believed because you have seen me? Blessed are those who have not seen and yet have come to believe [*makarioi hoi mē idontes kai pisteusantes*]" (20:29). Biblical scholarship, in sharp contrast, is the science that subjects the written body of Jesus to a rigorous examination.

As such, biblical scholarship has medicine as its sibling science.

4 *Beatha Eoin Bruinne* 2.10 (trans. from Schneemelcher, ed., *New Testament Apocrypha*). The language of the text is early modern Irish, into which it was translated from Latin prior to 1405. See further McNamara, *The Apocrypha in the Irish Church*, 95–98.

5 *Acts of Paul* 11.5 (trans. from Schneemelcher, ed., *New Testament Apocrypha*).

Ecclesia abhorret a sanguine

> [I]f the old beliefs had for so long such prohibitive
> power, it was because doctors had to feel, in the
> depths of their scientific appetite, the repressed
> need to open up corpses.
>
> —MICHEL FOUCAULT, *The Birth of the Clinic*

Foucault's *The Birth of the Clinic: An Archaeology of Medical Perception* examines the process by which the human body was reinvented as an object of scientific scrutiny in eighteenth- and nineteenth-century Europe.[6] During the same period, as it happens, the Bible was also being reinvented as an object of scientific scrutiny. What might be the relationship between these two gazes, these two glances, the medical and the exegetical?

In order for modern medicine to emerge, the medical gaze, long blunted by "the black stone of the body," had to hone itself, had to become scalpel-sharp.[7] Throughout the eighteenth century, in particular, medicine beheld a new space opening up before it, "the tangible space of the body,…that opaque mass in which secrets, invisible lesions, and the very mystery of origins lie hidden."[8] The age of pathological anatomy had arrived, but so had the age of biblical criticism. The pen took its place beside the scalpel.

Critical dissection of the biblical text has often been seen as an irreligious act. Examples from the history of biblical scholarship abound, such as the public outcry that greeted the publication of David Friedrich Strauss's *Das Leben Jesu, kritisch bearbeitet* (The life of Jesus, critically examined) in 1835–36. Gingerly picking up the spit-stained mantle of H. S. Reimarus (whose posthumously published critique of Christianity had itself created a colossal commotion in Germany), Strauss recklessly denied the historicity of all the supernatural elements in the Gospels.[9] The author was abruptly dismissed from his post at Tübingen, his conservative colleagues "incensed that a theologian of this persuasion was aspiring to teach prospective ministers."[10] Four years later, the attempts of liberal supporters to secure a chair

6 In French the subtitle of Foucault's book reads *une archéologie du regard médical,* "an archaeology of the medical gaze." It begins: "This book is about space, about language, and about death; it is about the act of seeing, the gaze" (ix).

7 Foucault, *The Birth of the Clinic,* 117.

8 Ibid., 122.

9 Seven extracts of Reimarus's critique were published between 1774 and 1778 (he died in 1768), with further extracts appearing in 1787 and 1850–52. The entire work is now available in German as Reimarus, *Apologie oder Schutzschrift für die vernünftigen Verehrer Gottes* (Apology or defense on behalf of the reasonable worshipers of God). For a partial English translation, see Reimarus, *Reimarus: Fragments.*

10 Baird, *History of New Testament Research,* 1:247; cf. Kümmel, *The New Testament,* 120.

for Strauss at Zürich were foiled by the good people of the town, who staged noisy protest meetings and circulated outraged petitions.[11]

More than a hundred and fifty years later, institutions of higher learning can still be found that harbor dark suspicions regarding the "higher criticism" of the Bible. And even when a scholar's own institution is not wary of biblical criticism, his or her students often are. My own first day at my current college—a fair-sized rhinestone on the fringes of the Bible Belt—began with an inquisitorial sophomore solemnly putting this question to me: "Dr. Moore, I'm tempted to take your New Testament course, but first I need to know if you're an atheist." My reply, although heavily qualified, was enough to enable him to overcome the temptation.

Of course, the public no longer burns our books, or even reads them— unless they happen to be juicy "lives of Jesus." "The Son of Man is coming at an unexpected hour," warns the Synoptic Jesus (Matt. 24:44, par. Luke 12:40; cf. Mark 13:35). Consider the unexpected appearance of John Dominic Crossan's *The Historical Jesus* in every shopping mall across the United States in the early 1990s. By the middle of the decade it was invariably flanked by the Jesus Seminar's *The Five Gospels: The Search for the Authentic Words of Jesus*, on one side, and Crossan's *Jesus: A Revolutionary Biography*, on the other (a digest of *The Historical Jesus* that he tenderly refers to as "baby Jesus").[12] The now infamous "finding" of *The Five Gospels* is that fully eighty-two percent of the discourses, parables, aphorisms, and other *bons mots* attributed to Jesus in the Gospels were never actually uttered by him;[13] while the rear jacket of Crossan's *Jesus* sports a startling summary of his "Revolutionary Discoveries":

- The infancy narratives were fable-like in their depictions and are easily clarified by historical fact. They were created to signal Jesus' importance and continuity with and fulfillment of the Torah.
- The resurrection is a myth signifying that Jesus' spirit, inspiration, teaching, and example lived on powerfully in his surviving followers.
- Jesus was more radical and threatening than any political revolutionary leader of his time or since, because he espoused absolute equality in a society that was completely segregated along class and gender lines.

11 See Baird, *History of New Testament Research*, 1:247–48; Kümmel, *The New Testament*, 492.

12 For *The Five Gospels*, see Funk et al. The eponymous fifth Gospel is the *Gospel of Thomas*, a complete copy of which was found near Nag Hammadi in northern Egypt in 1945. Founded by Funk in 1985, the Jesus Seminar is a group of about seventy-five New Testament scholars who meet biannually to sift early Christian traditions about Jesus for historicity.

13 The Fourth Gospel comes out worst, only one utterance of its protagonist—"A prophet has no honor in his own country" (4:44)—meriting a "pink" vote from the Seminar ("Jesus probably said something like this"). See Funk et al., *The Five Gospels*, 412; for further details, see anon., "The Jesus Seminar: Voting Records," esp. 9–14.

- Jesus' healing activities were not so much miracles of physical transformation but rather liberating declarations that sick people were fully acceptable members of society rather than untouchables afflicted by God for some sin.

Consider in addition the unprecedented attention that the media have devoted to the conclusions of Crossan and the Jesus Seminar (which Crossan co-chairs with Robert Funk)—in nationally circulated newspapers and periodicals, in radio and TV talk shows, and in innumerable local newspapers—eliciting the inevitable avalanche of outraged letters to the editor, indignant indictments from the pulpit, and, one presumes, hate mail addressed to the authors. It is hard to resist the conclusion that the mischievous spirits of Reimarus and Strauss are abroad once again in the persons of Crossan, Funk, and their fellow Seminarians.[14]

Significantly, Funk and his fellow authors chose to dedicate *The Five Gospels* to Galileo Galilei, "who altered our view of the heavens forever," and to David Friedrich Strauss, "who pioneered the quest for the historical Jesus," but also to Thomas Jefferson, "one of our own sons of the Enlightenment," who took a (surgical?) scissors to the text of the Gospels, trimming away what he took to be cancerous matter in an attempt to restore the original body of Jesus' deeds and sayings.[15] The signal feature of Jefferson's project is that he literally cut the Gospels to shreds. Introducing Jefferson's *The Life and Morals of Jesus of Nazareth: Extracted Textually from the Gospels in Greek, Latin, French, and English*, Cyrus Adler quotes an 1813 letter from Jefferson to John Adams in which he describes his method: "I have performed this operation for my own use, by cutting verse by verse out of the printed book...." The amputated verses were then sutured together and mounted on the pages of a blank book. "The result is an octavo of forty-six

14 And it is not only in the United States that they are abroad but also in their native Germany, as witnessed by the unexpected public outcry that greeted Gerd Lüdemann's sober but skeptical *Die Auferstehung Jesu* (The resurrection of Jesus) in March of 1994, an outcry so indignant that the publisher, Vandenhoeck & Ruprecht, timidly refused to reprint the book after it sold out overnight. Contrast Hans Frei, who, writing in the early 1970s, could state that the public has ceased to care what biblical critics have to say ever since Strauss's *Life of Jesus* (*The Eclipse of Biblical Narrative*, 227ff.).

15 Quotations from the dedication page of *The Five Gospels*, and p. 2. One "guiding principle" of Jefferson's enterprise—"witnessing to the heavy influence of Enlightenment rationalism on [his] religious positions—was that all miracles were to be excised" (Meier, *A Marginal Jew*, 2:632, n. 2; cf. 618, 837, 970).

pages."[16] Adler also recounts his own fortuitous discovery in 1886, while cataloging "a small but very valuable" collection of books donated to Johns Hopkins University, of "two copies of the New Testament mutilated"—the selfsame copies that Jefferson had dissected.[17] An accompanying note explained that they had lain for some years in a "medical library" belonging to a certain Dr. Macaulay.[18] Where else would they have felt so at home?

If critical dissection of the Bible has often been seen as a sacrilegious act,[19] the dissection of cadavers has been only slightly less suspect throughout much of Christian history. Foucault puts it memorably:

> Medicine could gain access to that which founded it scientifically only by circumventing, slowly and prudently, one major obstacle, the opposition of religion, morality, and stubborn prejudice to the opening up of corpses. Pathological anatomy had no more than a shadowy existence, on the edge of prohibition, sustained only by that courage in the face of malediction peculiar to seekers after secret knowledge; dissection was carried out only under cover of the shadowy twilight, in great fear of the dead: "at daybreak, or at the approach of night," Valsalva slipped furtively into graveyards...; later, Morgagni could be seen "digging up the graves of the dead and plunging his scalpel into corpses taken from their coffins."[20]

Foucault himself is skeptical of these tales from the crypt: "This reconstitution is historically false. Morgagni had no difficulty in the middle of the eighteenth century in carrying out his autopsies...."[21] But what of earlier centuries?

Andreas Vesalius (1514–64), prince of the Renaissance anatomists,[22] in a confessional passage from his magnum opus, *De humani corporis fabrica libri septem* (On the fabric of the human body in seven books), describes

16 Jefferson, *The Life and Morals of Jesus of Nazareth*, 15; cf. 16. The octavo, which was entitled "The Philosophy of Jesus," has not survived (although see Adams and Lester, eds., *Jefferson's Extracts from the Gospels*, 60–105, for an attempt to reconstruct it). Jefferson later enlarged the octavo to eighty-two pages and retitled it "The Life and Morals of Jesus." It was published posthumously in 1904 by order of the 57th Congress of the United States in a print run of 9,000 copies, "3,000 copies for the use of the Senate and 6,000 copies for the use of the House" (*The Life and Morals of Jesus of Nazareth*, 19).

17 Ibid., 10. The use of the term "mutilated" is interesting here. The first Christian to apply a dissecting knife to a Gospel was Marcion (d. ca. 160). "Marcion seems to have singled out Luke for mutilatation [*quem caederet*]," complains Tertullian (*Against Marcion* 4.2). The same language is used by Irenaeus (*Against Heresies* 1.27.2).

18 Ibid. Dr. Macaulay had purchased them "at the sale of Mr. Jefferson's library."

19 Cf. Tertullian, *Against Marcion* 4.5: "Luke's Gospel also has come down to us in...integrity until the sacriligious treatment of Marcion."

20 Foucault, *The Birth of the Clinic*, 124–25, quoting an early nineteenth-century source.

21 Ibid., 125.

22 To say the least. "Few disciplines are more surely based on the work of one man than is anatomy on Vesalius," Singer remarks, echoing the standard opinion (*A Short History of Anatomy*, 111).

how, as a student at Louvain, he had felt compelled to purloin from a gibbet the "dried cadaver" of a condemned criminal who had been "roasted over a fire of straw and then bound to a stake":

> After I had surreptitiously brought the legs and arms home in successive trips— leaving the head and trunk behind—I allowed myself to be shut out of the city in the evening so that I might obtain the thorax, which was held securely by a chain. So great was my desire to possess those bones that in the middle of the night, alone and in the midst of all those corpses, I climbed the stake with considerable effort and did not hesitate to snatch away that which I so desired. When I had pulled down the bones I carried them some distance away and concealed them until the following day when I was able to fetch them home bit by bit through another gate of the city.[23]

Elsewhere in the *Fabrica*, Vesalius admits to equally bizarre thefts from the Cemetary of the Innocents in Paris, recalls the riotous wave of body snatching that followed his dissection of "three human bodies and six dogs and other animals" before a large audience at Bologna in 1540, and indulgently recounts his own students' abduction of a deceased woman, "the handsome mistress of a certain monk."[24] She had "died suddenly as though from strangulation of the uterus...and was snatched from her tomb by the Paduan students and carried off for public dissection. By their remarkable industry they flayed the whole skin from the cadaver lest it be recognized by the monk who, with the relatives of his mistress, had complained to the municipal judge that the body had been stolen from its tomb."[25] As though in brazen defiance of such authorities and brutal dismissal of such sensibilities, the large historiated *I* used as an initial letter in the *Fabrica* depicts a cadaver-starved pack of anatomy students hungrily converging upon a grave in order to extract from its fertile earth the precious, overripe fruit.[26]

The authorities and sensibilities to be defied and dismissed were religious as well as secular. Throughout the Middle Ages, in particular, the Church had frowned sternly upon anatomical dissection as showing a lamentable lack of respect for the human body, "the temple of the soul."[27] The

23 Translated in O'Malley, *Andreas Vesalius of Brussels*, 64. No English translation of the entire *Fabrica* exists, but O'Malley's biography of Vesalius contains a sixty-page appendix of translated excerpts from his work.

24 See O'Malley, *Andreas Vesalius of Brussels*, 59–60, 99–100, and 113; cf. Harcourt, "Andreas Vesalius," 57, n. 27.

25 Translated in O'Malley, *Andreas Vesalius of Brussels*, 113–14.

26 As in all the historiated initials from the *Fabrica*, the anatomy students are fondly depicted as cherubs. In other initials, they boil a human skull to rid it of residual flesh, perform vivisection on a struggling pig, and hoist the body of a (live?) dog onto a gallows to be dissected (or vivisected). These initials are reproduced in Singer, *A Short History of Anatomy*, 118.

27 See Castiglioni, *A History of Medicine*, 409.

Church's censure rested on no less an authority than the Bishop of Hippo himself. "The entire nature of man is certainly spirit, soul, and body," cautions Augustine,

> therefore, whoever would alienate the body from man's nature is unwise. Those medical men, however, who are called anatomists have investigated with careful scrutiny, by dissecting processes, even living men, so far as men have been able to retain any life in the hands of the examiners; their researches have penetrated limbs, veins, nerves, bones, marrow, the internal vitals; and all to discover the nature of the body.[28]

Such knowledge is in any case unnecessary: "Of course it is far more excellent to know that the flesh will rise again and will live for evermore, than any thing that scientific men have been able to discover in it by careful examination...."[29] Augustine's irascible predecessor, Tertullian, is less polite in his dismissal of anatomy: "There is that Herophilus, the well-known surgeon, or (as I may almost call him) butcher, who cut up no end of persons, in order to investigate the secrets of nature, who ruthlessly handled human creatures to discover their form and make...."[30]

The *odium theologicum* of the medieval Church for human dissection was neatly expressed in the dictum, *ecclesia abhorret a sanguine*, "the Church abhors blood."[31] And as most physicians happened to be members of the clergy anyway, the study of medicine in this period "was largely confined to the library," the corpus of medical literature displacing the corpse as the preferred object of scrutiny.[32] For if the Church had its Bible, the medical profession too had its Scripture, the writings of Claudius Galen (ca. 130–200 C.E.), whom even Vesalius would acknowledge as "the prince of professors of dissection."[33] Galen was universally regarded as the greatest physician of late antiquity, on a level with Hippocrates himself.[34] Throughout the late Middle Ages and early Renaissance, anatomy was taught in the schools almost exclusively from the text of Galen, "which was regarded as a canon

28 Augustine, *On the Soul* 4.3 (trans. from Schaff and Wace, eds., *Nicene and Post-Nicene Fathers*); cf. ibid., 4.6–7.

29 Ibid., 4.14.

30 Tertullian, *Treatise on the Soul* 10 (trans. from Roberts and Donaldson, eds., *The Ante-Nicene Fathers*). He attacks Herophilus again in chap. 25.

31 See Starobinski, *A History of Medicine*, 38.

32 Ibid., 33; cf. 64, also Lassek, *Human Dissection*, 60; Singer and Underwood, *A Short History of Medicine*, 69ff.

33 Vesalius, *De humani corporis fabrica*, in O'Malley, *Andreas Vesalius of Brussels*, 321. Vesalius even extols Galen as "that divine man" (323), although elsewhere he attacks him mercilessly, as we shall see.

34 In *The Care of the Self*, Foucault comments at length upon Galen's physiological theories (105–23).

about which there could be no dispute."[35] The phrase *sicut asserit Galenus* ("thus declares Galen") carried a weight of authority that was second only to that of the Bible itself.[36]

Early in the fourteenth century, public dissections were revived, beginning at the University of Bologna, the practice having lapsed since the decline of the Alexandrian school of anatomy around 200 C.E. The centerpiece of these performances, however, was the solemn reading from Galen, not the dissection of the cadaver. The sole purpose of the latter was to illustrate the truth of the former. And when the opened cadaver turned on the text, impudently calling its accuracy into question, as often happened, the inerrancy of the text would be serenely reasserted, the professor remarking how the human body had changed its structure during the long centuries since Galen.[37] Alternatively, the discrepancies would be blamed on poor translation (a maneuver also known to modern biblical inerrantists).[38]

The performance required a minimum of three actors, not counting the cadaver:

> The professor of anatomy sat above the proceedings in a large, often ornate chair, discoursing from his text.... The dissection was done by a base mechanical, a surgeon, called a *demonstrator*. Additionally an *ostensor* performed the third office of indicating with his wand the precise parts of the body to which the professor's text referred. In some cases the *ostensor* also repeated verbatim the words of the professor.[39]

The entire procedure, therefore, in addition to being highly ritualized, even sacralized, was also thoroughly hierarchized. Contemporary illustrations of the practice show "the professor elevated and elaborately framed, the *ostensor* in academic garb but clearly of peripheral importance, and the surgeon differentiated from professors and students alike by his [menial] clothing" (see Figure 4).[40] Add to this the fact that the public dissection inaugurating this revival of anatomy, which was performed by Mondino de' Luzzi at Bologna in 1315, appears to have had as its subject the body of a woman, and

35 Castiglioni, *A History of Medicine*, 340.

36 Ibid., 317; cf. 344, 519.

37 See Wilson, "William Harvey's *Prelectiones*," 94–95, n. 31.

38 See Castiglioni, *A History of Medicine*, 344.

39 Wilson, "William Harvey's *Prelectiones*," 64, his emphasis. Lassek contributes other, more gruesome details: the dissection was accomplished "with crude instruments, including a huge cleaver-like knife," and "dogs yelped around the table waiting to devour the pieces of human flesh thrown to them when the professor finished his discourse" (*Human Dissection*, 63).

40 Wilson, "William Harvey's *Prelectiones*," 64. Harcourt observes: "As a resolutely manual operation, the actual conduct of a dissection simply lay outside the proper exercise of the professorial office" ("Andreas Vesalius," 36). And Wilson notes "the low esteem in which surgeons, who touched the body, were held relative to physicians, who did not" (ibid., 68; cf. 90–91).

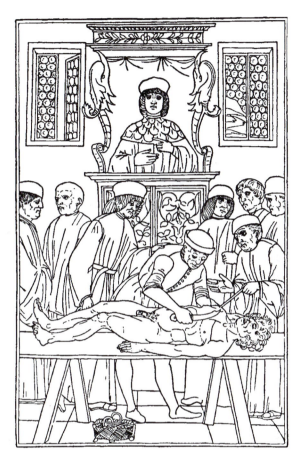

Figure 4: Dissection scene from Johannes de Ketham,
Fasciculo di medicina (1493).

the hierarchical subordination is complete, the anatomical performance
becoming a grotesque caricature of the society that regards it with so much
suspicion.[41]

The critique of Galenism had to await the High Renaissance and an intel-
lectual climate which, to an extent, permitted the interrogation even of bib-
lical dogma. Anatomy was the first branch of medicine to feel the full impact
of the Renaissance; henceforth, it would purport to be be based on meticu-
lous observation as opposed to blind reliance on tradition. For even Galen
himself "never dissected a human body," objects Vesalius, preferring to ply

41 The title page of Vesalius's *Fabrica* (Figure 5) also featured an eviscerated female corpse sur-
rounded by a throng of male spectators, notwithstanding the fact that, in actuality, "female
subjects were especially difficult to obtain" (Harcourt, "Andreas Vesalius," 57, n. 27). Sawday
comments: "With his right hand, Vesalius peels open the body to reveal the womb. The
corpse, passive beneath her dissector's hand, gazes directly at Vesalius…" (*The Emblazoned
Body*, 67; cf. 112–13).

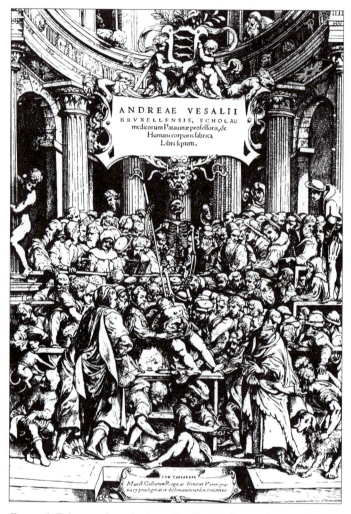

Figure 5: Title page from Andreas Vesalius, *De humani corporis fabrica* (1543).

his knife on apes; in consequence, Galen's anatomy was inaccurate "in well over two hundred instances."[42] Vesalius held the traditions of public dissection in contempt, the professors "like jackdaws aloft in their high chair, with egregious arrogance croaking things they have never investigated but merely committed to memory from the books of others," a situation in which the student physician learns less "than a butcher in his stall could teach [him]."[43] Vesalius therefore insisted on descending from his *cathedra*, rolling

42 Vesalius, *De humani corporis fabrica*, in O'Malley, *Andreas Vesalius of Brussels*, 321.
43 Ibid., 319–20; cf. Harcourt, "Andreas Vesalius," 36.

up his sleeves, and personally performing his own dissections, a predeliction that was to usher in the end of Galenism (see Figure 5). "Public dissections were practiced carefully and in greater numbers than heretofore. The ancient custom of reading from a text of anatomy, while often a clumsy assistant mishandled the organs," gradually receded into history.[44] Anatomy began to assume a conspicuous place in the European medical curriculum.

Increasingly, these sanctioned assaults upon the dead were accompanied by a rhetoric of light and enlightenment. "Open up a few corpses: you will dissipate at once the darkness," declared François-Xavier Bichat in his *Anatomie générale* of 1801.[45] Compare a fairly standard description of the Enlightened mindset that engendered the critical study of the Bible: "[A]lmost nothing was sacred—all was secular, everything was open to human scrutiny…. Humanity had progressed out of darkness and into a new light…."[46]

Of course, there was more to reading than mere seeing. One also touched the Book, if only to turn the page. One listened, if only to one's own inner voice murmuring the words on the page. The biblical scholar, like his medical counterpart, soon learned to read with a stethoscope, an instrument that exercised the eyes, the fingers, and the ears, while conferring an appearance of detachment on the examination.

How did the stethoscope originate? It was designed to circumvent a prohibition, as Foucault explains. He quotes Johann Zimmermann, an eighteenth-century physician, who, echoing the sentiments of many of his medical contemporaries, states that "doctors should be free to make their observations…by placing their hands directly on the heart," but adds that "our delicate morals prevent us from doing so, especially in the case of women."[47] The first stethoscope was made of paper, that quintessential critical tool. In 1816, René Théophile Hyacinthe Laënnec, "consulted by a young woman labouring under general symptoms of a diseased heart, and in whose case percussion and the application of the hand were of little avail on account of the great degree of fatness," had a brain wave. "I rolled a quire of paper into a sort of cylinder and applied one end to the region of the heart and the other to my ear, and was not a little surprised and pleased to find that I could thereby perceive the action of the heart in a manner much more clear and distinct than I had ever been able to do by the immediate appli-

44 Castiglioni, *A History of Medicine*, 490.
45 Quoted in Foucault, *The Birth of the Clinic*, 146.
46 Baird, *History of New Testament Research*, 1:5.
47 Foucault, *The Birth of the Clinic*, 163.

cation of the ear."[48] The stethoscope, which slowly assumed its present form during the remainder of the nineteenth century, enabled the male physician to maintain a decorous distance from his female patient, even while placing a cold prosthetic ear against her bare breast and listening intently to the secret sounds of her body. Thus, the decorous distance was something of a sham from the start.

For the biblical scholar, too, the semblance of distance became all important as he probed the text, stripping back its many layers. (Is it possible to peel away the editorial accretions in this particular text to reveal the original sources in their pristine state? And what palpitates beneath the surface of these sources? What fecund historical matrix? What visceral maze of motives?) But because the stethoscope was limited in its powers of penetration, the scholar came to rely on the scalpel.

A *Gray's Anatomy* of the Fourth Gospel

> Today anatomy is still closely associated in our minds with the dissection of a human cadaver, but the term was extended very early to include the whole field of knowledge dealing with the structure of living things.
>
> —HENRY GRAY, *Anatomy of the Human Body*

> The word of God is living and active. . . .
>
> —HEBREWS 4:12

The most famous anatomical textbook of our own time is undoubtedly Henry Gray's *Anatomy of the Human Body*, or *Gray's Anatomy*, as it is more familiarly known. First published in 1858 under yet another title—*Anatomy, Descriptive and Surgical*—it has the distiction of being the oldest continuously revised textbook still in use by the medical professions.[49] Considerably less famous is R. Alan Culpepper's *Anatomy of the Fourth Gospel* (1983), although it does have the distinction of being the best-known literary read-

48 Laënnec, *A Treatise on the Diseases of the Chest*, 211–12, quoted in Duke, *The Development of Medical Techniques*, 32–33, in the course of a chapter entitled "Listening to the Sounds of the Body: The Development of the Stethoscope."

49 Currently in its 30th (American) edition, it has ballooned from an original 754 pages to the present 1,676 pages (not counting front matter), so when I quote "Gray" below, I am really quoting the corporate authorial entity that now bears his name.

ing of a gospel text by a New Testament scholar.[50] The question therefore arises: What might be the relationship between Culpepper's *Anatomy*, and its many precursors, and *Gray's Anatomy*, and its many successors? Can we map the arterial network that connects these two volumes?

Culpepper's precursors include Robert A. Spivey and D. Moody Smith, authors of the 1969 textbook, *Anatomy of the New Testament*. Although Culpepper does not mention Spivey and Smith, they do mention him in the preface to the recent fifth edition of their *Anatomy*. Explaining that their own title was originally inspired by Northrop Frye's *Anatomy of Criticism*, they express their pleasure that "pioneering works" of New Testament literary criticism, "such as R. Alan Culpepper's *Anatomy of the Fourth Gospel* (1983), echoed [their] title while going far beyond [their] own work in methodological self-consciousness and sophistication."[51] Their description of their own accomplishment is no less modest: "What has resulted is certainly no comprehensive or uniform coverage of the New Testament, but a series of 'biopsies' designed to uncover the structure and meaning of the New Testament books, and of the collection as a whole—thus our title *Anatomy of the New Testament: A Guide to Its Structure and Meaning*."[52] But "biopsy," the examination of tissue taken from a living body (in this case a living Word?), is hardly an adequate synonym for "anatomy." Actually, the sentence just quoted has itself undergone surgery. Introducing the first edition of their *Anatomy*, Spivey and Smith described it as "a series of *dissections* or biopsies designed to uncover the nature and structure of the New Testament books and of the collection as a whole."[53] Few terms are as unfashionable as "dissection" in contemporary New Testament studies, hence the excision is understandable. As we are about to see, the discomfort that current New Testament scholars experience with the term is not at all misplaced.

Gray's Anatomy begins: "In ancient Greece, at the time of Hippocrates (460 B.C.), the word anatomy, *Anatomē*, meant a dissection, from *tomē*, a cutting, and the prefix *ana*, meaning up. Today anatomy is still closely associated in our minds with the dissection of a human cadaver...."[54] Is this what Dr. Culpepper had in mind when he decided to entitle his examination of the Fourth Gospel an *Anatomy*? Apparently not, for Culpepper frowns on dissection. He quotes disapprovingly Klaus Koch's source-critical definition of the

50 Specifically, it is a narratological reading of the Fourth Gospel, the narratology being primarily that of Gérard Genette and Seymour Chatman, the sort that easily shades over into reader-response criticism (indeed, the book ends with a chapter on the implied reader of the Fourth Gospel).

51 Spivey and Smith, *Anatomy of the New Testament*, xviii.

52 Ibid., xix.

53 Ibid. (1st ed.), vi, emphasis added.

54 Gray, *Anatomy of the Human Body*, 1.

literary critic as one who "approaches the text with, so to say, a dissecting knife in his hand...."[55] As Culpepper rightly remarks, the model that has dominated Johannine scholarship for generations "depends on dissection."[56]

The metaphoric equation of criticism with dissection has its roots in eighteenth-century Europe, as Barbara Maria Stafford has shown in her splendid book, *Body Criticism: Imaging the Unseen in Enlightenment Art and Medicine.* "The Galenic conception of anatomy as an 'opening up in order to see deeper or hidden parts' drives to the heart of a master problem for the Enlightenment," she writes.[57]

> How does one attain to the interior of things? Anatomy and its inseparable practice of dissection were the eighteenth-century paradigms for any forced, artful, contrived, and violent study of depths. Metaphors of decoding, dividing, separating, analyzing, fathoming permeated ways of thinking about, and representing, all branches of knowledge from religion to philosophy, antiquarianism to criticism, physiognomics to linguistics, archaeology to surgery.[58]

The "literal, corporeal sense" of dissection denoted "the tactile cuts inflicted by actual instruments"—sharp scalpels and scissors mercilessly probing and prying apart—whereas the "figurative sense" drew upon the literal to denote "an investigative intellectual *method* that uncovered the duplicity of the world"—or even the Word.[59] "Both meanings shared the connotation of a searching operation performed on a recalcitrant substance. One involved manual probing, the other cerebral grasping."[60] In sum, eighteenth-century criticism was a "rational science for the destruction and dissection of putative wholes."[61]

55 Koch, *The Growth of the Biblical Tradition,* 69, quoted in Culpepper, *Anatomy of the Fourth Gospel,* 10. Prior to the 1980s, the term "literary criticism" on the lips of biblical scholars almost always meant the extraction of hypothetical sources from the biblical texts. Today, it almost always means attention to the final form of the texts, specifically their narrative features (plot, character, point of view, etc.), a shift *Anatomy of the Fourth Gospel* helped bring about.

56 Culpepper, *Anatomy of the Fourth Gospel,* 3. A word of explanation for those unfamiliar with these methods of dissection:

> Johannine scholars have generally approached the text looking for tensions, inconsistencies, or "aporias" which suggest that separate strains or layers of material are present in the text. The next step is usually to place the "layers" in some sequence by noting the way they are embedded in the gospel and the probable direction of theological development. On the basis of this stratification, the history of the material, the process by which the gospel was composed, and developments within the Johannine community can all be studied. (Ibid.)

57 Stafford, *Body Criticism,* 47, quoting Galen, *On the Natural Faculties* 2.3.

58 Ibid. She goes on to document this claim in considerable detail (47–129).

59 Ibid., her emphasis; cf. Sawday, *The Body Emblazoned,* 1ff.

60 Stafford, *Body Criticism,* 47.

61 Ibid., 82. Sawday notes "the plethora of [non-medical] works which appeared in England in the late sixteenth and early seventeenth centuries containing the word 'anatomy' in the title" (*The Body Emblazoned,* 44).

Traditionally in the discipline of biblical studies, the art of dissection has been passed down from doctor-father to doctor-son. Robert T. Fortna, for example, preparing to cut into the Fourth Gospel in his important source-critical study, *The Gospel of Signs*, acknowledges his personal and professional debt to his "critical and demanding 'doctor-father,'" J. Louis Martyn.[62] For Culpepper, however, "dissection and stratification have no place in the study of the gospel and may distort and confuse one's view of the text."[63]

John Ashton, who otherwise disagrees profoundly with Culpepper regarding the physiology of the Fourth Gospel, voices a similar reservation: "The message of the Fourth Gospel is so patently sublime, the writing so calmly self-assured, that it seems almost sacriligious to take to this 'spiritual Gospel,' as Clement of Alexandria called it, the finely meshed net of critical scholarship and then to pin it down for close and scientific examination."[64] Ultimately, however, Ashton finds George Mlakuzhyil's methodology to be preferable to Culpepper's, even though Mlakuzhyil, in examining the Fourth Gospel, avails himself "of all the drills, needles, and probes that he can find in the literary critic's surgery...."[65]

Ashton's respectful yet unsentimental attitude toward the text finds an interesting parallel in John H. Langdon's introduction to his recent handbook, *Human Dissection for the Health Sciences*. "Our ability to use cadavers should always be regarded as a privilege," admonishes Langdon. "Cadavers should be treated with respect at all times...."[66] And again: "the remains of cadavers must be kept separate from trash for later respectful disposal. Be aware of the proper receptacles for body tissues from your cadaver and for paper. Clean up scraps on and around your table regularly."[67] Ashton uncensoriously classifies Mlakuzhyil as one those scholars "who have busied themselves with dissecting the Gospel in order to disclose its anatomical structure...."[68] For Culpepper, as we have just seen, such dissection distorts rather than deepens one's view of the text. What view of the text does Culpepper himself have? Here Foucault, ever the optometrist, may be of help.

62 Fortna, *The Gospel of Signs*, ix. Fortna's recourse to the German term *Doktorvater* is telling; the American term "dissertation adviser," or its British equivalent "thesis supervisor," hardly carries the same emotional charge.

63 Culpepper, *Anatomy of the Fourth Gospel*, 5.

64 Ashton, *Understanding the Fourth Gospel*, 9. In the companion volume, *Studying John*, Ashton subjects Culpepper's work, and that of other recent literary critics of the Fourth Gospel, to a withering critique (141–65).

65 Ashton, *Studying John*, 152; cf. Mlakuzhyil, *The Christocentric Literary Structure of the Fourth Gospel*.

66 Langdon, *Human Dissection for the Health Sciences*, 2.

67 Ibid.

68 Ashton, *Studying John*, 153.

In *The Birth of the Clinic*, Foucault distinguishes sharply between the medical *glance* and the medical *gaze*. The glance follows the path of the knife; it cuts beneath the surface, opens up the corpse, "that opaque mass in which secrets, invisible lesions, and the very mystery of origins lie hidden."[69] The glance feeds on fresh cadavers; its prosthesis is the scalpel, and its domain is the anatomy theater or the morgue. The gaze, in contrast, is content to graze (on) the surface of the body; its "correlative...is never the invisible, but always the immediately visible...."[70] It consists "of a general examination of all the visible modifications of the organism."[71] Its domain is the doctor's examining room.

Literary criticism, for Culpepper, far from being something performed with a dissecting knife, "is basically an inductive method in that one works from observations on the text being studied."[72] On Culpepper's own account, therefore, *Anatomy of the Fourth Gospel* is not an *Anatomy* at all, not the result of an anatomical dissection; rather, it is a physical examination. "Let's have a good look at you," is what Dr. Culpepper intends to say to John—not "Let's open you up and have a look." Visibly relieved, John removes his outer clothing and stretches out on the examining table—which in this case is a rectangular slab of paper.

And yet I wonder if Culpepper's methods are really so bloodless. By the time he is through with his examination, does he too not hold a dripping scalpel in his hand? Culpepper suggests as much in his conclusion: "[W]e have explored the 'anatomy' of the Fourth Gospel, tracing its rhetorical form and studying the function of each of its organs."[73] Organs can be thoroughly studied only under the knife, however. Jean Starobinski's admiring remark on Leonardo da Vinci's anatomical drawings also fits Culpepper's *Anatomy*: "We seem to see the scalpel uncovering the organs themselves."[74] And it is instructive to compare Culpepper's account of what he has accomplished in his *Anatomy* with Vesalius's account of what he has accomplished in his *Fabrica*: "The books [of the *Fabrica*] present in sufficient detail the number, site, shape, size, substance, connection to other parts, use and function of each part of the human body, and many other matters I have been accustomed to explain during dissection...."[75]

69 Foucault, *The Birth of the Clinic*, 122.

70 Ibid., 107.

71 Ibid., 111.

72 Culpepper, *Anatomy of the Fourth Gospel*, 9.

73 Ibid., 231. The organs in question would appear to correspond with the successive chapter topics: narrator and point of view, narrative time, plot, characters, implicit commentary, and the implied reader. Cf. ibid.: "My aim has been to expose the Fourth Gospel's rhetorical power to analysis by studying the literary elements of its 'anatomy.'"

74 Starobinski, *A History of Medicine*, 42.

75 Vesalius, *De humani corporis fabrica*, in O'Malley, *Andreas Vesalius of Brussels*, 322; cf.

Although their object of study clearly differs, Culpepper and Vesalius each employ formalist methods of analysis.[76] William Harvey (1578–1657), the London physician who discovered the circulation of the blood, and one of the foremost anatomists of his age, proposed a strictly formalist definition of the art of dissection: "[T]he end of anatomy is to know, or to be thoroughly acquainted with, the parts and to know the very reason for their existence, and to know…wherefore and why the parts are made, therefore, in order to know why one must study 1. the action and 2. the use of the parts."[77] Likewise, the end of *Anatomy of the Fourth Gospel*, as stated by its author, is "to contribute to understanding the gospel as a narrative text, what it is, and how it works."[78] In short, *Anatomy of the Fourth Gospel*, an exemplary application of formalist literary theory to a biblical text, appears to be an *Anatomy* after all, despite the peculiar reticence of its author to let the title of his work dictate his understanding of its nature.

But what kind of *Anatomy* is it? Here Gray provides the clue. "The whole field of anatomy has become very large," observes Gray, "and as a result a number of subdivisions of the subject have been recognized and named, usually to correspond with a specialized interest or avenue of approach."[79] Following Gray, Culpepper's enterprise can be termed *gross anatomy*, "the study of morphology, by means of dissection, with the unaided eye or with low magnification such as that provided by a hand lens."[80] Compare Culpepper: "This book is an attempt to make some initial tracings of what the gospel looks like through the lens of 'secular' literary criticism…. [R]eaders may be helped to read the gospel more perceptively by *looking at* certain features of the gospel. This process is to be distinguished from reading the gospel *looking for* particular kinds of historical evidence."[81] A major branch of gross anatomy, moreover, is *organology*, "the study of the structure of organs."[82] As we have already seen, Culpepper states in the conclusion to his *Anatomy* that he has studied the function of each of the Fourth Gospel's organs.

Harcourt, "Andreas Vesalius," 38.

76 Formalism can be loosely defined as an acute methodological attentiveness to the structural details of an object, especially, but not exclusively, a literary object. See further the articles on Russian Formalism, New Criticism, and Structuralism in Groden and Kreiswirth, eds., *The Johns Hopkins Guide to Literary Theory and Criticism*.

77 Harvey, *Prelectiones anatomiae universalis* (ca. 1615), quoted in Wilson, "William Harvey's *Prelectiones*," 80 (translation by Gweneth Whitteridge).

78 Culpepper, *Anatomy of the Fourth Gospel*, 5. Cf. ibid., 3: "little attention has been given to the integrity of the whole, the way its component parts interrelate…."

79 Gray, *Anatomy of the Human Body*, 1–2.

80 Ibid., 2.

81 Culpepper, *Anatomy of the Fourth Gospel*, 5, his emphasis.

82 Gray, *Anatomy of the Human Body*, 2.

Gray also notes that "considerable disagreement and confusion" have arisen in the field of anatomy "because of conflicting loyalties to teachers, schools, or national traditions."[83] Such disagreement is apparent in Culpepper's *Anatomy*, as we also saw. The subspecialization that Culpepper criticizes may be termed *embryology* or *developmental anatomy*, the study of an organism's growth from inception to birth.[84] For Culpepper, this would encompass "the history of the material, the process by which the gospel was composed, and developments within the Johannine community."[85] What Gray enables us to see, however, is that the source-and-background focused branch of biblical scholarship, on the one hand (with its roots deep in German soil), and the formalist branch of biblical scholarship, on the other (a distinctly American outgrowth), far from being radically different enterprises, are but two divergent branches of a general anatomy of the Bible.

(Beset on all sides, the biblical texts plead with us. Their voices raised in chorus, they chant: "The aim of the anatomists is attained when the opaque envelopes that cover our parts are no more for their practiced eyes than a transparent veil revealing the whole and the relation between the parts.")[86]

As Glenn Harcourt has noted, anatomical knowledge can be obtained only "through the violation and destruction" of its object.[87] The question therefore arises: What is the state of the Fourth Gospel once Culpepper has laid aside his scalpel and stripped off his surgical gloves? Dissection is a brutal business. "With a very sharp razor make a circular incision around the umbilicus, deep enough to penetrate the skin," instructs Vesalius; "then from the middle of the pectoral bone make a straight, lengthwise incision to the umbilicus, and from the lower region of the umbilicus proceed toward the pubes as far as the middle of the root of the virile member—if you are now employing a male cadaver...."[88] The Fourth Gospel is the risen body of Jesus, as we have seen. Is Jesus' glorified torso now an open cavity overflowing with excised organs, which have been carefully removed, curiously inspected, and hurriedly replaced?

More to the point, perhaps, who is the real victim of the biblical scholar's scalpel? Who bleeds? And who benefits? I shall address this question in due course. First I wish to make some further exploratory incisions in the *Anatomy of the Fourth Gospel* (for it appears that I too suffer from a repressed need to open up corpses or corpora).

83 Ibid., 4.

84 Ibid., 2.

85 Culpepper, *Anatomy of the Fourth Gospel*, 3.

86 Adapted from Foucault, *The Birth of the Clinic*, 166.

87 Harcourt, "Andreas Vesalius," 34.

88 Vesalius, *De humani corporis fabrica*, in O'Malley, *Andreas Vesalius of Brussels*, 345.

Culpepper's Eye-agram

> Anatomy is that branch of learning which teaches
> uses and actions of the parts of the body by ocu-
> lar inspection and dissection.
>
> —WILLIAM HARVEY, *Prelectiones anatomiae universalis*

Anatomy of the Fourth Gospel is an organology, as we have seen; but there is one organ that occupies it more than any other. That organ is the eye. In recent years, a certain diagram from Seymour Chatman's narratological study, *Story and Discourse: Narrative Structure in Fiction and Film*, has become a familiar sight in literary studies of the Bible:[89]

Figure 6: Diagram of the act of narrative communication from Seymour Chatman, *Story and Discourse* (1978).

Remarkably, Chatman's rectangular diagram of narrative communication becomes, in Culpepper's free adaptation of it, an oval containing three concentric circles—an outsized eye, in other words:[90]

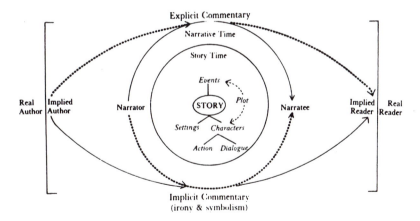

Figure 7: Diagram of the act of narrative communication from R. Alan Culpepper, *Anatomy of the Fourth Gospel* (1983).

89 See Chatman, *Story and Discourse*, 151. In particular, Chatman's diagram has had a profound impact on the way that New Testament literary critics conceive of the gospel text (cf. Powell, *What Is Narrative Criticism?*, 27; Moore, *Literary Criticism and the Gospels*, 46).

90 See Culpepper, *Anatomy of the Fourth Gospel*, 6. I can't seem to leave this eye alone; I have poked it from another angle in *Poststructuralism and the New Testament*, 79–80.

"Between author and reader is the text, enclosed above in brackets," explains C., or better, See.[91] The text is an eye, then. More precisely, the text is an eyeball (*bulbus oculi*), snug in its bony cavity (*orbit*), represented here by the brackets.[92] Absent from See's eye-agram are the text's cover and dustjacket, its eyelids (*palpebrae*). Gray describes the eyelids as "two thin movable covers" that protect the eye from injury "by their closure."[93]

See's eyeball neatly diagrams several of his enabling assumptions. It indicates, for example, that the real (historical) author and the real (original) readers are properly the objects of peripheral vision only for the formalist literary critic. "[U]nderstanding the interests and theology of the real author is not our primary concern," states See.[94] Later it emerges that the real reader is not See's central focus either.[95] Of course, a skeptic might respond that the eye-agram could equally be interpreted to suggest that the real author and audience, along with their interests and ideologies, are the blind spot of See's narrative theory.[96] The blind spot is located on the periphery of the eyeball, in the optic disk.[97]

With uncanny precision, however, See has positioned "story" in his eye-agram to correspond with the lens of the eye, while the narrator and narratee are positioned on the circumference of the retina. The lens serves to focus the external world, along with the retina, "a delicate nervous membrane, upon which the images of external objects are received."[98] Correspondingly in the eye-agram, the external world is focused, processed and relayed to the narratee through the agency of the narrator and the medium of the story.

Our word "theory" comes from Greek *theōria*. Etymologically, therefore, a theory is a sight, a spectacle, a speculation. See's narrative theory, however, is less a spectacle or sight than an *instrument* of sight: an unblinking eye that attempts to take in the Fourth Gospel at a glance. Trapped by the eye, the text is forced to assume its contours, becoming an oculomorphic entity.

But another question now arises: If the Fourth Gospel really assumes the form of an eye in See's *Anatomy*, might not the latter merely amount to a dissection of the risen Jesus' eye, and not his entire body, as we formerly supposed? If so, the following passages from the *Principles of Prosection* could serve as a defamiliarizing redescription of See's exegetical method.

91 Culpepper, *Anatomy of the Fourth Gospel*, 6.
92 Cf. Gray, *Anatomy of the Human Body*, 1285.
93 Gray, *Anatomy of the Human Body*, 1308.
94 Culpepper, *Anatomy of the Fourth Gospel*, 15.
95 Ibid., 212.
96 Such skepticism as is found, for example, in the Bible and Culture Collective, *The Postmodern Bible*, 110ff. (a critique of formalist biblical criticism, Culpepper's included).
97 See Gray, *Anatomy of the Human Body*, 1294; cf. Hollinshead, *Anatomy for Surgeons*, 1:139.
98 Gray, *Anatomy of the Human Body*, 1294; cf. Hollinshead, *Anatomy for Surgeons*, 1:138–40.

First, the preparation of the specimen for the knife, which would correspond to See's introductory chapter: "Eyes must be transferred from the small specimen containers in which they are usually received to a container with approximately 500 ml of 10% buffered formalin.... The globe should be washed overnight with running tap water and transferred to 60% alcohol for storage before cutting."[99] The focal feature of See's Introduction is the eye-agram. It has been transferred from the specimen container in which it arrived—Chatman's *Story and Discourse*—and now slumbers unsuspectingly in a stultifying solution of formaldehyde and methanol.

Next, the procedure itself, which would correspond to See's dissection and description of the Fourth Gospel (which he has assimilated to the form the eye-agram): "Use a double-edged razor blade, and, starting adjacent to the optic nerve, make a cut forward that will emerge just inside the corneal limbus. This plane of sectioning just misses or nicks the lens, which is hard and is usually dislocated by attempts to cut it...."[100] A meticulous description of "the cut surface" normally accompanies the dissection.[101] But why is the lens so hard to cut? The lens serves to focus the external world, as we have already seen, and so would correspond to the text's ideology,[102] which is indeed the feature of a text most stubbornly resistant to analysis. See does bring his blade to bear on the Fourth Gospel's lens, briefly examining its "ideological point of view," but he merely nicks it in passing.[103]

Is the Fourth Gospel really an eye, however? Arguably, the text does lend itself to this sort of reduction. For it is also the risen body of the Johannine Jesus, and what is the Johannine Jesus if not an instrument of vision? "No one has ever seen [*horaō*] God," the narrator announces in the prologue; it is the Son alone who has made him known (1:18; cf. 6:46; 8:38a; 12:45; 14:8–9; 15:24b). The Son focuses the radiant glory of the Father and relays it to the believer (cf. 11:40; 17:22); therefore, the Son is an eye. "I am the light [*phōs*] of the world," declares the eye; "whoever follows me will never walk in darkness [*skotia*] but will have the light of life" (8:12; cf. 9:5; 1:3–4; 3:19–21; 9:39; 11:9–10; 12:35–36, 40, 46).[104]

99 Pierson et al., *Principles of Prosection*, 163.

100 Ibid., 165; cf. Langdon, *Human Dissection for the Health Sciences*, 256; Anson and McVay, *Surgical Anatomy*, 1:55–89 passim.

101 Cf. Pierson et al., *Principles of Prosection*, 166.

102 A rough-and-ready definition of ideology, to be sure. For an exhaustive definition, see the Bible and Culture Collective, *The Postmodern Bible*, 272–77. Note, incidentally, that "ideology" derives from the Greek verb *idein*, "to see."

103 See Culpepper, *Anatomy of the Fourth Gospel*, 32–34. His construal of the Johannine ideology is, to my mind, too benign, too uncritical to cut any deeper than that.

104 Further on the light motif, see Dodd, *The Interpretation of the Fourth Gospel*, 201–12, 354–62; Schnackenburg, *The Gospel According to St. John*, 1:241–55 passim; 2:188–92, 242; and Ashton, *Understanding the Fourth Gospel*, 208–14.

The theory that the Johannine Jesus is an eye also sheds fresh light on 19:34, the enigmatic flow of water from Jesus' side. All the features of the eye that we looked at earlier—lens, retina, etc.—are located on the exterior of the vitreous body (*corpus vitreum*), a transparent, semigelatinous fluid that accounts for most of the volume of the eyeball:[105]

Figure 8: Horizontal section of the eyeball from the 30th American edition of *Gray's Anatomy* (1985).

In a cadaver, as Langdon explains, the "jelly-like" vitreous body "often has degenerated to a thin fluid."[106] It is only to be expected, therefore, that when Jesus' corpse—a dull, lifeless eye—is pricked with the point of a lance a colorless, waterlike liquid should gush forth from it, in addition to blood: "One of the soldiers pricked [*nyssō*] his side with a spear, and at once there flowed out blood and water [*hydōr*]" (John 19:34; cf. 20:25, 27; 1 John 5:6; Rev. 1:7; *Acts of Pilate* 16:7). As it happens, *nyssō* is also used in *Sirach* 22:19 for pricking the eye.[107]

Of course, this is not the only possible medical interpretation of this intriguing issue of water, which has so exercised the imaginations of physi-

105 Gray, *Anatomy of the Human Body*, 1289; cf. Hollinshead, *Anatomy for Surgeons*, 1:140.
106 Langdon, *Human Dissection and the Health Sciences*, 256.
107 Brown, *The Death of the Messiah*, 2:1177, n. 91.

cians down through the ages.[108] Vesalius proposes a rather different reading in his *Fabrica*:

> It is our custom,...to leave those who have been hanged on the gallows—as on a kind of cross—at the public highways outside the cities. If the weather is warm, within a few days after the hanging the bodies swell up into an astonishing mass as if they were bladders distended by water. I recollect that once in the warm season I skinned some dogs in order to examine the movement of some muscle; through carelessness I had not disposed of the bodies and, since they had been left by chance in the sun, a great quantity of serous water collected in the peritoneal and thoracic cavities. But let me hasten on..., lest I find myself involved in the theologians' sacred question of the mysterious abundance of water of our Saviour Jesus Christ, for I must not in the slightest degree upset the complete veracity of the authentic gospel of St. John by my considerations of the effect of a hot sun on those who have been hanged or otherwise executed.[109]

Beginning with Origen, a distinguished line of theologians had interpreted the issue of water as a supernatural occurrence. "Now, in other dead bodies the blood congeals, and pure water does not flow forth," explains Origen; "but the miraculous feature in the case of the dead body of Jesus was that...blood and water flowed forth from the side."[110] Origen is no doubt infected by the contagious excitement of the evangelist: "He who saw this has testified [*ho heōrakōs memartyrēken*] so that you also may believe. His testimony is true [*alēthinē autou estin hē martyria*], and he knows that he tells the truth" (19:35).[111] Vesalius dares to imply, however, that the theologians' construal of the event, and even the evangelist's own construal, do not themselves hold water.

Of course, Vesalius's own interpretation is itself improbable; Jesus' corpse would not have had enough time to bloat before being pricked. Nevertheless, Vesalius's readiness to bring his empirically honed lancet to bear upon the

108 See the surveys of Wilkinson, "The Blood and Water in John 19.34" (Wilkinson is himself a physician); Beasley-Murray, *John*, 355–57; and Brown, *The Death of the Messiah*, 2:1088–92.

109 Vesalius, *De humani corporis fabrica*, in O'Malley, *Andreas Vesalius of Brussels*, 175.

110 Origen, *Against Celsus* 2.36 (trans. from Roberts and Donaldson, eds., *The Ante-Nicene Fathers*). Wilkinson objects strenuously: "No one who has performed a post-mortem examination of a body recently dead would agree with Origen's observation..." ("The Blood and Water in John 19.34," 159).

111 "Doubtless a miracle is being recounted here," remarks Bultmann, referring less to the event itself than to the interpretation of it enshrined in this verse (*The Gospel of John*, 677). Many other twentieth-century commentators would concur—e.g., Loisy (*Le Quatrième évangile*, 492), Lagrange (*Évangile selon Saint Jean*, 499), Hoskyns (*The Fourth Gospel*, 533), and Brown (*The Death of the Messiah*, 2:1179)—although Barrett (*The Gospel According to St. John*, 462), Schnackenburg (*The Gospel According to St. John*, 3:289–90), Lindars (*The Gospel of John*, 586), and Beasley-Murray (*John*, 356) would not. The vexed question of whether 19:35 might be an editorial interpolation need not concern us here.

swollen corpus of patristic and medieval exegesis, thereby reenacting the soldier's skeptical lance-thrust, shows him to be a forefather—indeed, a *Doktorvater*—of the critical biblical scholars who would soon begin to appear.

Autopsy, in Which the Coroners and Medical Examiners Converge on the Corpse of Christ

In most instances, statutes authorize medicolegal
autopsies when death has resulted from violence....
—JURGEN LUDWIG ET AL.,
Current Methods of Autopsy Practice

If biblical scholarship has often taken the form of a paramedical science, medicine has sometimes taken the form of biblical scholarship, as we have begun to see. Over the years, in particular, a diverse body of medical specialists has converged on Jesus' still-warm corpse as it is removed from the cross—inspired, perhaps, by the anonymous soldier who has just initiated an autopsy with the point of his spear (see Figure 9).[112] One thinks of such book-length autopsy reports as Pierre Barbet's *A Doctor at Calvary: The Passion of Our Lord Jesus Christ as Described by a Surgeon*,[113] and numerous shorter studies in a similar vein.[114] To my mind, these studies can be read as inadvertent but instructive caricatures of biblical scholarship, considered as a paramedical science.

Barbet, for example, has frequent recourse to his extensive experience opening up corpses in order to open up the passion narratives. "I have repeated various experiments on dead bodies on which I was conducting autopsies," he confesses. "First of all I took a long needle mounted on a large syringe.... I rapidly inserted the needle into the fifth right interspace.... I then, under the same conditions, thrust in a large amputation knife."[115] Earlier, Barbet had performed the following experiment: "having amputated an arm two-thirds of the way up, I took, immediately after the operation, a square nail.... The hand was laid flat with its back to a plank.... Then, with

112 Cf. Starobinski, *A History of Medicine*, 36: "Surgical experience could...be gained at gladitorial schools or with the armies." In the *Acts of Pilate* 16.7, this aspiring surgeon picks up a nickname, Longinus (or "spearman").

113 Similar monographs include Stroud, *Treatise on the Physical Cause of the Death of Christ*, Schmittlein, *Circonstances et cause de la mort du Christ*, and Gilly, *Passion de Jésus*.

114 Edwards, Gabel and Hosmer list 14 articles of this sort ("On the Physical Death of Jesus Christ," 1463). Additional articles can be found in Brown, *The Death of the Messiah*, 2:893–94.

115 Barbet, *A Doctor at Calvary*, 121.

Figure 9: The post-mortem spear thrust of John 19:34 as reconstructed by W.D. Edwards, W.J. Gabel, and F.E. Hosmer (*Journal of the American Medical Association*, 1986).

a large hammer, I hit the nail, as an executioner would do who knew how to hit hard."[116] He admits that he "repeated the same experiment with several men's hands (the first hand had belonged to a woman)."[117]

A. F. Sava, author of "The Wound in the Side of Christ," also appears to be up to his elbows in blood as he writes. This curious article is punctuated with admissions such as the following:

> I have repeatedly pierced lungs of cadavers less than six hours after death.... I have collected into glass cylinders blood from different cadavers from 2 to 4 hours after death.... A stab wound through the chest directed to the heart, after [I] had previously filled the pericardial sac with 1000 cc. of water, failed to produce any of the water at the chest wound. Rather, inside the chest and especially around the right lung, the water literally flooded the area.[118]

These grisly confessions, which, to the nonmedical ear, are more evocative of Dr. Frankenstein than of Dr. Welby, are all the more startling for the fact that they appear in the ordinarily anemic pages of *The Catholic Biblical Quarterly*.

When these articles appear in a medical journal, the effect is no less surreal. An excellent case in point is W. D. Edwards, W. J. Gabel and F. E. Hosmer's "On the Physical Death of Jesus Christ," a blow-by-blow medical account of the scourging and crucifixion of Jesus, which appeared in *The*

116 Ibid., 102.

117 Ibid.

118 Sava, "The Wound in the Side of Christ," 344, 345, 346. Sava is also the author of "The Wounds of Christ," and "The Blood and Water from the Side of Christ."

Journal of the American Medical Association side by side with glossy advertisements for pain medication, on the one hand, and scientific papers on such timely topics as "Self-induced Vomiting and Laxative and Diuretic Use Among Teenagers," on the other. And this exhumation and dissection of Jesus' remains was not performed in an obscure corner of the journal. On the contrary (and highly appropriately?), this issue of *JAMA* carries on its cover a color reproduction of Édouard Manet's *Christ Mocked*, and the article itself was part of a high-profile series on systematic state-sponsored torture and physician complicity in such.

Dr. Edwards and his associates begin by frankly admitting that the subject of their autopsy is not an actual corpse: "The source material concerning Christ's death comprises a body of literature and not a physical body or its skeletal remains."[119] Laid out on the slab, in other words, is not a fresh cadaver but a moldering pile of paper. And this literary corpus is composed not only of ancient sources but also of modern scholarship on the historical Jesus, as the authors go on to explain. As it happens, this is the same chaotic pile of paper that the Fourth Evangelist alludes to at the end of his Gospel: "There are also many other things that Jesus did; if every one of them were written down, I suppose that the world itself could not contain the books that would be written [*oud' auton oimai ton kosmon chōrēsai ta graphomena biblia*]" (21:25).

In recent years, innumerable dissections of this corpus have been performed by biblical surgeons in search of the historical Jesus. The first great dissection of this sort, however, was performed by Albert Schweitzer in Strasbourg in 1905. Leaving no cavity of the colossal cadaver unexplored, Schweitzer carefully removed all the vital organs and placed them in neat piles around his study. Here is his own account of the autopsy:

> When I had worked through the numerous lives of Jesus, I found it very difficult to organize them into chapters. After vainly attempting to do this on paper, I piled all the "lives" in one big heap in the middle of my room, selected a place for each of the chapters in a corner or between the pieces of furniture, and then, after considerable thought, sorted the volumes into the piles to which they belonged. I pledged myself to find a place for every book in some pile, and then to leave each heap undisturbed in its place until the corresponding chapter in the manuscript was finished. I followed this plan to the very end. For many months people who visited me had to thread their way across the room along paths that ran between heaps of books.[120]

119 Edwards, Gabel and Hosmer, "On the Physical Death of Jesus Christ," 1455.
120 Schweitzer, *Out of My Life and Thought*, 46. The manuscript in question was Schweitzer's *Von Reimarus zu Wrede*, which has been translated into English as *The Quest of the Historical Jesus*.

As the paper whale rose up to swallow Schweitzer, Schweitzer proceeded to dissect the whale with a paperknife, confident that the corpse of the historical Jesus was interred deep in its innards (cf. Matt. 12:40).

Just how close is the connection between the post mortem and the historical examination? The word "autopsy" has its origins in *autopteō*, which Liddell and Scott render as "see with one's own eyes...esp. witness a divine manifestation...."[121] The cognate noun, *autoptēs* ("eyewitness"), was used by Herodotus and Josephus as a term for the first-hand historical researcher. In *Against Apion*, for example, Josephus avers: "As for the History of the War, I wrote it as having been an actor myself in many of its transactions, an eyewitness [*autoptēs*] in the greater part of the rest...."[122] It would appear that autopsy and historiography are blood relations, then. The opening of Jesus' corpse with a lance can be regarded as an autopsy, since the author of the incision knows that the subject is deceased: "But when they came to Jesus and saw that he was already dead [*hōs eidon ēdē auton tethnēkota*]..." (John 19:33). Significantly, this autopsy is accompanied by an *autopsia*, a seeing with one's own eyes, a witnessing of a divine manifestation: "He who saw this has borne witness [*ho heōrakōs memartyrēken*] so that you also may believe" (19:35). Autopsy, historiography, evangelical witness.... Albert Schweitzer, who went on to become a medical practitioner—and a medical missionary to boot—exemplifies the curious combination of these three elements that has so characterized modern biblical scholarship.[123]

What distinguishes the average autopsy from the average work of New Testament scholarship is that the author of the latter is, or once was, emotionally involved with the person laid out on the slab. Most New Testament scholars, even when actively involved with the deceased, manage to maintain a brisk professional demeanor. What happens when the scholar fails to maintain the necessary clinical detachment? Ironically, a spectacular example of such failure is provided by a book whose author was not a biblical professional, but a medical professional. It is time we turned once again to Pierre Barbet's *A Doctor at Calvary*.

Several of the book's chapter titles, and even some of the chapter contents, might not be out of place in a regular autopsy report—"The Causes of the Rapid Death," "The Wounds of the Hands," "The Wounds in the Feet,"

121 Liddell and Scott, *A Greek-English Lexicon*, s.v. *autopteō*.

122 Josephus, *Against Apion* 1.55 (Whiston's trans.); cf. Herodotus, *Histories* 2.29; 3.115. *Autoptēs* occurs in the New Testament only in Luke 1:2, where it refers, not to the author himself, the diligent historical researcher who has "investigated everything carefully from the very first" (1:3), but to the original "eyewitnesses" on whom he claims ultimately to rely.

123 To complete the picture, Schweitzer also had a lifelong fascination with organs. The same year that *Von Reimarus zu Wrede* appeared, he also published *Deutsche und französische Orgelbaukunst und Orgelkunst* (The German and French arts of organ building and organ playing).

"The Wound to the Heart"—although the standard autopsy report, even more than the standard work of biblical scholarship, is exceedingly cold to the touch, which Barbet's book seldom is.

Indeed, one suspects that even the most animated autopsy report would tend to be colder and more clinical than the most "objective" work of biblical scholarship. Both genres, however, aspire to transcend the verbal medium in which they are enfleshed. In *Current Methods of Autopsy Practice* one finds the following statement of aims: "Autopsy protocol writing is an art. Descriptions should be brief yet complete. *There should be no interpretations* and no descriptions of the mechanics of dissection ('The left atrium of the heart is opened...')."[124] Few if any biblical scholars would be bold (or naive) enough to propose an interpretion-free dissection of the biblical text. Nevertheless, the apparent objectivity of scientific discourse has long served as a model for biblical critics. W. G. Kümmel's *The New Testament: The History of the Investigation of Its Problems* begins: "It is impossible to speak of a scientific view of the New Testament until the New Testament became the object of investigation as an independent body of literature...that could be considered...without dogmatic or credal bias."[125] And faith in a bias-free, "scientific" biblical scholarship is not yet a quaint relic of a distant, generally Germanic past. "Although we cannot be sufficient for this, our aim has been to be loyal to the tradition of disinterested and objective study in biblical criticism," W. D. Davies and Dale C. Allison announce in the preface to their recent, three-volume commentary on Matthew.[126]

Barbet clearly regards his investigation of Jesus' death as more scientific than that of non-medical exegetes. "It has always been my aim to look on this as a scientific question and to put forward my conclusions as hypotheses, in my opinion solidly established but capable of modification," he explains.[127] He complains of "the difficulty of explaining scientific conclusions to the uninitiated...."[128] Lumped in the latter category are professional theologians and exegetes, who are ill–qualified to pronounce on the physical circumstances of Jesus' death: "The truth is they scarcely understand them...."[129] Barbet's mission statement follows: "And it is indeed essential that we, who are doctors, anatomists and physiologists, that we who know, should proclaim abroad the terrible truth...."[130] He proceeds to detail his

124 Ludwig et al., *Current Methods of Autopsy Practice*, 264, emphasis added.
125 Kümmel, *The New Testament*, 13. Such a view "began to prevail only during the course of the eighteenth century..." (ibid.).
126 Davies and Allison, *The Gospel According to Saint Matthew*, 1:xi.
127 Barbet, *A Doctor at Calvary*, 9.
128 Ibid., 10.
129 Ibid., 7.
130 Ibid., 8.

own credentials: "I am first of all a surgeon, and thus well versed in anato-
my, which I taught for a long time; I lived for thirteen years in close contact
with corpses and I have spent the whole of my career examining the anato-
my of the living. I can thus, without presumption, write 'the Passion accord-
ing to the surgeon'...."[131]

And yet, in the estimation of another doctor at Calvary, Raymond E. Brown,
Th.D., Barbet's dissection of the passion narratives is miserably mishandled,
as are the dissections of practically every other medical professional who has
examined them. In *The Death of the Messiah*, concluding his section on "The
Physiological Cause of the Death of Jesus," Brown complains: "In my judg-
ment the major defect of most of the studies I have reported on thus far
[including Barbet's] is that they were written by doctors who did not stick to
their trade and let a literalist understanding of the Gospel accounts influence
their judgments on the physical cause of the death of Jesus."[132] In effect,
Brown is accusing Barbet and his fellow physicians, not of butchering the
corpus/cadaver of Scripture (specifically, the passion narratives), nor even of
failing to cut it up correctly, but of not cutting into it at all. Barbet and his the-
ologically conservative colleagues have performed a bloodless dissection of
the biblical text. They have failed to dig beneath the surface, to extract the
historical core of the passion narrative—its spinal cord, so to speak—from its
fleshy, fictional housing.[133] ("Removal of the spinal cord...can be accom-
plished very easily within 10 to 15 minutes by the use of an oscillating
saw...and should be part of every autopsy.")[134] And why? Because they have
felt too attached emotionally to the literary corpus laid out on the slab, or
rather to the person whose body that corpus has become.[135]

131 Ibid., 11.
132 Brown, *The Death of the Messiah*, 2:1092. In other words, these articles tend to treat the pas-
sion narratives as historical reports, accurate down to even the smallest details. Dennis E.
Smith, too, has sternly criticized this tendency on the part of medical exegetes; see his
"Autopsy of an Autopsy," a dissection of Edwards, Gabel and Hosmer's "On the Physical Death
of Jesus Christ."
133 "[W]hy is a nice journal like this publishing such a *shallow* article?" is Smith's summary of
the fifteen critical letters to the editor that Edwards, Gabel, and Hosmer's *JAMA* article elicit-
ed ("An Autopsy of an Autopsy," 14, emphasis added).
134 Ludwig et al., *Current Methods of Autopsy Practice*, 162.
135 Contrast the stern example that Jesus himself sets, anatomizing his own flesh, as Jonathan
Sawday has observed (*The Body Emblazoned*, 117–18). First, Jesus partitions his own sym-
bolic body at the Last Supper (Mark 14:22 and pars.; cf. 1 Cor. 11:23–24; John 6:51). Later he
invites his dubious disciples to examine the incisions in his risen body (Luke 24:39–40; John
20:20, 27). Later still, in 1673, as the Age of Anatomy approaches its zenith, he exposes his
throbbing heart to a Roman Catholic nun, Sister Margaret Mary Alacoque, thereby inaugu-
rating the devotional cult of the Sacred Heart. A picture of the Sacred Heart dominated the
living room of my childhood home (and just about every other living room in Catholic
Ireland), so that my earliest impressions of Jesus were intimately bound up with his weirdly
exposed heart.

Barbet is the paramount example. His book is a mixed genre, part autopsy report, part Good Friday sermon. He expresses modest pretensions to scientific objectivity in his Preface, as we have seen, but in his final chapter, "The Corporal Passion of Jesus Christ," he sheds all such pretensions as easily as a lab coat. The chapter commences with a prayer: "*O bone et dulcissime Jesu*, come to my aid. You, Who had to bear them, make me able to describe Your sufferings. Perhaps, by forcing myself to be objective, in opposing emotion with my surgical 'insensibility,' perhaps I shall be able to reach that goal. If I should shed tears before the end, do you, my good friendly reader, do the same as me and not be ashamed...."[136] An exceptionally detailed reenactment of Jesus' sufferings follows. Barbet is determined not to leave anything out: "The Passion really begins at the Nativity, since Jesus, in His divine omniscience, always knew, saw and willed the sufferings which were awaiting His Humanity. The first blood shed for us was on the occasion of the Circumcision, eight days after Christmas."[137]

Many cuts and bruises later, we arrive in tears at the place of utmost torment:

He has been placed at the foot of the *stipes*, with His shoulders lying on the *patibulum*. The executioners take the measurements. A stroke with an augur, to prepare the holes for the nails, and the horrible deed begins.

An assistant holds out one of the arms, with the palm uppermost. The executioner takes hold of the nail (a long nail, pointed and square, which near its large head is one third of an inch thick), he gives him a prick on the wrist.... One single blow with the great hammer, and the nail is already fixed in the wood, in which a few vigorous taps fix it firmly.

Jesus has not cried out, but His face has contracted in a way terrible to see. But above all I saw at the same moment that His thumb, with a violent gesture, is striking at the palm of His hand: *His median nerve has been touched*. I realize what He had been through: an inexpressible pain darts like lightning through his fingers and then like a trail of fire right up His shoulder, and bursts in His brain. The most unbearable pain that a man can experience is that caused by wounding the great nervous centres. It nearly always causes a fainting fit, and it is fortunate that it does. Jesus has not willed that He should lose consciousness. Now, it is not as if the nerve were cut right across. But no, I know how it is, it is only partially destroyed; the raw place on the nervous centre remains in contact with the nail; and later on, when the body sags, it will be stretched against this like a violin-string against a bridge, and it will vibrate with each shaking or movement, reviving the horrible pain. This goes on for three hours....[138]

136 Barbet, *A Doctor at Calvary*, 158–59.
137 Ibid., 159.
138 Ibid., 167; cf. 104–5.

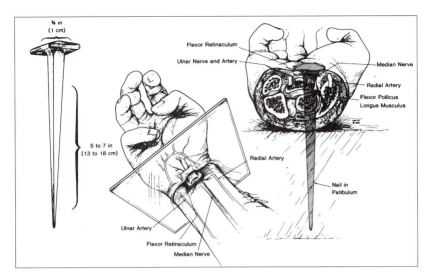

Figure 10: Detail of a Roman crucifixion as reconstructed by W. D. Edwards, W. J. Gabel, and F. E. Hosmer (*Journal of the American Medical Association*, 1986).

Like the Good Friday sermons of my childhood. Indeed, upon first reading this passage I realized with amazement that the Redemptorist Father who had so expertly caused me to vomit on the steps of the Redemptorist Church in Limerick long ago had read it too. It was the vibrating median nerve stretched taut against the nail like a violin-string against a bridge that did it (see Figure 10), inviting a fainting fit as Barbet says, although I too had decided that I should not lose consciousness.

In short, Barbet, being in love with Jesus, does not have the heart or the stomach to gut him, or at least the text that has become his cadaver, coldly opening it up to reveal its internal contradictions, its hidden anomalies, its profound implausibilities. But does Brown himself have the stomach for this gruesome work? According to John Dominic Crossan in *Who Killed Jesus?* (essentially a book-length riposte to Brown's *The Death of the Messiah*), Brown's own hand trembles and he too does not cut deeply enough into the biblical corpus.[139] But Crossan's anatomy in turn appears squeamish, even shallow, compared to that of Burton Mack, whose dismemberment and dissection of the body of Jesus traditions assembled in the canonical Gospels is terrifyingly thorough.[140] And so it goes on, each surgically gloved professional impatiently wresting the scalpel from his or her colleagues in order

139 Crossan, *Who Killed Jesus?*, esp. ix–xi, 1, 6–13, 137–41, 177–81.

140 See, e.g., Mack, *A Myth of Innocence*, 53–77, *The Lost Gospel*, 29–39, 105–30, and *Who Wrote the New Testament?*, 39–40, 45–47, 87, 147–83. Stafford documents the emergence in the eighteenth century of "a new erudite critic curious to the point of cruelty" (*Body Criticism*, 54). Arguably, among contemporary Jesus scholars, it is Mack who most approximates this type.

to cut up the cadaver more thoroughly. Compare A. M. Lassek's account in *Human Dissection: Its Drama and Struggle* of the precocious ferocity displayed by the young Vesalius while still a student at the University of Paris: "The studies made were superficial, at most; they included only the intestines and abdominal muscles.... He took matters into his own hand, grabbed a scalpel, pushed the prosectors aside and systematically proceeded on his own, dissecting down to the bones...."[141]

But who actually bleeds when the biblical scholar dissects? Who really goes under the knife? To my mind, that question is best addressed in the context of the classroom. The biblical studies classroom, especially in a secular university, can indeed be an anatomy theater at times. The tableau is late medieval or early Renaissance, depending upon the proclivities of the professor. More often than not, the professor of biblical anatomy will stand above the proceedings at a podium, discoursing from an authoritative text—Spivey and Smith's *Anatomy of the New Testament*, for example, or Culpepper's *Anatomy of the Fourth Gospel*, or one of a vast number of other such texts whose titles are less frank about their methods. Like Vesalius, the professor will undoubtedly wish to double in the role of *demonstrator*, performing his or her own dissection of the biblical corpus in order to illustrate the material in the textbook. In the larger classes, teaching assistants fill the role of *ostensor*; in due course they will indicate to their charges the precise parts of the biblical corpus to which the professor's text referred, often repeating verbatim the professor's own words. And the students will see the biblical corpus open up beneath the professor's scalpel.

Some will not like what they see. Some will wince, blanch, or simply tune out as the professor's oscillating saw severs the historical Jesus from the Christs of the Gospels; or cuts the historical Paul loose from as many as six of the thirteen letters that the New Testament attributes to him; or separates all the remaining letters and books of the New Testament from the names traditionally attached to them (Matthew, Mark, Luke, John, James, Peter, Jude...); or slices "what the New Testament teaches" into a multiplicity of contrasting and conflicting perspectives.

Personally, I do not have the stomach to perform a full dissection of the New Testament for beginning students, even if I had the skill. From what they tell me, and more especially from what they write, I know that some of them are joined at the hip to Jesus, just as I myself once was, permanently in his presence, in his gaze, in intimate proximity to him, and carrying on an unceasing internal conversation with him. I readily confess that I killed this controlling twin. I had to. Beginning in June 1976, and using a knife I had found concealed in the pages of a New Testament textbook, I began to

141 Lassek, *Human Dissection*, 94.

inflict cuts on him, just nicks and scratches at first, but eventually great gashes, until he finally stopped breathing in my ear. This took a long time. He was still breathing faintly, almost imperceptibly, six or seven years after I began. Sometimes I imagine that I can hear him even today.

I doubt that very many of my born-again students want to be separated from Jesus in this way. And I'm not sure that I want to be the surgeon doing the separating in any case. We educators often talk glibly about "touching students' lives"; but just how intimately are we authorized to touch them? Especially when it is a scalpel that is doing the touching? But perhaps I am merely magnifying my paltry power. I have been amazed at how impervious some students are to the blade of biblical criticism, taking course after course with me, yet ceding none of their faith in the absolute perfection of the New Testament, the bibliomorphic body of Christ, an outcome I find oddly consoling. A few students even claim to have been drawn back into the fold as a result of my classes, attending church again after years of absence.

But I have also been issued grim warnings, especially on the last day of class when the students are equipped with course evaluation forms and encouraged to grade the teacher. Some of these anonymous warnings might be paraphrased thus: "Tread softly, for you tread on what you take to be my dreams, but what is actually my most intimate reality." Others protest that the Word of God is alive (cf. Heb. 4:12; 1 Pet. 1:23), not dead, as I seem to suppose, whereupon the classroom becomes a place of unspeakable cruelties, of vivisection rather than mere dissection.[142]

Epilogue
"That Miserable Mangled Object"

As scholar-surgeons, we subject the Book and the Word to examination by dissecting them. Do we carve them up only in order to prepare them for the dinner table? Less and less, I suspect, although the Book has always begged us to devour it, and the Word has always urged us to ingest him. Why do we decline these urgent invitations to dine? Is it because we fear that the Book and the Word, if swallowed whole, will have mind-altering effects that we will be unable to control? Assuredly, such fears are not without foundation. In the end, perhaps, it all amounts to the covert execution of a tyrant by his

142 Baldasar Heseler concludes his eyewitness account of Vesalius's public dissections at Bologna in 1540 with a detailed description of the vivisection of a dog, "the fifth or perhaps the sixth killed in our anatomy" (*Andreas Vesalius's First Public Anatomy*, 292–93). Throughout most of the history of anatomy, animal vivisection has been standard, and human vivisection not unknown (see Singer, *A Short History of Anatomy*, 28, 34–35, and Castiglioni, *A History of Medicine*, 427).

physicians. He dies on the operating table, which has imperceptibly become a dissecting table. What began as an appendectomy ends as an autopsy.

Or even as a punitive dissection. In 1752, five years prior to the public dismemberment of Damiens the regicide before the main door of the Church of Paris, the British Parliament passed an act decreeing that the corpses of selected executed criminals be handed over to the surgeons "to be dissected and anatomized."[143] As one of the "masters of anatomy" at Surgeons' Hall later explained, having himself just dissected a certain malefactor (surnamed Lamb, as chance would have it), "this was to strike a greater terror into the minds of men," although "not by inhuman tortures on the living subject, as in other countries...."[144] The master's next statement might well be intoned anew over the New Testament corpus after more than two centuries of critical dismemberment and dissection: "I think few who now look upon that miserable mangled object before us can ever forget it."[145]

143 Forbes, "To Be Dissected and Anatomized," 490; see further Sawday, *The Body Emblazoned*, 54–66.

144 *Old Bailey Sessions Papers* for October 1759, quoted in Forbes, "To Be Dissected and Anatomized," 491.

145 Ibid.

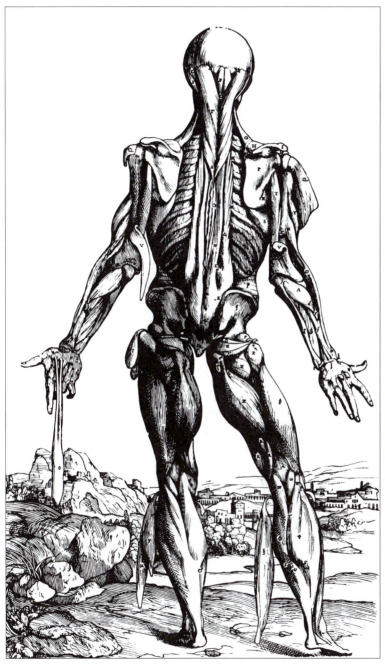

Figure 11: Sixth myological figure of Andreas Vesalius, *De humani corporis fabrica*, (1543).

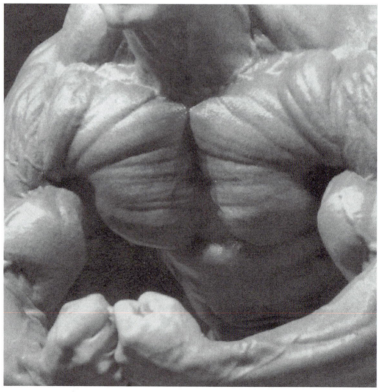

Figure 12: *Bodybuilder Americanus*: View of trapezius, deltoids, and pectoralis major.

resurrection
HORRIBLE PAIN,
GLORIOUS GAIN

O dry bones, hear the word of the Lord. Thus
says the Lord God to these bones: I will cause
breath to enter you, and you shall live. I will lay
sinews on you, and I will cause flesh to come
upon you. . . .

—EZEKIEL 37:5–6

. . . to die is gain.

—PHILIPPIANS 1:21

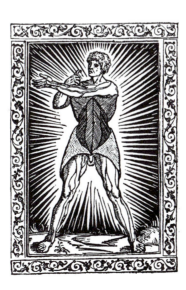

Figure 13:
Self-demonstrating
figure from
Berengario da Carpi,
Isagogae breves
(1523).

Recent editions of *Gray's Anatomy* have employed an unnamed male body-builder to illustrate the superficial musculature of the torso and limbs (see Figure 14).[1] Decidedly at home in this hugely built tome, he displays a level of muscular development that would have made him a phenomenon, indeed a freak, forty or fifty years ago, but today would hardly raise a penciled eyebrow in the most civilized, chrome-bedecked health club.

I quit bodybuilding myself at age thirty-two because it was cutting too deeply into my research time. I set about building up my bibliography instead. The flesh began to peel away from my bones. I cut it into squares, stacked it in piles, and traded it for an assistant professorship.

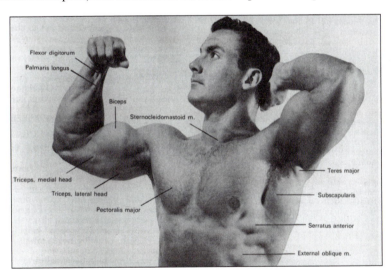

Figure 14: Unnamed model from the 30th American edition of *Gray's Anatomy* (1985).

Bodybuilding was already big when I hung up my lifting belt, but since then it's gotten even bigger.[2] At my local FOOD 4 LESS, *Muscle & Fitness*, the top-selling bodybuilding magazine, has just been promoted from the maga-

1 See Gray, *Anatomy of the Human Body*, 81, 83, 87, 101, 105, 107, 110, 112.

2 It is even making inroads in academe. With the boom in cultural studies and gender studies, and the irruption of queer theory, the iron-pumped physique has increasingly come under the critical gaze. Gaines and Butler, *Pumping Iron*, is the precursor of this phenomenon, and Klein, *Little Big Men*, its most polished product to date. In addition, see Bolin, "Vandalized

zine aisle, at the rear of the store, to the checkout counter.[3] No longer obliged to rub (massive) shoulders with *Hand Gunning* and *Wrestle Madness*, *Muscle & Fitness* can now nestle up to *The National Enquirer* and *Weekly World News* instead.

Weekly World News has regularly featured the Bible, and, more recently, the Dead Sea Scrolls, on its front page ("Infallible Weight-Loss Formula Found in Scriptures, Leading Scholars Claim"; "Dead Sea Scrolls Reveal Our Future! Russia Becomes America's 51st State and Hillary Clinton Elected President in 1996!"; etc.). But while the relationship of *Weekly World News* to the Bible is relatively transparent (the purpose of the latter is to boost sales of the former), that of *Muscle & Fitness*, and bodybuilding in general, to the Bible is less readily apparent.[4] In what follows, however, I hope to show that the relationship is a rich and revealing one.

Pure Muscle

> How can a young man keep his way pure?
> —PSALM 119:9

Hardcore bodybuilding is a purity system, arguably the most rigorous purity system to be found in contemporary Western culture. It begs comparison with the purity codes of the Pentateuch. Such a comparision will put us in a position to tackle the sizeable but slippery body of Yahweh in the Hebrew Bible, our real purpose in this chapter.

The anthropologist Mary Douglas, in her celebrated study of "The Abominations of Leviticus," noted how the dietary prescriptions of Leviticus are coupled with a command to be holy as Yahweh himself is holy (Lev. 11:44–45; 20:22–26; cf. Exod. 22:31; Deut. 14:4–21).[5] It is in relation to this

Vanity," esp. 87–95; Dutton, *The Perfectible Body* ("The question of how we are to understand...the muscular...body is the major concern of this book" [15]); Fussel, *Muscle*, and "Bodybuilder Americanus"; Halperin, *Saint Foucault*, 115–19; Honer, "Beschreibung einer Lebenswelt"; Klein, "Of Muscles and Men"; Lingis, *Foreign Bodies*, 29–44; Miller, *Bringing Out Roland Barthes*, esp. 28–31; Paglia, "Alice in Muscle Land"; Simpson, *Male Impersonators*, 21–43; Tasker, *Spectacular Bodies*, esp. 77–83, 118–23; Thompson and Bair, "A Sociological Analysis of Pumping Iron"; Walters, *The Nude Male*, 293ff.; and Warner, "Spectacular Action."

3 "7,612,000 readers worldwide" is the boast on the cover.

4 Notwithstanding statements such as the following: "I am going to make my magazine [*Muscle & Fitness*] the bible for men and women...who crave healthy, strong and beautiful bodies" (Joe Weider, quoted in Klein, *Little Big Men*, 254). "The champions consider *Flex* the bible of hardcore bodybuilding" (Weider, standing editorial in *Flex*). Weider publishes both magazines.

5 See Chapter 3 of Douglas, *Purity and Danger*. She has returned to Leviticus intermittently over the years (see, most recently, "The Forbidden Animals in Leviticus")

command, first and foremost, therefore, that these puzzling prescriptions must be explained.[6] But what is holiness? Central to Douglas's understanding of holiness is her observation that, in Leviticus, holiness connotes not only separation or setting apart (the root meaning of *qdš*, apparently), but *wholeness* as well.[7] As Jerome H. Neyrey puts it, paraphrasing Douglas: "[W]hat animals may be offered on the altar? Only 'holy' animals, that is, those which are in accord with the definition of a clean animal and which are physically perfect (unblemished) [Lev. 22:17–25].... [W]ho may offer them? Only a 'holy' priest, who has the right blood lines, enjoys an unblemished physical condition, and is in a state of ritual purity [21:16–23]."[8]

Cut to the modern bodybuilding gym, a ritual-sodden space in which the ancient priestly preoccupation with bodily wholeness has achieved the status of an all-consuming obsession. For what drives competitive bodybuilders is the desire for absolute physical wholeness, the complete development of almost every voluntary muscle (for some, such as the sphincter, still go unworked), and thus neck-to-toe physical perfection.

But what is "perfection"? To the untrained eye, the hypermuscular male physique looks like a mass, indeed a mess, of large lumps and bumps, and other prodigious protuberances. To the trained eye, in contrast, each knob, ridge, and protrusion is fully legible, enhancing a whole whose parts have been built up according to laws as unambiguous and inflexible as those that once governed the construction of sonnets.[9]

6 Douglas, *Purity and Danger*, 49.

7 Ibid., 51; cf. 57. Among critical commentators on Leviticus, Gordon J. Wenham is especially convinced by Douglas's thesis (see *The Book of Leviticus*, 23–25, 169, 184, 188, 222–23, 265). In the first volume of his colossal commentary on Leviticus, Jacob Milgrom takes Douglas to task for certain exegetical errors (*Leviticus 1–16*, 649, 666, 720–21, 726–27, 1001). He does, however, concede: "To be sure, her definition of the term 'Holy as wholeness and completeness' [*sic*] is justified" (721). And again: "That wholeness (Hebrew *tāmîm*) is a significant ingredient of holiness cannot be gainsaid" (1001). Milgrom is less happy with the conclusions Douglas draws from this insight (721, 766, 1001), but that need not concern us here.

8 Neyrey, "The Symbolic Universe of Luke-Acts," 277–78; cf. his "Wholeness," esp. 180–82. He continues: "Who may participate in the sacrifice? Only Israelites and only those with whole bodies..." ("Symbolic Universe," 278; cf. 282). Here, however, he is on more uncertain ground (cf. Milgrom, *Leviticus 1–16*, 721, 766, 1001).

9 For practical reasons, my remarks on the bodybuilding physique will be confined to the male of the species. At present, the criteria governing women's competitive bodybuilding are ambiguous in the extreme. For male competitors, the invariable formula for success is muscle mass, symmetry, and definition (more on this below). One cannot have too much mass provided it is symmetrical and defined. But for female competitors there is an intangible fourth ingredient—femininity—that sets strict limits on the amount of muscle that can be amassed. *Flex*, the premier hardcore "musclemag," now features centerfolds of female bodybuilders posing nude. The shots are prefaced by the following statement, which says it all:

> Women bodybuilders are many things, among them symmetrical, strong, sensuous and stunning. When photographed in competition shape, repping and grimacing or squeezing out shots, they appear shredded, vascular and hard, and they can be perceived as threatening.

To begin with the neck, it should be a thick, fluted column of muscle ("'pencil neck' is a bodybuilding term for the weak and impure," as Alan Klein observes).[10] The neck should be framed by fully developed trapezius muscles (known more familiarly as "traps"), two ridges that rise high above the shoulders on either side. The shoulders themselves (deltoids or "delts") should be fully developed in all three heads of the muscle ("cannonball delts" is the cliché regularly invoked to describe the resulting effect). The pectorals ("pecs") should be especially massive, two striated slabs of muscle eternally separated from each other by a deep groove running all the way up to the collar bone (see Figure 16). The latissimus dorsi ("lats"), the workhorse muscles of the back, should sweep upwards and outwards from a wasplike waist, achieving an altogether unlikely width as they approach the deltoids, and branding the bodybuilder's torso with the classic "V"

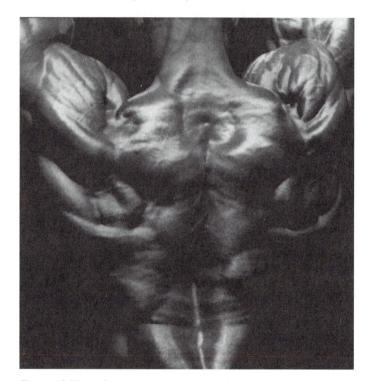

Figure 15: View of trapezius, latissimus dorsi, and erector spinae.

Offseason they carry more bodyfat, presenting themselves in a much more naturally attractive condition. To exhibit this real, natural side of women bodybuilders, *Flex* has been presenting pictorials of female competitors in softer condition. We hope this approach dispels the myth of female-bodybuilder masculinity and proves what role models they truly are. For an incisive analysis of this glaring double standard, see Bolin, "Vandalized Vanity," 87–95.

10 Klein, *Little Big Men*, 264.

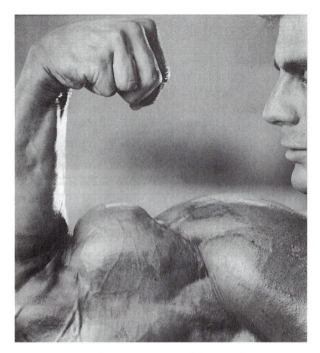

Figure 16: View of biceps, triceps, and forearm flexors.

shape. Across its length and breadth, moreover, the back should be a study in fine detail, each muscle group, major or minor, writhing like copulating serpents beneath the skin (see Figure 15). The biceps at rest should be larger than cantaloupes, and they should rise to a near-pinnacle when flexed. Each head of the triceps muscle should be fully developed, producing the coveted "horseshoe" shape when displayed. The forearms too should be formidable, narrowing to relatively small wrists (see Figure 16). The abdominals ("abs") should be as free of subcutaneous fat as an oak frieze, and should be replete with exquisitely chiseled details. The upper legs should be particularly massive ("tree-trunk thighs" is the cliché of choice here), the quadriceps ("quads") billowing out from the hips like sails, and the hamstrings ("hams") billowing out from below the buttocks like balloons. The quadriceps should also display a high degree of muscle separation, the four heads of the muscle divided by deep rivulets, and the striations on each head showing clearly through the skin. The calves should be colossal, carefully cut diamonds. The overall impression, finally, should be one of absolute symmetry, no one muscle group overpowering any other, but all combining to overpower the spectator instead.[11]

11 John J. Pilch defines "purity" as the value that directs each member of a given culture "to have everything in its place and a place for everything" ("Purity," 151).

Muscle mass and symmetry alone, however, are not sufficient to win major bodybuilding titles. Muscle "definition" is the third indispensable ingredient. In contest condition, the champion bodybuilder is an ambulatory, three-dimensional anatomy chart; each muscle, however minor, is clearly visible through the skin, which, stripped of almost all subcutaneous fat through a dangerously stringent dieting regime, adheres to the muscles as closely as Saran Wrap (see Figure 12).

Hence the startling similarity between the contest-ready bodybuilder and the myological figures of medieval and Renaissance anatomy books—the "musclemen" of Vesalius's *Fabrica*, for example (as they are commonly called). "This illustration presents mainly the anterior aspect of the body, from which I have removed the skin with the fat and fleshy membrane," writes Vesalius, introducing the first muscleman (see Figure 17).[12] Mournfully, the flayed figure flexes his painfully exposed physique, hitting the first of the sixteen poses that Vesalius will demand from him.[13]

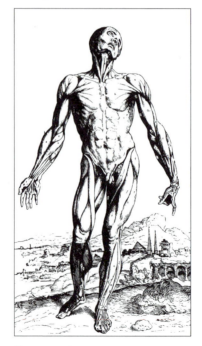

Figure 17: First myological figure from Andreas Vesalius, *De humani corporis fabrica* (1543).

12 Translation from O'Malley, *Andreas Vesalius of Brussels*, 161.

13 All sixteen are reproduced in Saunders and O'Malley, *The Illustrations from the Works of Andreas Vesalius*, 92–120. Vesalius suggests that they embody "muscular and, as it were, ideal representations of men" (*De humani corporis fabrica*, quoted in O'Malley, *Andreas Vesalius of Brussels*, 161).

(Appropriately enough, Charles Gaines and George Butler employ this figure in *Pumping Iron: The Art and Sport of Bodybuilding* to introduce the major muscle groups.)[14] The mannerist illustrator of Juan de Valverde de Humasco's *Historia de la composicion del cuerpo humano* (1556) goes one better, his outrageous *écorché* triumphantly holding his self-flayed flesh aloft in one hand, while his other hand holds the skinning knife—truly a prescient portrait of the modern musclebuilder (see Figure 18).[15]

"It is the business of anthropologists to discover the system of lines, definitions and classifications which makes up the symbolic universe of a given culture," notes Neyrey.[16] In the subculture of competitive bodybuilding, these lines, definitions and classifications are inscribed directly on the flesh itself. To this extent, this subculture can be considered the paradigmatic symbolic universe, since symbolic behavior typically adopts the body as its medium.[17] Bodybuilding can also be regarded as an exemplary purity

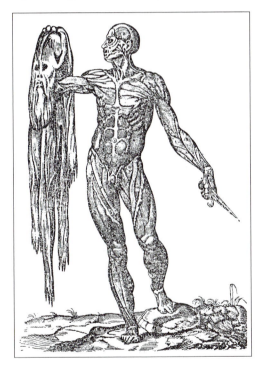

Figure 18: Flayed figure from Juan de Valverde de Humasco, *Historia de la composicion del cuerpo humano* (1556).

14 Gaines and Butler, *Pumping Iron*, 36–37.

15 Valverde's illustrations are discussed in Herrlinger, *History of Medical Illustration*, 123–27.

16 Neyrey, "The Symbolic Universe of Luke-Acts," 274.

17 See Douglas, *Natural Symbols*, esp. vii.

system, as I have already suggested, "purity" here being shorthand for a regulated system of lines, boundaries, and divisions, coupled with an obsession with physical integrity. As such, the competitive bodybuilder would be paradigmatic of the ritually pure subject, his or her symbolic universe being bound up, almost without remainder, with his or her physical person.

Corporeal God

> We shun indeed in words the monstrosity of saying that God is of human form. . . .
> —PHILO, *On the Sacrifices of Abel and Cain* 29.95[18]

> His disciples asked [Hillel the Elder]: "Master, whither are you bound?" He answered them: "To perform a religious duty." "What," they asked, "is this religious duty?" He said to them: "To wash in the bath-house." Said they: "Is this a religious duty?" "Yes," he replied; "if the statues of kings...are scoured and washed by the man who is appointed to look after them,...how much more I, who have been created in the Image and Likeness; as it is written, *For in the image of God made He man*"?
> —*Leviticus Rabbah* 34:3[19]

"Be holy [*qādôš*] as I, Yahweh your God, am holy" is the refrain that runs through Leviticus (11:44–45; 19:2; 20:7, 26; 21:6–8).[20] "Be separate as I am separate." "Be whole as I am whole." Whole of body? But does the God of Israel *have* a body? On this the Hebrew Bible is oddly ambivalent. Let us briefly review the evidence.

The incorporeality of Yahweh is (perhaps) implied by Deuteronomy 4:12, 15–18: "Then Yahweh spoke to you out of the fire. You heard the sound of words but saw no form [*ûtĕmûnāh 'ĕnĕkem rōîm*].... Since you saw no form when Yahweh spoke to you at Horeb out of the fire, take care...so that you do

18. Translation from Colson and Whitaker, eds., *Philo*.
19. Translation from Slotki, ed., *Midrash Rabbah*.
20. This refrain, therefore, is especially characteristic of the Holiness Code (Lev. 17–26); cf. Ackroyd, *Exile and Restoration*, 87ff.

not act corruptly by making an idol for yourselves....”[21] This passage would seem to be alone in suggesting that Yahweh has no body—if indeed it does, for even here there is no outright denial that he has *těmûnāh* (cf. Deut. 5:4). Elsewhere, anthropomorphisms abound: Yahweh strolls in the garden of Eden in the cool of the evening (Gen. 3:8), helpfully shuts the door of the ark behind Noah (7:16), appreciatively inhales the fragrance of Noah’s sacrifice (8:21), curiously descends from heaven to see what is going on at the tower of Babel (11:5), and so on. Even the most passionate assertion of Yahweh’s unrepresentability in the Hebrew Bible—that of Second Isaiah (40:12–26)— is itself riddled with anthropomorphisms.[22]

The most intriguing anthropomorphism in the Hebrew Bible—certainly the most debated—is Genesis 1:26: “Let us make humankind in our image [*ṣelem*], according to our likeness [*děmût*]....” What precisely does this mean? Among the many solutions that have been proposed to the riddle, two in particular stand out.[23] First, the image makes the human being God’s representative or vice-regent, exercising dominion on his behalf over the rest of creation (cf. Gen. 1:28; Ps. 8:3–8). This interpretation, which goes back at least to Chrysostom, on the Christian side,[24] is extremely popular with modern commentators, who appeal to parallel Egyptian and Mesopotamian texts that depict the king as being in the image of a god.[25] Alternatively, the image consists of a physical resemblance between creature and creator.

Of course, these two interpretations are not mutually exclusive. The first specifies the function, consequences, or benefits of the divine image, but it leaves us guessing as to what the image is in itself, as Gordon J. Wenham points out.[26] Might it not consist of a physical resemblance between God and

21 This, at any rate, is how it has generally been interpreted. See, e.g., Weinfeld, *Deuteronomy and the Deuteronomic School*, 198, and, more recently, his *Deuteronomy 1–11*, 204; also Christensen, *Deuteronomy 1–11*, 87.

22 Cf. Cherbonnier, “The Logic of Biblical Anthropomorphism,” 192.

23 For bibliographies of critical studies of Gen. 1:26–28, see Westermann, *Genesis 1–11*, 147–48, and Wenham, *Genesis 1–15*, 26–27. Much of interest on the precritical fortunes of the passage, and of the creation narratives in general, can be found in Jaki, *Genesis 1 through the Ages*, and Robbins, ed., *Genesis 1–3 in the History of Exegesis*.

24 In contrast, Alon Goshen Gottstein notes that “humanity’s dominion over nature, as related to the image of God in Gen. 1:26, finds no echo in rabbinic teaching” (“The Body as Image of God in Rabbinic Literature,” 185).

25 See, e.g., von Rad, *Genesis*, 59–60; Davidson, *Genesis 1–11*, 25; Jacob, *The First Book of the Bible*, 10; Vawter, *On Genesis*, 57–59; Sarna, *Genesis*, 12–13; and Wenham, *Genesis 1–15*, 30–32. The chief dissenter is Westermann (*Genesis 1–11*, 153–54).

26 Wenham, *Genesis 1–15*, 32. Wenham is also correct, it seems to me, in questioning any sharp distinction between *ṣelem* and *děmût* in this verse. Gen. 5:3 suggests instead a high degree of interchangeability between the two terms (ibid., 30; cf. Sarna, *Genesis*, 12). Moreover, as von Rad remarks: “The essential word for the idea of God’s image is obviously *ṣelem* (‘image’), which appears without *děmût* (‘likeness’) in the solemn v. 27; likewise in ch. 9.6” (*Genesis*, 58).

humankind? In support of this disarmingly straightforward reading is the fact that, outside of the passages that concern us (Gen. 1:26 and its "echoes": 1:27, 5:3, 9:6), "(physical) image" is far and away the most common meaning of *ṣelem* in the Hebrew Bible.[27] Furthermore, in Genesis 5:3 Adam is said to have fathered "a son in his likeness [*děmût*], according to his image [*ṣelem*]," presumably a reference to physical resemblance. Like many a commentator before him, however, Wenham squirms at the idea that the *ṣelem* of Genesis 1:26 is solely, or even partly, a reference to physical resemblance.[28] "The OT's stress on the incorporeality and invisibility of God makes this view somewhat problematic (cf. Deut. 4:15–16)," he demurs.[29] But Deuteronomy 4:15–16 is the exception that proves the rule, as we saw earlier; elsewhere in the Hebrew Bible anthropomorphism dominates.[30] "The difficulty is increased," continues Wenham, "if, as is usually the case, the material is assigned to the late P[riestly] source, for this would be too gross an anthropomorphism for exilic literature."[31] But is it any more gross than Ezekiel's description of Yahweh as having "something that appeared like a human form [*děmût kěmarēh 'ādām*]" (1:26; cf. 8:2)—Ezekiel who was himself a priest in exile?[32] Even if Genesis 1:26 does not mean only that God's body resembles a human body, therefore,[33] a compelling case can nonetheless be made for regarding this as part of its "intended" meaning. Gerhard von Rad has made the case exceptionally well. Here is an excerpt from his closing arguments:

27 *ṣelem* means "(physical) image" in Num. 33:52; 1 Sam. 6:5, 11; 2 Kings 11:18 [= 2 Chron. 23:17]; Ezek. 7:20; 16:17; 23:14; and Amos 5:26. (*Děmût* also refers to physical likeness in 2 Kings 16:10 and 2 Chron. 4:3.) *ṣelem* is used figuratively in the two remaining examples of its occurrence, Pss. 39:7 and 73:20, where it means something like "(mere) semblance."

28 The scruple is, of course, an ancient one; see, e.g., the epigraph from Philo above; also Origen, *Homilies on Genesis* 1.13 ("For the form of the body does not contain the image of God"), and Augustine, *On the Soul and Its Origins* 4.20 ("God is not a body. How, then, could a body receive His Image?"). All three writers voice this reservation repeatedly.

29 Wenham, *Genesis 1–15*, 30. Other modern commentators are still more uncomfortable with the "corporeal" interpretation; see esp. Jacob, *The First Book of the Bible*, 10, and Cassuto, *A Commentary on the Book of Genesis*, 1:56.

30 Even in Deuteronomy itself (1:30–31, 34, 37; etc.), although to a lesser extent than in other materials, as Weinfeld has shown through his comparison of the deuteronomic and Priestly traditions (*Deuteronomy and the Deuteronomic School*, 191–209). But that hardly supports a non-anthropomorphic reading of Gen. 1:26–27.

31 Wenham, *Genesis 1–15*, 30. Compare Calvin: "The *Anthropomorphites* were too gross in seeking this resemblance in the human body; let that reverie therefore remain entombed" (*Commentaries on the First Book of Moses*, 1:94).

32 Von Rad remarks: "The equally subtle and careful statement in Ezekiel ('a likeness as it were of a human form'...) seems exactly the prelude to Gen. 1.26" (*Genesis*, 59; cf. Humbert, *Études sur le récit du paradis*, 172).

33 Although for Humbert this is all that it means (*Études sur le récit du Paradis*, 153–63).

The interpretations...are to be rejected which proceed from an anthropology strange to the Old Testament and one-sidedly limit God's image to man's spiritual nature, relating it to man's "dignity," his "personality" or "ability for moral decision," etc. The marvel of man's bodily appearance is not at all to be excepted from the realm of God's image. This was the original notion, and we have no reason to suppose that it completely gave way, in P's theological reflection, to a spiritualizing and intellectualizing tendency. Therefore, one will do well to split the physical from the spiritual as little as possible: the whole man is created in God's image.[34]

Who is permitted glimpses of the divine physique? Candidates include the following (although we are rarely told just what it is that they see):[35] Abraham (Gen. 18:1ff.; cf. 12:7; Exod. 6:3), Jacob (Gen. 32:24–30; cf. 35:1; 48:3; Exod. 6:3), Moses (Exod. 33:17–23; cf. 3:6; 4:24; 33:11; Num. 12:6–8; Deut. 34:10) and seventy-three of his fellow wanderers (Exod. 24:9–11), David (2 Chron. 3:1; cf. 2 Sam. 24:17 [= 1 Chron. 21:16]), Solomon (1 Kings 3:5 [= 2 Chron. 1:7]; 9:2 [= 2 Chron. 7:12]; 11:9), Micaiah (1 Kings 22:19), Job (42:5; cf. 19:26), Isaiah (6:1, 5), Ezekiel (1:26–28; 8:2ff.; 43:2ff.), Amos (7:7; 9:1; cf. 7:1, 4), and Daniel (7:9).[36]

Most are impressed by what they see, none more than Ezekiel, whose attempt to drape the divine form in words carries him to the brink of aphasia:

...seated above the likeness of a throne was something that appeared like a human form. Upward from what appeared like the loins I saw something like gleaming amber, something that looked like fire enclosed all around; and downward from what looked like the loins I saw something that looked like fire, and there was a splendor all around. Like the bow in a cloud on a rainy day, such was the appearance of the splendor all around. This was the appearance of the likeness of the glory of Yahweh [*marēh děmût kěbôd-YHWH*]. (1:26–28; cf. 8:2)

34 Von Rad, *Genesis*, 58. Essentially, this is also how the rabbis saw it; see, e.g., *Genesis Rabbah* 8:10; *Leviticus Rabbah* 34:3 (an epigraph to the present section); *Mekhilta de Rabbi Ishmael. Baḥodesh* 8; *b. 'Aboda Zara* 43b; *Tosefta Yebamot* 8:4; *Midrash Tana'im* (Hoffman ed.) 132. See further Urbach, *The Sages*, 1:226–27, and especially Gottstein, "The Body as Image of God in Rabbinic Literature," who demolishes Marmorstein's claim (*The Old Rabbinic Doctrine of God*, esp. 2.23ff.) that an anti-anthropomorphic school of rabbinic thought also existed. Boyarin, "The Eye in the Torah," and Stern, *Parables in Midrash*, 97–101, are also excellent on rabbinic anthropomorphism.

35 James Barr remarks: "in many cases the describing of the theophanic appearance is less important than the registering of the words spoken; or perhaps more probably,...the recording of the appearance in detail was felt by writers often to be too serious and difficult to attempt except in special cases" ("Theophany and Anthropomorphism," 32).

36 See also Gen. 16:13; Exod. 16:10; Lev. 9:23; Num. 14:10, 14; 16:19; 20:6; 24:4; Judg. 6:12, 22; 13:3, 22; Pss. 11:7; 17:15; 27:4; 84:7; Zech. 3.

Howard Eilberg-Schwartz remarks on this passage: "But even this description does not indicate whether God has a full body. It is not clear, for example, whether God's 'nether' regions are human in form."[37] But Eilberg-Schwartz is being a little too cautious here. Cognate visions in the Hebrew Bible do not hesitate to ascribe feet to Yahweh: "And they saw the God of Israel. And under his feet [*ûtaḥat raglāyw*] there was something like a pavement of sapphire stone..." (Exod. 24:10).[38] Eilberg-Schwartz is correct, nevertheless, in claiming that God's body is "incompletely represented" in the Hebrew Bible.[39] Extreme circumspection in the representation of the divine body is the norm, even when the medium is verbal rather than visual. References to certain synecdochically charged body parts do abound—Yahweh's face, eyes, mouth, ears, arms, hand, and feet are frequently mentioned—but anything approaching a head-to-toe description of the divine physique would be unimaginable in the context of the Hebrew Bible.

Gigantic God

> Have you an arm like God. . . ?
>
> —Job 40:9

> What is the measure of the body of the Holy One, blessed be He. . . ? . . .From His right shoulder to His left shoulder is 160,000,000 parasangs.
>
> —*Shi'ur Qomah* (*Sefer Haqqomah* 51, 91)

It is not left entirely to us, however, to impertinently imagine the unimaginable, to complete the biblical authors' (necessarily) incomplete thoughts on the body of Yahweh, to press the logic of their divine body-talk through to its (possibly unnatural) conclusion. For the unthinkable was long ago thought in the *Shi'ur Qomah*, a Jewish mystical writing extant in five separate recensions, abandoned offspring of a single parent text, according to the late Gershom Scholem, still the towering authority on ancient Jewish mysticism, and Martin S. Cohen, currently the *Shi'ur Qomah*'s most dedi-

37 Eilberg-Schwartz, *The Savage in Judaism*, 193.

38 Some scholars suggest that Exod. 24:10 actually underlies Ezek. 1:26 (see, e.g., Greenberg, *Ezekiel 1–20*, 50). Yahweh's feet also appear in 2 Sam. 22:10; 1 Chron. 28:2; Pss. 18:9; 99:5; 132:7; Isa. 60:13; 63:3, 6; 66:1; Ezek. 43:7; Nah. 1:3; Hab. 3:12; Zech. 14:4. See further Wolfson, "Images of the Divine Feet."

39 Eilberg-Schwartz, *The Savage in Judaism*, 193. He has since suggested that this reticence arose in part from a desire "to veil the divine sex" ("The Problem of the Body," 31–32), an intriguing notion subsequently elaborated at great length in *God's Phallus*, esp. 59–133.

cated investigator. Scholem, however, dated the parent text to the late second century C.E., while Cohen dates it to the seventh century, and Peter Schäfer, another authority on ancient Jewish mysticism, casts doubt on its existence altogether, suggesting that the *Shi'ur Qomah* was never a single text to begin with.[40]

Shi'ur Qomah means "Measure of the Body," the body in question being that of Yahweh.[41] The anonymous authors of the *Shi'ur Qomah* bring to the contemplation of Yahweh's corporeality a sensibility that would not be out of place in the pages of *Flex*, *MuscleMag*, *Ironman*, or *Muscle & Fitness*. For in bodybuilding magazines the gods of the sport are regularly reduced to their anatomical measurements—"In his prime, Arnold's arms measured 22 inches, his chest 57 inches, his waist 31 inches, his thighs 28 inches, his calves 20 inches," and so on. The hero of the *Shi'ur Qomah* is also big—bigger even than Arnold, as it turns out:

> What is the measure of the body of the Holy One, blessed be He, who lives and exists for all eternity, may His name be blessed and His name exalted?... From His right shoulder to His left shoulder is 160,000,000 parasangs.[42] The name of the right shoulder is Tatmehininiah and the name of the left is Shalmehinini'el.[43] From His right arm until His left arm is 120,000,000 parasangs.[44] His arms are folded. The name of His right arm is Gevar Hodiah and the name of the left is Va'ans.[45]

40 See especially Scholem, *Jewish Gnosticism, Merkabah Mysticism, and Talmudic Tradition*, 36–42; Cohen, *Liturgy and Theurgy*, 21–27, 51–76; and Schäfer, "*Shi'ur Qoma*," 75–83.

41 On the correct translation of the title, see Cohen, *Liturgy and Theurgy*, 77–81.

42 Ordinarily a parasang is a Persian mile, equivalent to about 1,320 yards. As the *Shi'ur Qomah* goes on to explain, however, a divine parasang "is four mils, and each mil is ten thousand cubits, and each cubit is three *zĕrātôt*. And His *zeret* fills the entire universe, as it is stated: 'Who measured the waters with the hollow of His hand, and the skies, with His *zeret*'" (lines 105–107). A mil is 5,000 feet, a cubit (in rabbinic literature) either five or six handspans, and a *zeret* either one handspan or the length of the little finger (Cohen, *Liturgy and Theurgy*, 215–16, nn. 4–6).

43 The name of the right shoulder seems to be derived from *tāmāh*, "to wonder at, to be amazed," and probably means "God is my wonder." The name of the left shoulder is obscure (Cohen, *Liturgy and Theurgy*, 212, nn. 56–57).

44 A oddly meager measurement, given the width of the divine shoulders. Elsewhere in the text, the distance from the right arm to the left arm is given as 770,000,000 parasangs, which seems in better proportion (lines 17–18). The discrepancy is not a trivial one, since, for the *Shi'ur Qomah*, knowledge of God's precise measurements is the path to salvation (lines 120–23).

45 *Shi'ur Qomah* lines 51–52, 91–95. The name of the right arm means "man of thanksgiving," the name of the left is obscure (Cohen, *Liturgy and Theurgy*, 212, nn. 59–60). The translation quoted here is Cohen's, who is using the *Sefer Haqqomah* recension of the text (Oxford ms. 1791). The five extant recensions are distributed over approximately thirty-four manuscripts, eight of the most important of which are reproduced in Cohen, *Texts and Recensions*, 183–212.

This statuesque pose, arms folded to accentuate the thickness of the fore-arms, shoulders spread, chest flexed, is also found in the mystical *Hekhalot* literature to which the *Shi'ur Qomah* is closly related.[46] This is the pose that the deity favors when the celestial hosts are assembled before him to sing their songs of adulation.[47] "You are big [*gādôl*] and Your name is big," they cry. "You are strong and Your name is strong.... You are awesome and Your name is awesome...."[48]

How did the *Shi'ur Qomah* come about?[49] Cohen is convinced that it was the product of a "school" of practical mysticism "developed around the set of Biblical descriptions of the godhead rooted in the notion of divine *gĕdullāh*. The adjective *gādôl*, usually translated as 'great' or 'magnificent' was taken at its most literal, and understood to mean simply 'big.'"[50] And so when the psalmist exclaims "Our Lord is *gādôl*" (147:5), for example, he is simply taken at his word;[51] while v. 19 of the same Psalm, understood to be saying "He reveals his dimensions to Jacob," is treated as evidence "that the God of Israel intended all along for His physical dimensions to be known to the elect of Israel."[52] In addition, the description of the body of the bride-groom in the Song of Songs (5:10–15), the bridegroom being identified as Yahweh, may also have provided the authors of the *Shi'ur Qomah* with a scriptural model and pretext for their speculations.[53] The result, in any case, is a text that, as Scholem aptly puts it, "reads like a deliberate and excessive indulgence in anthropomorphism."[54]

Let us ponder some further excesses. The first man was made in the

46 See *Hekhalot Rabbati* 11:2; 12:1.

47 Cf. Cohen, *Liturgy and Theurgy*, 212, n. 58.

48 *Shi'ur Qomah* lines 5, 8, 10.

49 Leaving open the question of whether an *Urtext* of the *Shi'ur Qomah* ever existed. If not, the phrase *Shi'ur Qomah* would simply refer to a category of Jewish esoteric knowledge repre-sented by a cluster of closely related texts (cf. Janowitz, "God's Body," 186).

50 Cohen, *Liturgy and Theurgy*, 9; cf. 104–105. See further Idel, *Kabbalah*, 157–58.

51 Cf. Deut. 7:21; 10:17; 2 Chron. 2:4; Neh. 1:5; 8:6; 9:32; Pss. 77:14; 86:10; 95:3; 99:2; 135:5; Isa. 12:6; Jer. 10:6; 32:18; Dan. 9:4.

52 Cohen, *Liturgy and Theurgy*, 11.

53 See Scholem, *Jewish Gnosticism, Merkabah Mysticism, and Talmudic Tradition*, 37, 39; *Major Trends in Jewish Mysticism*, 63–64; and *Origins of the Kabbalah*, 20. This view seems to have originated with Adolph Jellinek, the nineteenth century compiler of the *Bet Hammidrash*. Cohen's view of the relationship between the *Shi'ur Qomah* and the Song of Songs is more nuanced (see *Liturgy and Theurgy*, 19–20; cf. *Texts and Recensions*, 1).

54 Scholem, *Jewish Gnosticism, Merkabah Mysticism, and Talmudic Tradition*, 36. He adds: "Small wonder that it has deeply shocked later and more sober Jewish thought.... Jewish apologetics has always tried to explain it away" (ibid.). Why not simply ignore it? Because "it was hailed by the Kabbalists of the Middle Ages as the profound symbolic expression of the mysteries of what could be called the Kabbalistic *plērōma*" (ibid.; cf. Scholem, *Major Trends in Jewish Mysticism*, 63).

image and likeness of God, according to Genesis 1:26–27.[55] Independently of the *Shi'ur Qomah* but with impeccable logic (cf. 1 Kings 8:27 [= 2 Chron. 6:18]; 2 Chron. 2:5–6; Isa. 66:1), Adam too turns out to be gigantic in other ancient Jewish sources.[56] We learn that Adam's physical dimensions were truly brobdingnagian, reaching from heaven to earth and from east to west—and not because he was prodigiously obese. For in addition to his impressive size, Adam also possessed the most perfectly formed physique the world has ever seen (cf. Ezek. 28:12ff.).[57] (In these sources, as in modern muscle magazines, the male form is the yardstick of physical perfection. Eve was the most beautiful woman who ever lived, we are told, but "compared with Adam, Eve was like a monkey.")[58] What we have in this oversized Adam is, as Louis Ginzberg long ago observed, a "special application of the idea that all primordial creations came out fully developed."[59] Adam at his creation was twenty years old—an extraordinarily precocious age at which to achieve full muscular development.[60] Alas, Adam's brawn was not matched by his brain. According to numerous other sources, Adam was a brainless hunk at first, devoid of intellect, which the Creator only later installed.[61] In the beginning was the body.

Adam's splendid physique, then, mirrored Yahweh's own—so much so, indeed, that the angels initially mistook him for the deity: "When the Holy One, blessed be he, came to create the first man, the ministering angels mistook him [for God, since he was in God's image]."[62] But a puzzling question now arises. If Yahweh possesses a body, and a perfect body at that—"What blemish in any manner is heard of him? What defect is heard of him?"[63]— why is the vision of God in the Hebrew Bible so often confined to his face?

55 As was the first woman, of course (*'ādām* is used generically here), but that is another story.

56 See, e.g., *Genesis Rabbah* 8:1; 21:3; 24:2; *Leviticus Rabbah* 14:1; 18:2; *b. Ḥagigah* 12a; *b. Sanhedrin* 38b; *Pirqe Rabbi Eliezer* 11. Here and in what follows, I am indebted to Ginzberg, *The Legends of the Jews*, for directing me to many of the sources (see esp. 5:79ff.). Urbach, *The Sages* (esp. 2:787ff.), also proved invaluable in this regard.

57 See *b. Baba Batra* 58a; cf. *Genesis Rabbah* 12:6; *Leviticus Rabbah* 20:2; *Pesiqta de Rab Kahana* 4, 12, 36b, 101a; *Pesiqta Rabbati* 14, 62a.

58 *B. Baba Batra* 58a; contrast *Apocalypse of Sedrach* 7:6–7, which seems to suggest that Eve was more beautiful than Adam. On the androcentrism of rabbinic Judaism, see Boyarin, *Carnal Israel*, esp. 94–106 passim; and further on the fortunes of Eve in rabbinic tradition, see ibid., 77–106, along with Bronner, *From Eve to Esther*, 22–41, and Weissler, "*Mizvot* Built into the Body."

59 Ginzberg, *Legends of the Jews*, 5:78, n. 21.

60 See, e.g., *Genesis Rabbah* 14:7; *Numbers Rabbah* 12:8.

61 See, e.g., *Pesiqta Rabbati* 23 (cf. 46, 115a, 187b); *Yalqut Shim'oni* 34. In part, this tradition seems to have been an attempt to harmonize the two creation accounts: If Adam has already been created in Gen. 1:27, then what is God about in 2:7?

62 *Genesis Rabbah* 8:10; cf. *Ecclesiastes Rabbah* 6:10; *Life of Adam and Eve* 13–15. The translation of *Genesis Rabbah* used here and in what follows is Jacob Neusner's.

63 *Genesis Rabbah* 12:1. *Abot de Rabbi Nathan* A2 even suggests that Yahweh is circumcised.

The answer biblical scholars generally give runs along the following lines. Semantically, *pānîm* far exceeds the standard usages of the English noun "face." *Pānîm* can be a synecdoche for the entire person, for example, as when Yahweh declares to Moses "My face will go with you [*pānay yēlēkû*], and I will give you rest," to which Moses replies, "If your face will not go [*im-'ên pānêkā hōlĕkîm*], do not carry us up from here" (Exod. 33:14–15; cf. 2 Sam. 17:11; Isa. 63:9; Lam. 4:16; Pss. 21:10; 139:7). More generally, *pānîm* is the most common term for "presence" in the Hebrew Bible. In particular, to "see the face" of a king is to be granted an audience with him or to be allowed to enter his presence (e.g., 2 Sam. 3:13; 14:28, 32; 1 Kings 12:6; 2 Kings 25:19; Esth. 1:10). To see the face of Yahweh, therefore, is to be granted the awesome privilege of a personal audience with him (which is only for the very few, as we have seen). More common is the circumlocutionary *niph'al* phrase, "to be seen (i.e., to appear) before the face of Yahweh [*nir'āh lipnê-YHWH*]," which generally denotes a visit to his sanctuary (e.g., Exod. 23:17; 34:23; Deut. 16:16; 31:11; 1 Sam. 1:22; Ps. 42:2; Isa. 1:12).[64]

To content ourselves with such a sensible explanation, however, would be to fall sadly short of the sublime exegetical standards set by the ancient Jewish sages. Surely there are other reasons for Yahweh's agonizing shyness in the Hebrew Bible? Why does he not want anyone to see his body?

The rabbis once again supply the clue, although they fail to follow it through. In our earlier appraisal of Adam's admirable physique, we omitted to note one small abnormality: initially he had two faces, a condition that persisted until the creation of Eve.[65] Indeed, Eve's creation was possible only because of Adam's two faces, say our sources, for one of the faces was female. In each of these sources another tradition is also cited—although essentially it is the same tradition—according to which Adam was created initially as an androgyne: "When the Holy One, blessed be he, came to create the first man, he made him androgynous, as it is said, 'Male and female created he them....'"[66] Subsequently, this androgyne was anesthetized by Yahweh (cf. Gen. 2:21), who had decided to separate it into its male and female components. The surgery, although crude, was a success: "When the Holy One, blessed be he, came to create the first man, he created him with

64 For exhaustive treatments of Yahweh's face, see Nötscher, "*Das Angesicht Gottes schauen*," esp. 3–9, 85–98, 147–70; and Reindl, *Das Angesicht Gottes*, esp. 7–52.

65 See, e.g., *Genesis Rabbah* 8:1; 17:6; *Leviticus Rabbah* 14:1; *b. Berakot* 61a; *b. 'Erubin* 18a; *Tanḥuma Tazria'* 2.

66 *Genesis Rabbah* 8:1 (the Greek term *androgynos* is used in the original). And it is not only in rabbinic texts that the androgynous Adam is found; see, e.g., *Jubilees* 2:14 (although some would say that Adam is not fully androgynous here), and *Apocalypse of Adam* 1:4–5.

two faces, then sawed him into two and made a back on one side and a back on the other."[67]

"Let us make humankind in our image," declares God in Genesis 1:26. This "image" (*selem*) includes the idea of bodily image, as we have seen. The resulting creation is a two-faced androgyne. The implications are interesting, to say the least; it follows that the God of Israel is also androgynous—*physically* androgynous, I hasten to add. The more familiar form of the argument runs something like this: Genesis 1:26–27 is a "plain declaration of the existence of the feminine element in the Godhead, equal in power and glory with the masculine." So wrote Elizabeth Cady Stanton in *The Woman's Bible*, the first volume of which appeared in 1895.[68] A century later, we find Susan Niditch in *The Women's Bible Commentary* (unknowingly?) echoing Stanton's comment: "Without establishing relative rank or worth of the genders, the spinner of this creation tale indicates that humankind is found in two varieties, the male and the female, and this humanity in its complementarity is a reflection of the deity."[69] This now popular interpretation has, I realize, an essential role to play in countering the exclusion of the feminine from Jewish and Christian conceptions of the deity and the subjugation of women that such exclusion has reinforced (see, e.g., 1 Cor. 11:2–16, esp. v. 7). But what this interpretation brackets, it seems to me, is the awkward yet intriguing fact that the biblical God is an embodied being, and the question of whether or not this body is a gendered one.[70] The remainder of this chapter will be staged inside these brackets (a space that is a posing dais as well as a stage, as we shall see).

67 *Genesis Rabbah* 8:1. According to Boyarin, the two-face tradition is best understood as "a specification and interpretation" of the androgyne tradition. The first human, which had genitals of both sexes, "was like a pair of Siamese twins who were then separated by a surgical procedure" (*Carnal Israel*, 43). The myth of a primal androgyne was widespread in the ancient world (see ibid., 36–44 passim; Ginzberg, *Legends of the Jews*, 5:88–89; and Urbach, *The Sages*, 1:228–30).

 Independently of the rabbinic and other ancient sources (which she does not cite), Phyllis Trible has arrived at a similar position, arguing that *'ādām* is "sexually undifferentiated"; prior to the creation of the female it cannot be regarded as male (*God and the Rhetoric of Sexuality*, 80). Trible's *'ādām* is not androgynous, however, for androgyny "assumes sexuality" (141, n. 17). Mieke Bal has developed Trible's argument further in *Lethal Love*, esp. 112–14. For a sympathetic critique of Trible and Bal, see Pardes, *Countertraditions in the Bible*, 20–25, 26–33.

68 Stanton, *The Woman's Bible*, 1:14.

69 Niditch, "Genesis," 12–13.

70 Barr evokes H.H. Rowley's objection that "in the OT God is nowhere conceived of as essentially in human form," but instead is "conceived of as pure spirit, able to assume a form rather than having in himself physical form," only to dispose of it convincingly (Rowley, *The Faith of Israel*, 75; Barr, "Theophany and Anthropomorphism," 32ff.). Cf. Cherbonnier's argument that the biblical God is invisible *de facto* but not *de jure* ("The Logic of Biblical Anthropomorphism," 198–99).

Androgynous God

> Yahweh goes forth like a soldier, like a warrior he
> stirs up his fury; he cries out, he shouts aloud, he
> shows himself mighty against his foes. For a long
> time I have held my peace, I have kept still and
> restrained myself; now I will cry out like a woman
> in labor, I will gasp and pant.
>
> —ISAIAH 42:13–14

> And He who was milked is the Father.
> And She who milked Him is the Holy Spirit.
> Because His breasts were full. . . .
>
> —*Odes of Solomon* 19.2[71]

The God of Israel is an androgyne, a hermaphrodite, a she-male, as we have
seen. But is s/he also two-faced, like the original Adam? The crucial proof-
text here is Exodus 33:18–33. "Show me your glory [*kābôd*] I pray," pleads
Moses, to which Yahweh replies: "I will make all my goodness [*kol tôbî*] pass
before you, and will proclaim before you the name, 'Yahweh'.... But you can-
not see my face [*l'ō tûkal lir'ōt et-pānāy*]; for no one shall see me and live"
(cf. 19:21; Gen. 16:13; Lev. 16:2; Judg. 13:22; Isa. 6:5).[72] He continues, how-
ever, in a more conciliatory tone: "See, there is a place by me where you
shall stand on the rock; and while my glory passes by I will put you in a cleft
of the rock, and I will cover you with my hand until I have passed by; then I
will take away my hand, and you shall see my back [*wěrā'ītā et-'ahōrāy*];
but my face shall not be seen" (33:21–33).[73]

Now, Yahweh would have had a splendid back, fanning out from a near
non-existent waist to a truly awe-inspiring width, every square inch of it
tatooed with exquisitely chiseled details. Brevard Childs remarks: "Even to
be allowed a glimpse of [Yahweh's] passing from the rear is so awesome to
the man Moses that God himself—note the strange paradox—must shield

71 Translation from Harvey, "The Odes of Solomon," 92.

72 Weinfeld remarks: "The underlying imagery of the concept of God's Glory..., the '*Kabod* of
Yahweh,'...is drawn in corporeal and not abstract terms. This is most clearly seen in the book
of Ezekiel.... In Ezekiel ch. 1 the *Kabod* is described as having a human form..."
(*Deuteronomy and the Deuteronomic Tradition*, 201). But it is also seen in Exod. 33:18ff., as
Weinfeld observes (202, n. 3).

73 Although as R.W.L. Moberly remarks, the term '*āhôr* "is not the usual term for 'back' in the
physical or anatomical sense (*gaw, gēw*), but more vaguely means 'hinder part,' thus con-
veying the idea of a view from behind, while being less explicit about exactly what is seen"
(*At the Mountain of God*, 82). This raises the delicate question of what Moses might have
glimpsed in addition to Yahweh's back (cf. Eilberg-Schwartz, *God's Phallus*, 70).

him with his own hand."[74] Should we conclude, therefore, that Yahweh is simply showing Moses one of his better bodyparts? ("Fully, massively, powerfully and deeply developed from the base of the skull to the top of the pelvis and from armpit to armpit, the back is one of a bodybuilder's greatest assets," declares Joe Weider [see Figure 15].)[75] No, for then we too would be taken in by Yahweh's ruse. What is really significant in this scene is not what Yahweh is purporting to show but what he is attempting to hide. And it is not his face that he is attempting to cover up, for he does disclose it elsewhere, even to Moses himself (Exod. 33:11; Deut. 34:10; cf. Num. 12:6–8). Yahweh does not have two faces, therefore. But s/he does have another condition that s/he wishes to conceal. Had Moses been afforded a full-frontal peek at the divine physique, he would have glimpsed a massively muscular chest (naturally), but one that was also unmistakably female.[76]

That we are still on the right track is confirmed by an intriguing tradition preserved in *Hekhalot Rabbati*, a compilation of Jewish esoteric material from the late antique and early medieval periods.[77] A vision of the divine glory forms the near-unattainable summit of the mysticism enshrined in this material. And one of the principal objects of this vision is the *ḥālûk*, a long shirt-like robe in which the deity is draped. This is no mere nightshirt, however. Incomparably radiant (cf. Ps. 104.2; Dan. 7:9b; *1 Enoch* 14:20; 71:10), it is covered with repetitions of the Tetragrammaton, the ineffable name of God.[78] No doubt the *ḥālûk* displays the contours of the divine musculature to good effect. (Former bodybuilder Sam Fussell recalls his own attainment of a godlike physique: "From the back of the bodybuilding magazines, I sent off for XXL T-shirts specially cut for bodybuilders.... Just eighteen months before, these shirts would have billowed over my bony frame.

74 Childs, *The Book of Exodus*, 596. The passage exhibits a "tremendous anthropomorphism," as Childs concedes (ibid.)

75 Weider, *The Weider System of Bodybuilding*, 129.

76 Trible trembles on the threshold of this realization (*God and the Rhetoric of Sexuality*, 61), Biale boldly plunges through ("The God with Breasts," 240–56). Neither of them is reflecting on Exod. 33:18–33, however, but rather on a possible connection between the divine epithet *'ēl šadday* and the word for breasts, *šādayîm* (see esp. Gen. 49:25). See further Cross, *Canaanite Myth and Hebrew Epic*, 54–55.

 What does a massively muscular female chest look like? To find out, pick up any hardcore bodybuilding magazine. Sam Fussell fondly recalls his night of bliss with G-spot, a female bodybuilder: "There was barely room for our lips to meet above our swollen, pumped up chests. When, finally, I reached below her gold dumbbell pendant for her breast, I found it harder than my own" (*Muscle*, 158).

77 On *Hekhalot Rabbati* see Scholem, *Major Trends in Jewish Mysticism*, 45–79 passim, along with several of the essays in Schäfer, *Hekhalot-Studien* (esp. "Identität der *Hekhalot Rabbati*").

78 See especially *Hekhalot Rabbati* 3:4, and see further Scholem, *Jewish Gnosticism, Merkabah Mysticism, and Talmudic Tradition*, 57–64.

Now, they stretched over my mountains of muscle like a taut second skin.")[79]
And yet, even in the moment of supreme bliss, the visionary is left in the
oddly prurient position of having to imagine what God would look like with-
out his clothes. We are now in a position to recognize, however, that the pur-
pose of the *ḥālûk* is less to frustrate the visionary than to keep the divine
breasts a secret.

Certain pieces of our puzzle are are still missing. Let us see if we can
track them down. Yahweh's physique is phenomenal, according to the *Shi'ur
Qomah*. How did s/he get so big? The Hebrew Bible supplies several impor-
tant clues.

First, there is Yahweh's diet, which is composed primarily of red meat;
for the Hebrew Bible does speak repeatedly of sacrifices as Yahweh's food.
Some scholars refuse to take this seriously. Walther Eichrodt, for example,
while conceding that there are indeed frequent references to sacrifices as
Yahweh's food in the Hebrew scriptures, that "the meat is sometimes boiled
before being offered," that salt is used to make it more "tasty," that "[t]he
subsidiary offerings of food and wine...recall the drink and side-dishes
which go with the main meat course," and even that "the Israelite sacrifice
ultimately derives from the conception of the feeding of the deity," never-
theless concludes that "it is extremely doubtful whether this conception was
still a *living* reality in Israel."[80] Jacob Milgrom, too, while conceding that
"the original aim of the sacred furniture of the Tabernacle-Temple—the
table for the bread of presence, the candelabrum, and the incense altar—
was to provide food, light, and pleasant aroma for the divine residence," like-
wise concludes that "these words, objects, and mores are only fossilized ves-
tiges from a dim past, which show no signs of life in the Bible."[81] Against this
anorectic school of thought, Gary A. Anderson argues:

> [O]ne must account for the enormous amount of evidence that portrays Israelite
> sacrifice as food for YHWH.... The altar itself is called "the table of YHWH" [e.g.,
> Ezek. 41:22; 44:16; Mal. 1:7, 12]. The sacrifices can be called "YHWH's food" [e.g.,
> Lev. 3:11, 16; 21:6, 8, 17, 21–22; 22:25; Num. 28:2, 24; Ezek. 16:19; 44:7; Mal. 1:7, 12].
> The aroma of the burnt offerings is said to be "a sweet savor to YHWH" [e.g., Gen.
> 8:21; Exod. 29:18, 25, 41; Lev. 1:9; 6:21; 8:21; Num. 15:3, 13, 14, 24; 18:17]. All of this
> is dismissed by some biblical scholars as ancient relics of Israel's pagan past. No
> account is made of the fact that these terms and phrases are *freely* introduced into
> *all genres* (cultic and epic narratives, psalms, and more) of Israel's literature in all
> periods.... While one can point to a few isolated poetic texts that speak of YHWH's
> freedom from human needs such as food [esp. Ps. 50:13], one must dismiss dozens

79 Fussell, *Muscle*, 68.
80 Eichrodt, *Theology of the Old Testament*, 1:142–43, his emphasis.
81 Milgrom, *Leviticus 1–16*, 440.

of other texts from a variety of genres as unrepresentative, or as relics from an archaic past.[82]

What are the implications of this colossal daily intake of animal protein? Clearly it suggests that Yahweh is a bodybuilder; his or her mass is no more "natural" than that of an Arnold Schwarzenegger.

In the offseason, competitive bodybuilders consume a minimum of 1.25 grams of protein daily for every pound of body weight. "To become a self-willed grotesque is no mean feat," concedes Fussell, referring to the hugely drab and dreary diet of the heavyweight contender, who may inflate to 300 lbs. in the off-season.[83] "With breakfast being the most important meal of the day, I don't hold back and will scarf down a dozen eggs," confesses champion bodybuilder Mike Matarazzo. "With my eggs, I'll have two cups of oatmeal and six or seven wholewheat pancakes...."[84] The second of Mike's five square meals features a further dozen pancakes, along with three turkey patties; his third meal features more turkey patties together with a pound of macaroni; his fourth meal features a pound and three-quarters of flank steak; and his final meal features a second pound and three-quarters of steak, although for variety he will sometimes substitute two pounds of jumbo shrimp (not an option for Yahweh, of course—cf. Lev. 11:10–12; Deut. 14:10).[85]

Needless to say, Yahweh's daily consumption of red meat dwarfs even that of Matarazzo: "Now this is what you shall offer on the altar: two lambs a year old regularly each day" (Exod. 29:38; cf. Num. 28:3; Ezek. 46:13). (Thus it becomes possible to calculate Yahweh's minimal bodyweight. For example, if his or her protein intake is estimated conservatively at one hundred lbs. per day, representing at least 1.25 grams of protein for each pound of body-weight, then the latter must be at least 36,288 lbs.)[86] Far from being "fos-

82 Anderson, "Sacrifice and Sacrificial Offerings," 872, his emphasis. (The examples are my own.) For further details, see Anderson, *Sacrifices and Offerings in Ancient Israel*, 15, of which the above quotation is a distillation. Anderson's adversary in this section of his book (14–19) is Roland de Vaux (*Studies in Old Testament Sacrifice*), whose views match those of Eichrodt and Milgrom.

83 Fussell, "Bodybuilder Americanus," 48.

84 Matarazzo, "Pile It On!," 21.

85 Ibid., 21–24. Compare Gaines and Butler's description of the young Arnold, out for a light lunch, cruising "across a patio of small people eating spinach salads" to his table, where he orders "a side dish of four scrambled eggs with his Stuffed Sirloin Spectacular" (*Pumping Iron*, 52).

86 This does not take into account the additional quantities of meat that Yahweh regularly consumed beyond his basic ration (see esp. Lev. 1–7; Num. 28–29), nor the massive binges in which he sometimes indulged: 700 oxen and 7,000 sheep on one occasion (2 Chron. 15:11), for example, and 22,000 oxen and 120,000 sheep on another (1 Kings 8:63 [= 2 Chron. 7:5]; cf. 1 Kings 8:5). Cf. Matarazzo, "Pile It On!," 24: "I adhere to this [disciplined] meal plan six days a week; the seventh is my cheat day. That's when all the rules are off."

silized vestiges from a dim past, which show no signs of life in the Bible," therefore, the repeated references to animal sacrifices as Yahweh's principal source of nutrition point to some of his or her most profound needs— physical but also psychological, as I shall explain in a moment.

The second clue to the secret of Yahweh's size lies in his or her violent temper. For the biblical God is a God of wrath, as everyone knows. Yahweh's frequent outbursts of fury and accompanying acts of violence (e.g., Num. 16:20–35, 44–49; Deut. 29:19–28; Josh. 7:25–26; 1 Sam. 6:19; 2 Sam. 6:6–7; 24:1, 15; Isa. 63:3–6), coupled with his or her gross physical bulk, suggest only one thing: anabolic steroids. The wrath of God in the Bible is nothing other than "'roid rage." Alan Klein defines the latter as "aggressive behavioral outbursts" induced by excessive steroid use.[87] The substances in question might include methyl-testosterone, thyroid, rhesus monkey hormones, and human growth hormone drawn from the pituitary gland of cadavers.[88] (Would Yahweh have flouted his own prohibition in order to partake of the latter? "Whoever touches anything made unclean by a corpse [*hannōgēʿa bĕkol-tĕmēʾ-nepeš*]...shall be unclean"—Lev. 22:4–6; cf. Num. 19:11ff.) Fussel writes of his own years on steroids: "I was fueled by my own anger, which I seemed to draw from an inexhaustible source.... I wasn't just aching for a fist fight, I was begging for it. I longed for the release. So I strutted through the city streets, a juggernaut in a do-rag, glaring at and menacing anyone who dared meet my eye."[89] Compare Yahweh's admission in Isaiah 63:5–6: "So my own arm brought me victory, and my wrath [*waḥamātî*] sustained me. I trampled down peoples in my anger [*bĕʾappî*], I crushed them in my wrath [*baḥamātî*], and I poured out their lifeblood on the earth."

The irascible Yahweh has not lacked apologists. Gary A. Herion's remarks are typical: "At best, only a very few passages seem to suggest that, like other ANE deities, Yahweh could behave in an irrational manner unrelated to any moral will: Gen 32:23–33 [—Eng 32:22–32]; Exod 4:24–26; 19:21–25; Judg 13:21–23; and 2 Sam 6:6–11.... The objects of such anger tend to be those who, unfortunately, are simply in the wrong place at the wrong time."[90] But as Yahweh became more powerful, he also became more paranoid. Paul D. Hanson has argued convincingly that local rampages such as Isaiah 63:1–6 contain the seeds of a full-blown apocalyptic eschatology, one that "construes the enemy increasingly in terms of absolute evil. All the nations of the

87 Klein, *Little Big Men*, 151; cf. Dutton, *The Perfectible Body*, 280.
88 Fussell, "Bodybuilder Americanus," 49; cf. his *Muscle*, 117–23.
89 Fussel, *Muscle*, 130.
90 Herion, "Wrath of God," 993. Other scholars are yet more defensive of the rage-prone Yahweh; see esp. Heschel, *The Prophets*, 279–98; cf. 299–306.

world would be portrayed as one monolithic force confronting the Divine Warrior Yahweh in the final cosmic battle."[91]

Of course, neither side will have to face the final posedown unaided. Fussell recalls his own final contest: "As soon as I opened the door [of the men's room] I saw him: a short, stocky competitor bending down, the syringe in his palm, his thumb working the plunger, the needle inserted deep into his calf muscle. It was Escline, the last minute inflammatory. 'Shit,' he groaned, feeling the rush as his calves swelled before my eyes."[92] But Fussell's own body was expanding even as he beheld this chemical miracle. Earlier his accomplice, Nimrod, had handed him a vial of pills: "'They're niacin, friend. Pop four of them right now and watch your veins explode....' I threw five of the little white 250-milligram pills down my throat.... Within minutes the niacin kicked in and I was breathing fire."[93] "Oh yes! Oh yes! Judgment Day!" Fussell's other brother-in-iron, Vinnie, screams rapturously when Fussell finally takes the stage, now himself a Divine Warrior.[94]

Yahweh's use of steroids also explains his or her androgyny. Certain steroids can produce a condition known as gynecomastia ("bitch tits" in gym vernacular). To counteract the steroid-induced flood of testosterone, the male body boosts its manufacture of estrogen. "If the estrogen/testosterone ratio is changed in favor of estrogen, dormant mechanisms in the male are stimulated—among them, breast development."[95] Ordinarily this breast development does not advance beyond a bulbous swelling under one or both nipples. In Yahweh's case, however, it seems that the immeasurable quantities of testosterone unleashed in the divine body have produced a prodigious estrogen reaction, leading not just to tumor-like swellings below the nipples, but to bona fide breasts. The effect on Yahweh's genitals may have been just as drastic ("My testicles had shrunk to the size of cocktail peanuts," confesses former Mr. Universe Steve Michalik); on this the Hebrew Bible, and even the rabbis, are (ominously?) silent.[96]

But an important question remains: Does Yahweh actually lift weights? On this the Bible is also silent,[97] but certain mystical and midrashic texts afford us valuable vignettes of the divine workout. Yahweh's arm routine in particular deserves mention ("Have you an arm like God...?" Yahweh asks

91 Hanson, *The Dawn of Apocalyptic*, 207.
92 Fussell, *Muscle*, 229–30.
93 Ibid., 228–29.
94 Ibid., 231. "You're the fucking King of Kings, man!" Vinnie had exclaimed earlier as Fussell awaited his turn (228).
95 Brainum, "Spank That Baby Fat!," 211.
96 Michalik is quoted in Klein, *Little Big Men*, 150.
97 Although it frequently lauds his impressive strength (e.g., Exod. 6:1; 13:3, 9, 14, 16; 15:6; 32:11; Josh. 4:24; 1 Chron. 29:12; Job 9:4; Pss. 29:1; 62:11; 68:34; Jer. 50:34).

Job, flexing his mountainous bicep under the envious mortal's nose—40:9;
cf. Exod. 6:6; 15:6; Deut. 7:19; Ps. 44:3). The *Shi'ur Qomah* reports: "He
hangs *mĕ'ônāh* [the sixth heaven] on His arm." *Midrash Konen* states that
the primeval Torah hangs from the divine arm, and in *Seder Rabbah de
Ber'eshit* we learn that the entire world is suspended from the arm of God.[98]
Throughout, the divine posterior never rises from the seat of the *merkābāh*;
therefore the arm exercise in question would most likely have been seated
dumbbell curls, the unimaginable weight being curled inexorably upwards
in a semicircular arc toward the shoulder, first by one arm, then the other,
while the hosts of heaven look on in awe.[99] His training partner in several of
these texts is the supernal archangel Metatron, himself of singular size.
Metatron recalls: "[T]he Holy One, blessed be he, laid his hand on me and
blessed me with 1,365,000 blessings. I was enlarged and increased in size
till I matched the world in length and breadth" (*3 Enoch* 9:1-2).[100]

3 Enoch testifies eloquently to the effectiveness of Yahweh's arm routine.
The visionary in *3 Enoch* (as so often in the *merkābāh* literature, not least
the *Shi'ur Qomah*) is Rabbi Ishmael, and his celestial tour guide is Metatron.
The seer is shown all the mysteries of the seventh heaven, but the most sub-
lime secret of all, the supreme hidden reality, is "the right arm [*yāmîn*] of
the Omniscient One.... From it all kinds of brilliant lights shine, and by it the
955 heavens were created" (48A:1).[101] *3 Enoch* climaxes with Rabbi
Ishmael's vision of the Arm:

> I went with him, and, taking me by his hand, he bore me up on his wings and
> showed it to me, with all kinds of praise, jubilation, and psalm: No mouth can tell
> its praise, its honor, and its beauty. Moreover, all the souls of the righteous who are
> worthy to see the joy of Jerusalem stand beside it, praising and entreating it, say-

98 See Cohen, *Liturgy and Theurgy*, 253, n. 35, for exact references and further examples.

99 The *merkābāh* is the chariot-throne of Yahweh (cf. Ezek. 1:15ff.). Speculation about the
merkābāh was a wellspring of Jewish mysticism. A remarkably early example of *merkābāh*
mysticism occurs in the Dead Sea Scrolls (see 4Q405 in Newsom, ed., *Songs of the Sabbath
Sacrifice*).

100 The translation is Philip S. Alexander's, from Charlesworth, ed., *The Old Testament
Pseudepigrapha*. Metatron's story (*3 Enoch* 3–16) is the ultimate "before and after" testimo-
nial. He began life as Enoch, who "walked with God; then he was no more, because God took
him" (Gen. 5:24; cf. *1 Enoch* 70–71). Translated into heaven, Enoch acquired a new name—
and a magnificent new body (cf. *2 Enoch* 22:10). The new name appears to derive from Greek
metathronos, "one who stands behind the throne" (Lieberman, "Metatron," 237–39)—stands
there, that is, to assist Yahweh in the unlikely event that he is unable to complete a lift. Other
massively built angels also populate the pages of *3 Enoch* (see 17–26 passim).

101 Here and in what follows, Alexander renders *yāmîn* as "right hand" rather than "right arm"
in his translation of *3 Enoch* 48A. In favoring the right arm, I am following Michael Fishbane,
who explicates *3 Enoch* 48A by way of a parallel passage in *Pesiqta de Rab Kahana* 17:5,
where *yāmîn* clearly means "right arm" rather than the more usual "right hand" ("Arm of
the Lord," 275ff.).

ing three times every day, "Awake, awake! Clothe yourself in strength, arm of the Lord [Isa. 51:9], as it is written, 'He made his glorious arm go at the right hand of Moses'" [Isa. 63:12]. (48A:2–3)

In general, therefore, whether from the biblical texts themselves or from midrashic unfurlings of their contents, it emerges that Yahweh is a God who, from all eternity, has been intent on amassing the defensive trappings of hegemonic hypermasculinity, preeminently an awe-inspiring physique. "Hypermasculinity is an exaggeration of male traits, be they psychological or physical," explains Klein. "Whether one looks at hypermasculinity through a psychological or sociological lens, there is embedded in it a view of radical opposition to all things feminine. Male self-identity is the issue here."[102]

Why would Yahweh have had any doubts about his masculinity? (He was not always androgynous, as we have seen.) His diet again provides the clue. Although monstrous by human standards, Yahweh's daily intake of animal protein would have been positively anorectic relative to that of many of his divine cousins in the Ancient Near Eastern pantheons. The Akkadian god Anu and his consort Antu, for example, along with certain other deities "dwelling in the city of Uruk," enjoyed a daily bill of fare (spread over four meals) of

> twenty-one first-class, fat, clean rams which have been fed barley for two years; two large bulls; one milk-fed bullock; eight lambs; thirty *marratu*-birds; thirty ...-birds; three cranes which have been fed ...-grain; five ducks which have been fed ...-flour; two ducks of a lower quality than those just mentioned; four wild boars; three ostrich eggs; three duck eggs.[103]

This was served with 243 loaves of bread, along with a corresponding quantity of beer, wine, milk, dates, figs, and raisins, and rounded off with a daily supplement of ten additional "fat, clean rams."[104] Yet A. Leo Oppenheim characterizes this particular diet as relatively "human" in scale as compared with "the gargantuan quantities of Egyptian sacrificial repasts."[105] (And it was not only the meals of the Egyptian gods that were gargantuan, according to Ezekiel 23:19–20. Feeling small and rejected, Yahweh bitterly accuses Jerusalem of "remembering the days of her youth, when she played the

102 Klein, *Little Big Men*, 221. For a fascinating look at the figure of David in this light, see Clines, *Interested Parties*, 212–43 (esp. 216–19).

103 Pritchard, ed., *Ancient Near Eastern Texts*, 344.

104 Ibid., 343–44. A colophon dates this unusually detailed text to "the reign of the kings Seleucus and Antiochus" (probably Seleucus I and his successor Antiochus I, whose combined reigns extended from 312 to 261 B.C.E.), but claims it is copied "from tablets which Nabuaplausur, king of the Sea Land, carried off as plunder from the city of Uruk" (345).

105 Oppenheim, *Ancient Mesopotamia*, 188.

whore in the land of Egypt and lusted after her paramours there, whose members were like those of donkeys, and whose emission was like that of stallions [*'ašer běar hamôrîm běśārām wězirmat sûsîm zirmātām*].") The implication is clear: these Egyptian and Mesopotamian deities would have dwarfed Yahweh physically—hence his determination to get bigger at any cost. Being a god, he was spectacularly successful in the attempt—too successful, in fact. So hypermasculine did he become that his body ceased to be merely male, and began to sprout female parts. Far from being assuaged, his insecurities about his masculinity now had something new to feed on— a pair of female breasts.

Yahweh's mammiferous metamorphosis should not surprise us. "[E]very time men try to grasp something consolingly, sturdily, essentially masculine," notes Mark Simpson, "it all too easily transforms into its opposite. Bodybuilding gives an insight into the *flux* of masculinity right at the moment it is meant to solidify it in a display of exaggerated biological masculine attributes."[106] Towering on stage, engorged muscles ready to explode through his taut skin, the male bodybuilder seems a veritable caricature of the ultra-virile male. In all probability, however, as Sam Fussell discloses (and Ezek. 23:19–20 notwithstanding), "he's pumped so full of steroids that he's literally impotent."[107] "But not only is he less of a man at his moment of majesty," continues Fussell, "he's actually more of a woman. Faced with a flood of surplus testosterone, the body reacts by temporarily shrinking the testicles (with a resultant sperm count drop) and releasing an estrogen counterbalance," which can eventually engender a pair of pubescent breasts, as we have seen.[108] "Of course, the bodybuilder reacts with horror to this development, but that is just the horror of the caterpillar finding itself pupating," as Simpson sagely observes. "The bodybuilder does not understand that he was destined all along to be a transsexual butterfly."[109] Suddenly everything about the bodybuilding lifestyle makes perfect sense: the meticulous removal of all body hair, whether by shaving, depilatory creams, or electrolysis (not front-page material in the musclemags); the unrelenting obsession with diet and weight; the fact that musclemags, like girly mags, come wrapped in plastic with fold-out centerfolds of near-naked physiques.[110] Pull the posing trunks off of the entire enterprise and what is revealed? Simpson, who has looked, files the following report:

106 Simpson, *Male Impersonators*, 30, his emphasis.
107 Fussell, "Bodybuilder Americanus," 52.
108 Ibid.
109 Simpson, *Male Impersonators*, 42.
110 See Simpson, *Male Impersonators*, 42, and Fussell, "Bodybuilder Americanus," 46–47; also Dutton, *The Perfectible Body*, 293–307 passim; Lingis, *Foreign Bodies*, 37–38, 42; and Walters, *The Nude Male*, 295. Simpson's chapter on male bodybuilding is tellingly entitled "Big Tits!"

The male bodybuilder dramatizes in his flesh the insecurity, the uncertainty, the enigma of masculinity. He is a living testament not so much to the capabilities of the male body, its phallic power, its massive irresistible virility ("I saw my chest swelling to such gargantuan proportions that no shirt on Earth could contain it"), but rather to…the fluidity of the categories male and female, masculine and feminine, hetero and homo, and the fabulous, perverse tricks they play.[111]

Caught in this quandary, feeling the cool of the blade against his scrotum, Yahweh hit upon a brilliant strategy. He would create an androgynous being in his own image and likeness, and he would do to this being what he longed to do to himself—siphon off its female side and banish it altogether into another body, thereby eradicating it. (Note that the notion that it is not good for the androgyne to be alone comes not from the androgyne itself but from Yahweh—Gen. 2:18.) Thus would Yahweh vicariously effect that which he had failed to accomplish through bodybuilding alone. To complete the therapy, he would later devise a sublimely perfect punishment for his objectified female self, making the woman's body a direct source of pain for her, and giving the man license to dominate her: "To the woman he said, 'I will greatly increase your pangs in childbearing [*harbāh arbeh 'issĕbônēk wĕhērōnēk*]; in pain [*bĕ'eseb*] you shall bring forth children; and your desire shall be for your husband, but he shall rule over you [*wĕhû' yimšāl-bāc*]'" (Gen. 3:16).[112]

The therapy, however, is only marginally successful. Afterwards Yahweh does note a slight increase in his ability to accept his own semi-female physique. In his stronger moments, he is even able to apply female metaphors to himself. In Isaiah 42:14 he styles himself "a woman in labor," for example (cf. 45:10; 66:9),[113] and in Isaiah 66:13 a mother comforting her child (cf. 46:3–4; 49:15; Jer. 31:20).[114] Similarly, in Psalms 22:9 and 123:2 Yahweh is a midwife and a mistress respectively (although he himself is not

111 Simpson, *Male Impersonators*, 42 (the parenthetical quote is from Fussell, *Muscle*, 49). Certain gay bodybuilders, however, are both acutely aware of, and entirely at home with, this ambivalence. For example: "At the 1992 gay pride parade in New York City, there was a handsome, intensely muscular man in full leather regalia, sporting on his distended chest a T-shirt that read, KEEP YOUR LAWS OFF OF MY UTERUS (Sedgwick, *Tendencies*, xi). Further on gay muscles, see Halperin, *Saint Foucault*, 115–18, and Miller, *Bringing Out Roland Barthes*, 28–31.

112 Such, at any rate, is the traditional Christian, infinitely influential way of translating this verse. For a very different translation/interpretation, see Meyers, *Discovering Eve*, 95–121; also Bledstein, "Are Women Cursed in Genesis 3.16?"

113 Taken in context, however, this metaphor is less than tenderly maternal: see 42:13–15, which begins, "Yahweh goes forth like a soldier [*kaggibbôr*], like a warrior [*kĕ'îš milḥāmôt*] he stirs up his fury…."

114 See further Bronner, "Gynomorphic Imagery in Exilic Isaiah," and Gruber, "The Motherhood of God in Second Isaiah."

the speaker in either instance).[115] Overwhelmingly, however, he still continues to refer to himself with male metaphors (designed to feed his fantasies of domination?), such as *father* (e.g., 2 Sam. 7:14; Ps. 2:7; Jer. 3:19; 31:9; Mal. 1:6), *husband* (e.g., Isa. 54:5; Hos. 2:16, 19–20; Jer. 31:32), *king* (e.g, 1 Sam. 8:7; Isa. 33:17; Ezek. 20:33), *military commander* (e.g., Isa. 13:3; Josh. 5:13–15; Joel 2:11), *warrior* (e.g., Exod. 15:3; Isa. 42:13; 63:1–6; Jer. 20:11), and *judge* (e.g., Gen. 15:14; Ps. 75:2; Isa. 3:13; Ezek. 34:17, 20, 22). In addition, he ensures that masculine pronouns are consistently applied to him throughout the Hebrew scriptures. In the end, this unrelenting torrent of masculine pronouns powerfully reinforces "a male image of God, an image that obscures, even obliterates, female metaphors for deity," as even Phyllis Trible is obliged to admit.[116] But that is exactly how Yahweh wants it.

No Pain, No Gain

> For this is why even the very young, by following
> a philosophy in accordance with devout reason,
> have prevailed over the most painful instruments
> of torture.
>
> —*4 Maccabees* 8:1

> What you sow does not come to life unless it
> dies. And what you sow is not the body which is
> to be. . . .
>
> —1 CORINTHIANS 15:36–37

Like father, like son. "Whatever [the Father] does, the Son does likewise [*ha gar an ekeinos poiē, tauta kai ho huios homoiōs poiei*]," explains the Johannine Jesus (5:19; cf. 5:17; 8:28; 12:49; 14:10). The Father bodybuilds, as we have seen, and so Jesus too is a bodybuilder. Indeed, the canonical Gospels may fruitfully be read as bodybuilding manuals, for what all four boil down to is this: *No pain, no gain*—which also happens to be the supreme gym logion and the fundamental syllogism of bodybuilding philosophy.

"No pain, no gain" is what Jesus' passion predictions in the Synoptic Gospels, distilled to their essence, amount to: "the Son of Man must undergo great suffering [*polla pathein*],...and after three days rise again [*anastēnai*]" (Mark 8:31 and pars.; cf. 9:31 and pars.; 10:33–34 and pars.; Luke

115 Through admirable sleight of hand, Trible manages to wrest various other female metaphors for God from the text of the Hebrew Bible (see *God and the Rhetoric of Sexuality*, esp. 31–71; also her "God, Nature of, in the OT").

116 Trible, *God and the Rhetoric of Sexuality*, 23, n. 5.

24:26, 46). "No pain, no gain" is what the Johannine Jesus' analogous announcement amounts to: "Very truly, I tell you, unless a grain of wheat falls into the earth and dies, it remains just a single grain; but if it dies it bears much fruit [*polun karpon pherei*]" (12:24; cf. 1 Cor. 15:35ff.).

Dying to bear fruit—grapefruit-sized biceps, cantaloupe-shaped deltoids, melon-thick thighs—is what bodybuilding is all about. One subjects oneself to a murderous regime, as Jesus did (cf. John 18:11), in order to emerge with a glorious body: "Was it not necessary that the Christ should suffer [*pathein*] these things and so enter into his glory [*doxa*]?" (Luke 24:26; cf. Rev. 1:18).

"The notion that pain is a *sine qua non* of creation is based on an element of truth," writes former Mr. Universe, Mike Mentzer, in a recent article for *Flex*.[117] "The expectant mother willingly endures the travail of maternity, for she understands its necessity," while the expectant bodybuilder "not only endures brutalizing physical stress, but revels in it."[118] The aphorism "'no pain, no gain' is now widely regarded as a sacred bodybuilding truth," he continues. "Enter any serious bodybuilding gym anywhere in the world and the tableau is always the same."[119] And so, without further ado, we are ushered into the Temple itself (about which I shall have much more to say below): "Gold's Gym in Venice, California…. In the center of the crowded main room, made conspicuous by his Brobdingnagian size and the mega-intensity of his workout, is Dorian Yates. His struggle to complete the last rep of a set of cable crossovers is so fierce one would think that the fate of the world depended on it."[120] From the "contorted countenance" of this mes-siah-with-muscles, "giant rivulets of sweat" are cascading

> onto his enormous, striated pecs, which seem distended to the point of exploding. Those watching experience a sense of reverential awe, as Dorian, grunting and quaking, sustains his effort to complete that last rep for several seconds. Upon suc-ceeding, Dorian releases his grip and accepts a towel from the nearest idolater to clear his sweaty brow, then looks at his shaken audience and says, smiling, "Ah, such sweet pain!"[121]

Yates is the reigning Mr. Olympia, the most prestigious title in professional bodybuilding. The death-by-torture that he undergoes daily, buried under a massive mound of iron, but confident of an ever more glorious resurrection (cf. Heb. 11:35b), is the stuff of bodybuilding mythology. "Who can even imag-ine the pain this man subjected his body to over the last twelve months?"

117 Mentzer, "The Furthest Reaches of the Pain Zone," 100. A lightly retouched version of this arti-cle later appeared in *Muscle & Fitness* under the title "Welcome to the Pain Zone."
118 Mentzer, "The Furthest Reaches of the Pain Zone," 100.
119 Mentzer, "Welcome to the Pain Zone," 138.
120 Mentzer, "The Furthest Reaches of the Pain Zone," 100.
121 Ibid.

muses Johnny Fitness, roving reporter for *MuscleMag International*, on the occasion of Yates's second Mr. Olympia win.[122]

Each month, blood-curdling screams can be heard echoing from the (magazine) rack as the gurus of pain 'n' gain push themselves to temporary muscular failure—absolute inability to complete a further "rep"—and beyond. For training to "failure" only brings you to the threshold of the "pain zone." Immediately beyond failure is the torturous terrain of "forced reps," in which your training partner assists you—ever so slightly, ever so sadistically—so that you can complete further repetitions of the movement. Immediately beyond forced reps is the dark realm of "negative reps," in which your training partner (or rather your torturer) raises the weight altogether for you—but only so that you can let it descend with infinite slowness, resisting its downward momentum with all the might remaining in your spasmodically twitching muscles. And immediately beyond negative reps is the fiery furnace of *forced* negative reps, in which the descent of the weight can be slowed at all only with considerable assistance from your training partner, so excruciating has the buildup of lactic acid in the tormented muscles become. To these techniques add "burns," "preexhaustion," "continuous tension," and "cheating" (which, for serious bodybuilders, means finding ways to make the exercise *harder* on the muscles involved) and the screams will come as no surprise.

For these priests of pain, torment is a sacrament. "[T]he last thing I want to do is live with the guilt of a poor workout," confesses one, "so if I can't get it going, I'll give myself a day off, but punish myself extra hard two workouts in a row to more than make up for it. I call this practice *penance shocks*."[123] "I want my pecs to actually hurt the next day, as though I've torn a muscle," confesses another. "Just being sore isn't enough; I want to feel as though I've injured myself."[124]

And when the iron-pumping penitent really does tear a muscle, or rupture a disc, or rip a tendon from the bone, as all too often happens, the drama of training becomes a passion narrative indeed, as in Yates's terrible struggle in 1994 to win his third successive Mr. Olympia title:

> In March he'd torn a ligament that impinged on the rotator cuff in his left shoulder joint.... In April, still in the throes of sorting out his shoulder injury, Yates tore the vastus muscle in his left thigh.... And then in July 12, less than nine weeks before [the contest], just as Yeats thought he'd overcome the worst year of his training life, a searing pain shot up his arm as he repped out on bent rows with 405 pounds. Mr. Olympia had torn his left biceps muscle.[125]

122 Fitness, "Whoomp! It's Dorian...," 46–47.
123 Taylor, "Penance Shocks," 249–50, his emphasis.
124 Schmidt, "A Chest Full of Miracles," 137.
125 McGough, "A Shadow of Doubt," 136. ("The Shadow" is Yates's nickname.)

Miraculously, by the morning of the contest, a 260-pound Dorian, "as hard as ever" and "with improvements to his delts, chest, thigh sweep and overall symmetry," is ready to emerge from the tomb, or at least the dressing room, with his eyes set on the prize.[126] To add insult to injury, however, he is seized with a terrible stomach cramp "after a noontime meal of rice-cakes, a banana and an amino-fuel bar,...making it hard for him to inhale without pain."[127] Ignoring the agony, Dorian steps forth from his tomb—and all those assembled are struck with awe.[128] "Oh, *Jesus*! Dorian was untouchable, completely!" one of his arch-rivals had been heard to exclaim backstage the previous year.[129] This year too his fellow-contestants are issued the stern prohibition, "Do not touch me..." (John 20:17), as they contemplate the master's risen body.

Go(l)d's Gym

> The exterior of the building wanted nothing that
> could astound either mind or eye. For, being
> covered on all sides with massive plates of gold,
> the sun was no sooner up than it radiated so
> fiery a flash that persons straining to look at it
> were compelled to avert their eyes, as from the
> solar rays.
>
> —JOSEPHUS, *Jewish War* 5.5.6 §222[130]

Do bodybuilders have a central shrine or sanctuary, a place of pilgrimage, a temple? They do, as I have already intimated. Their temple is Gold's Gym in Venice, California (and their sacred literature includes *The Gold's Gym Nutrition Bible*, and other muscle-building manuals bearing the holy name of Go[l]d['s]).[131] A secondary shrine and lesser place of pilgrimage is Temple Gym in Birmingham, England. Temple Gym is the training home of Dorian Yates. But whereas Temple Gym is regularly described in the bodybuilding

126 Ibid., 137.

127 Ibid., 138.

128 Bodybuilder Bev Francis remarks on an earlier appearance of Yates: "At the show, I had goose pimples as I announced Dorian, 'cos backstage I'd seen what he looked like—nobody has ever carried that much muscle. When he walked onstage there was such a collective intake of breath from the 1,000 or so crowd that all the oxygen left the auditorium" (quoted in McGough, "Hard Times," 114). Yates's 5'10" frame carries around 295 lbs. in the off-season, which was when the epiphany in question occured.

129 Flex Wheeler, quoted in McGough, "Brutal Beauty," 114.

130 Thackeray's translation.

131 See Kimber et al., *The Gold's Gym Nutrition Bible*.

literature as a dark dungeon, a place of pain, Gold's Gym is regularly described as a sumptuous spectacle.

Everywhere one looks, the colossal temple is lavishly adorned—not with gold, however, as one might expect, but with iron, two million pounds of it in all.[132] Around noon and 6:00 p.m., the hours of worship, the mirror-lined sanctuary is thronged with the faithful.[133] In the midst of this multitude "is a core of 150 to 200 who most characterize bodybuilding subculture. These are the people who not only look and act like bodybuilders—training, dieting, talking iron—but subordinate all other life concerns to bodybuilding."[134] In short, these are the priests.

This hierarchy is reflected in—indeed, maintained by—the design of the temple itself. Flavius Josephus, Jesus' near-contemporary, who has left us two splendid descriptions of the Herodian temple, had prepared me to understand all that I encountered upon entering my first Gold's Gym.[135] (I have yet to behold the original Gold's. Fortunately, however, there are now more than four hundred franchises.) Josephus explains how having negotiated the outermost court, "variegated with paving of all manner of stones," one arrives at "the second court of the temple," which is

> surrounded by a stone balustrade, three cubits high and of exquisite workmanship; in this at regular intervals stood slabs giving warning, some in Greek, others in Latin characters, of the law of purity [tēs hagneias nomos], to wit that no outsider [allophylos] was permitted to enter the holy place, for so the second enclosure of the temple was called. It was approached from the first by fourteen steps.... Beyond the fourteen steps there was a space of ten cubits between them and the wall, forming a level terrace. From this again other flights of five steps led up to the gates. Of these there were eight on the north and south, four on either side, and two on the east—necessarily; since in this quarter a special place of worship was walled off for the women, rendering a second gate requisite....[136]

Ascending the steps from the parking lot to the front entrance of Gold's, I found myself in a large lobby decorated with large posters of large men. My

132 Distributed over 10,000 square feet (so Klein, *Little Big Men*, 22, 30). Klein declines to name this gym, the site of much of his field work for his ethnographic study of bodybuilding. Given the clues strewn throughout his text, however—for example, it is to bodybuilders "what Mecca is to the Islamic faithful" (20)—it can only be Gold's.

133 Ibid., 22.

134 Ibid., 30.

135 See Josephus, *Jewish War* (esp. 5.5) and *Jewish Antiquities* (esp. 15.11), the former written around 79 C.E. (although the last of its seven books may be considerably later), and the latter written a decade or more afterwards—such, at any rate, is the scholarly consensus. The only other detailed account of Herod's temple that we possess is the Mishnaic tractate *Middot* ("Measurements"), completed more than a century later.

136 Josephus, *Jewish War* 5.5.2 §§192–98; cf. *Antiquities* 15.11.5 §§417–19. Here and in what follows, I have made some minor changes to Thackeray's translation.

own lack of largeness loudly declaimed my status as an outsider. I passed through unchallenged, however, and ascended a further flight of steps that led up to the gymnasium proper. I now found myself in an enclosure filled with every kind of aerobic device—stationary bicycles, treadmills, stair machines, ski simulators, and many others whose names were unknown to me. I surmised that this was the Court of Women, for there were no men to be seen within its precincts. Beyond this court was a second enclosure filled with weight machines of every kind, all of them richly decorated with chrome and naugahide. A sign in bold letters proclaimed in English and Spanish "Circuit Training Only." A ragged procession of perspiring men moved grimly from station to station. I surmised that this was the Court of Israel, the men's court.[137]

In the midst of this second court was a large free-weights area containing benches of every kind, squatting racks, pulleys, cables, and other instruments of pain, as well as a veritable forest of weight-trees, each one laden down with its heavy crop of iron plates.[138] I surmised that this was the Court of Priests, for those who labored therein bore the heavy musculature that is the mark of their consecration.[139] This enclosure was entirely bereft of women. Josephus explains that even men who were "not thoroughly pure [*katharos*] were debarred from admission to the inner court...."[140] In the midst of the Court of Priests was the altar of burnt offering. Josephus notes that "all who were of priestly stock but were prevented from officiating by some physical defect [*pērōsis*], were admitted within the partition, along with those free from any imperfection [*holoklēros*]...."[141] However, only "priests who were without blemish [*amōmos*]" were permitted to ascend to the altar.[142]

The altar of burnt offering was a heavily reinforced platform, upon which was a single bench, thicker and more fearsome than its fellows; a single squat rack, also formidable; and a dense grove of weight-trees bearing not only plates of forty-five pounds and under, like those in the Court of Priests,

137 Cf. Josephus, *Antiquities* 15.11.5 §419; *m. Middot* 2.5.

138 We have not strayed far from *4 Maccabees* and the nightmarish workout arena of Antiochus Epiphanes with its "wheels and joint-dislocators, rack and hooks and catapults and caldrons, braziers and thumbscrews and iron claws and wedges and bellows" (8:13).

139 The *Letter of Aristeas* (93) testifies to the horrendous strength of the Second Temple priests: "They divide the legs of the bullocks with both hands, though they are more than two talents in weight [ca. 150 lbs.] in almost every case, and then with an upward movement rip off with each hand in an amazing way a sufficiently large portion with unerring accuracy. The sheep and the goats are similarly treated in a remarkable way, weight and fat notwithstanding" (trans. from Charlesworth, ed., *Old Testament Pseudepigrapha*).

140 Josephus, *Jewish War* 5.5.6 §227.

141 Ibid. 5.5.7 §228; cf. *Antiquities* 15.11.5 §419.

142 Josephus, *Jewish War* 5.5.7 §229.

but hundred-pound plates in addition. Upon this altar, several priests with whole bodies, their loins tightly bound with thick leather girdles, their knees, wrists, and elbows wrapped about with bands of cloth, their palms ritually smeared with chalk, and their upper garments rent to reveal the massive muscles of their torsos, were offering whole body parts to their all-demanding God as they benched, squatted, and deadlifted bar-bending masses of metal.[143] After each deadlift, they would drop the weight to the platform with a mighty crash.[144] The vault of the temple echoed to their fearsome roars as they gripped and raised the awful weights, and I trembled greatly at the sound. Behind the altar of burnt offering, I learned later, is the Holy of Holies, a small room entirely empty but for the mirrors that cover its walls, and prohibited to all save the holiest of the whole.[145]

Colossal Christ

[As to the stature of the messiah:] R. Yudan said,
"He will be a hundred cubits tall."
R. Simeon said, "Two hundred."
R. Eleazar b. R. Simeon said, "Three hundred. . . ."
R. Abbahu said, "Nine hundred cubits."

—*Genesis Rabbah* 12:6[146]

He was, by all accounts, a man of immense
stature and strength with huge lungs rendered the
more powerful by the practice of a kind of orato-
ry. He was certainly nailed to the cross by the
wrists and feet, his body left to leap like a strand-
ed fish to gasp in what air it could, but when
exhaustion came death was still some way off, for

143 Cf. Fussel, *Muscle*, 93–94, on "the heavy leather weight-lifting belt" worn "at all times" in the bodybuilding gym. For the most part, the belts are unnecessary, only needed for support in exercises directly involving the lower back (at which time they are cinched so tightly that the upper body threatens to "pop from the pressure"). Nevertheless, they are "vital for purposes of collective identity…."

144 Fussel describes the deadlift: "[I]t was the deadlift…which was the apotheosis of pain. The wrist straps…dangled from my wrists, until I bent down and wrapped them around the bar at my feet…. I surged upwards with my legs and back, keeping my ass down, rising with the weight until my back straightened and the bar rested on my upper thighs. The pain was unavoidable, a piercing sensation deep within my lower spine. Blood trickled from my scraped shins. Rep after rep, I grimaced and wobbled, while my training partners, arms folded across their chests, nodded their heads in approval" (ibid., 63–64).

145 Cf. Josephus, *Jewish War* 5.5.5 §219.

146 Neusner's translation.

those vast lungs, in the control of the muscles of
a powerful midriff, still held enough air to sustain
life. His legs were not broken, as we know, and
the spear that pierced his side seems to have
ruptured no inner organ. It was as a whole man
that he was removed from that tree of shame,
with full vitality in brief abeyance but ready to be
restored after a healing sleep. It was no great act
of strength for such a colossus to shove aside
the stone that served as a door to his tomb, and
it was like his humor to replace that stone.

—ANTHONY BURGESS, *The Kingdom of the Wicked*

Jesus' own bodybuilding career, while meteoric, was also highly enigmatic.
According to Luke, Jesus was a regular at the synagogue throughout much
of his career (4:15–16, 44; 6:6; 13:10). Near the close of his career, he became
a regular at the temple (19:47). The temple is Go(l)d's, as we have just
seen,[147] and so the synagogues would have been the lesser gymnasia of
lower Galilee and Judea.[148] In addition, Luke frequently depicts Jesus at
prayer—that is, in training—outdoors: on a riverbank (3:21), a mountain
(6:12; 9:28; 22:39, 41–44), or in some other natural setting (cf. 5:16; 9:18;
11:1). Presumably Luke intends us to imagine Jesus doing push-ups, free-
standing squats, and other non-apparatus exercises.[149] We also learn from
Luke that during Jesus' final days in Jerusalem "he was teaching every day
in the temple [*ēn didaskōn to kath' hēmeran en tō hierō*]" (19:47; cf. 21:37;
22:53). Here Luke deftly conjures up an image of the successful, title-win-

147 As Luke's Gospel closes, Jesus' disciples are continually at prayer in the temple (24:53). This
practice extends into Acts: "One day Peter and John were going up to the temple at the hour
of prayer, at three o'clock in the afternoon" (3:1). By now it should be clear how this state-
ment is to be interpreted. We are being told that Peter and his training partner John worked
out regularly in the temple, as did the Jerusalem church in general (Acts 2:46; 5:12, 20, 42;
21:26; cf. Barrett, *The Acts of the Apostles*, 1:176–77). Peter proceeds to cure a man of a phys-
ical defect that would have disqualified him from becoming a priest (see Lev. 21:16–18), and
the would-be trainee joyfully accompanies the pair into the temple (Acts 3:2–8; cf. Johnson,
The Acts of the Apostles, 64–65, 72).

148 These would have been home gyms for the most part. To date, only three excavated syna-
gogues in the Jewish homeland have been securely dated to the Second Temple period, sug-
gesting that private houses were initially used for communal worship (see Levine, ed.,
Ancient Synagogues Revealed; Meyers, "Synagogue").

149 Jesus would have had a good foundation upon which to build. For his trade—that of *tektōn*
(best translated "woodworker"—Mark 6:3; cf. Matt. 13:55)—"involved no little sweat and mus-
cle power. The airy weakling often presented to us in pious paintings and Hollywood movies
would hardly have survived the rigors of being Nazareth's *tektōn* from his youth to his early
thirties" (Meier, *A Marginal Jew*, 1:281).

ning bodybuilder (Christ, Son of God, Son of Man...) with a gaggle of novice trainees in tow.[150]

Recent scholarship on the historical Jesus has tended to depict him as a teacher of a subversive wisdom out to overturn the enabling assumptions of his social world.[151] Certainly, Jesus' training methods would have seemed like a parody of conventional bodybuilding wisdom. Not only did he overeat ("Look, a glutton [*phagos*]..."—Luke 7:34; cf. Matt. 11:19), he also over-trained. Present-day bodybuilders tend to train three days in succession, followed by a day of complete rest to allow the torn-down muscle tissue to rebuild and increase its mass, after which the cycle begins again ("three on, one off" is gym vernacular for this standard training regimen). In contrast, most of Jesus' Jewish contemporaries worked out six days a week, resting only on the seventh ("six on, one off"). According to the combined testimony of the evangelists, however, Jesus himself affected a seven-on system for much of his career, working out even on the Sabbath, and disdaining rest days altogether (Mark 3:1–6 and pars.; Luke 13:10–17; 14:1–6; John 5:1–18; 7:21–24; 9:13–16).[152] His justification for this outlandish routine? "My Father is still working out [*ergazetai*], and so I also am working out [*ergazomai*]" (John 5:17).

But although Jesus ostentatiously overtrained for much of his brief career, he just as ostentatiously undertrained as it drew to a close. This emerges most clearly in John's account of the unpleasant scene in Go(l)d's Gym when Jesus (in the throes of "'roid rage"?) fashions "a whip of cords" (*phrag-ellion ek schoiniōn*) and drives out all the sellers of iron-pumping para-phernalia (belts, straps, wraps), protein supplements, mega-vitamin packs, anabolic booster packs, posing trunks, posing oil, tan-in-a-bottle, muscle-shirts, muscle posters, and muscle-mags (2:14–16). "What sign [*sēmeion*] can you show us for doing this?" his fellow builders ask indignantly, to which Jesus replies: "Destroy this temple, and in three days I will raise it up." "He was speaking of the temple of his body [*ho naos tou sōmatos autou*]," the narrator hastily adds (2:19–21). In other words, Jesus is proposing a one on, three off routine, which would be a once-off routine to boot. "Destroy this body," he is bragging, "blast and blitz every muscle group in a single mega-intensity workout, give me three days to recover, and prepare to be astounded." Jesus is promising the impossible. He is claiming that one work-

150 Cf. Klein, *Little Big Men*, 79: "In walks a Mr. California with a full slate of 'pencil necks' to train. He passes a Mr. Olympia with his ducklings in tow."

151 See especially Crossan, *The Historical Jesus, Jesus*, and *The Essential Jesus*; Funk et al., *The Five Gospels*; Borg, *Jesus* and *Meeting Jesus Again*; Mack, *A Myth of Innocence*, 53–77, and *The Lost Gospel*, 29–39, 105–30; Downing, *The Christ and the Cynics* and *Cynics and Christian Origins*.

152 Cf. Mark 2:23–28 and pars.; *Infancy Gospel of Thomas* 2.1–5.

out is all he needs to get into world-beating shape.[153]

And what a workout it turns out to be! On the appointed evening, following a light, carbohydrate-rich meal and accompanied by his elite trainees, Jesus sets off for an outdoor exercise facility located east of the Kidron valley on a slope of the Mount of Olives (Mark 14:26, 32 and pars.; John 18:1).[154] Almost immediately he runs into difficulties. Peter, James, and John are selected to "spot" Jesus—to assist him if he is unable to complete a lift—but they fall asleep as he is warming up (Mark 14:37 and pars.). And so it is that Jesus finds himself struggling to complete the final repetition in a back-breaking set of squats, the bar bending ominously under the bone-crushing weight, knowing that he can raise the dead but cannot raise this bar another centimeter to save his life, and hearing only the loud snores of his spotters for encouragement. Desperately he prays: "Father, if you are willing, remove this cup from me; yet not my will but yours be done" (Luke 22:42; cf. Mark 14:36; Matt. 26:39)[155]—whereupon "an angel from heaven appeared to him and gave him strength [*ōphthē de autō aggelos ap' ouranou enischuōn auton*]" (Luke 22:43).[156] Gripping Jesus tightly about the waist, the powerful angel hauls him into the upright position. Then he forces Jesus to descend yet again, but slowly (for the negative phase of the lift can also be highly productive, if performed properly, as we have already noted), and helps him once more to drive the weight back up. And so it goes on, repetition after gruelling repetition, the angel all the while roaring encourage-

153 A workout still several years distant, in the Johannine context. The Synoptics, in contrast, place the temple incident near the end of Jesus' career (Mark 11:15–19 and pars.). As Beasley-Murray notes, "There is reasonably widespread agreement now that: *(i)* the event happened only once, not twice...; *(ii)* it took place in the last week of the life of Jesus" (*John*, 38; cf. Meier, *A Marginal Jew*, 1:381). The Synoptics also omit Jesus' boast that he will destroy and rebuild the temple, although they do hint at it elsewhere (Mark 14:57–58 and par.; 15:29–30 and par.; cf. Acts 6:13–14; *Gospel of Thomas* 71; Mark 13:2 and pars.). See further Sanders, *Jesus and Judaism*, 61–76, and *The Historical Figure of Jesus*, 254–62.

154 "If you have the chance to work outdoors (as I sometimes do when I go to the outdoor weight-lifting platform at Venice Beach) do so," advises Arnold. "Working out in the sun tightens your skin and gives you a good color, which in turn adds a great deal to the way you feel about your body" (Schwarzenegger and Hall, *Arnold*, 177).

155 What is this "cup" (*potērion*)? The cup of God's wrath (so, e.g., Cranfield, "The Cup Metaphor in Mark xiv. 36"), God thereby becoming Jesus' bullying, bellowing trainer? Or the cup of suffering (e.g., Brown, *The Death of the Messiah*, 1:168–71)? Or the cup of destiny (e.g., Fitzmyer, *The Gospel According to Luke X–XXIV*, 1442)? Fitzmyer adds: "His reaction refers not only to the physical suffering and psychic anguish that are coming, but includes as well inner distress and doubt about the meaning of it all"—emotions all too familiar to the bodybuilder.

156 Vv. 43–44 are absent from many Greek mss. and ancient versions, and scholars are sharply divided on their "authenticity" (Lukan composition or scribal addition?). For a concise summary of this seemingly interminable debate, see Brown, *The Death of the Messiah*, 1:180–86 (also 1:115–16, where he lists sixteen other attempts to resolve the problem, not counting commentaries). Brown himself favors Lukan authorship of the verses.

ment at Jesus, or insults as necessary.[157] By now Jesus' thighs are turning from rubber into water, and his sweat is "like great drops of blood [*thromboi haimatos*] falling down on the ground" (Luke 22:43).

At this point the workout is mercifully interrupted by the arrival of Judas and his party. Incredibly, however, Jesus' entire body has already begun to grow as a result of this single set of squats.[158] John brings this out most clearly, telling us that the arresting party was literally floored at the sight of Jesus' body: "they drew back and fell to the ground [*apēlthan eis ta opisō kai epesan chamai*]" (18:6).[159]

That was the evening before the contest. Elite bodybuilding contests have two parts, the "prejudging" portion, which takes place before a relatively small audience of afficionados, and in which the winner is usually decided, followed some hours later by the "finals," the choreographed spectacle that most fans pay to see. Early the next day, at the prejudging before Pilate (Mark 15:1ff. and pars.; John 18:28ff.), Jesus is contest-ready.

Jesus' appearance before Pilate is subtly bound up with Yahweh's self-revelation to Moses in Exodus 33, a scene we contemplated earlier. "You shall see my back [*rā'îtā et-'aḥōrāy*]," Yahweh magnanimously announced to Moses (33:23), and although the text unfortunately stops short of describing the divine back, we can be certain of one thing: Yahweh's back was *ripped*, as his Son's would later be. In bodybuilding parlance, the term "ripped" and its synonyms—"cut," "cut to the bone," "shredded," "diced 'n' sliced"—refer to the startling physical condition achieved by the contest-ready bodybuilder whereby he or she becomes a myological figure, a flayed man or woman, an ambulatory anatomy illustration, so much subcutaneous fat having been pared away that even the muscle fibers show clearly through the skin, which has become translucent and "thin as Bible paper. (see Figure 12)."[160] This highly coveted "inside-out" look is achieved partly through injections of diuretics, but principally through a dieting regimen so severe that more than one elite contender has dropped dead on stage, and many others have had to be rushed to emergency rooms.

Approaching his final trial or contest, Jesus adopted even more drastic methods to achieve this shredded look. The instrument of choice was a short scourge with several single or braided leather thongs, as we saw earlier, in

157 Cf. Fussel, *Muscle*, 112: "Forced squat reps. With 600 pounds. Even with my knees wrapped and my back secured with my belt, I couldn't believe the pain."

158 A phenomenon frequently hinted at in bodybuilding literature. For example: "The best squatters—champs...who do 20 reps with 600+ pounds in every thigh workout—learn to love the movement.... And not only have they improved their thighs, but *they've stimulated their entire body metabolism into a naturally anabolic state* when they squat heavily" (Weider, *The Weider System of Bodybuilding*, 208, emphasis added).

159 "...as a man sinks down before the epiphany of Deity" (Bultmann, *The Gospel of John*, 639).

160 Fussell, "Bodybuilder Americanus," 49.

which small metal balls and jagged fragments of bone had been sewn at intervals. One, or preferably two, training partners were required for the procedure (see Figure 2):

> The back, buttocks, and legs were flogged either by two soldiers...or by one who alternated positions.... As the Roman soldiers repeatedly struck the victim's back with full force, the iron balls would cause deep contusions, and the leather thongs and sheep bones would cut into the skin and subcutaneous tissues. Then, as the flogging continued, the lacerations would tear into the underlying skeletal muscles and produce quivering ribbons of bleeding flesh.[161]

"Whoever has seen me has seen the Father," declares the Johannine Jesus (14:9; cf. 1:18; 12:45). Moses's curious glimpse of the divine back (massive, symmetrical, cut to the bone) is thus intimately bound up with Jesus having his own back laid bare at Pilate's prurient behest.[162]

At the prejudging before Pilate, then, Jesus is shredded. His back in particular is unbelievably ripped. Nevertheless, he loses to Barabbas, evidently a crowd favorite (Mark 15:6–15 and pars.; John 18:38–40).[163] Or is it that Pilate himself prefers classic Grecian male physiques—slim, smooth, symmetrical—to "straining, fleshless monsters with ugly knotted and veined torsos, suggesting nothing so much as flayed animals in an abattoir," as one commentator cruelly puts it?[164] Jesus is just such an animal, as we have seen, a slaughtered lamb to be precise (cf. John 1:29, 36; 19:13–16; Acts 8:32ff.; 1 Cor. 5:7; 1 Pet. 1:18–19; Rev. 5:6–13), soon to be hung from a crude cross hewn from a butcher's block. The butcher is Jesus' own Father, as we have also seen, who himself wears posing trunks under his blood-spattered apron.

In any case, at the main event, which takes place on Golgotha soon after the prejudging, Jesus is clearly past his prime. He has peaked a little too

161 Edwards, Gabel, and Hosmer, "On the Physical Death of Jesus Christ," 1457. Blinzler, too, writes of the flesh of the scourged hanging "in bleeding shreds" (*The Trial of Jesus*, 222), as does Barbet: "[S]hreds of skin become detached and hang down. The whole of the back is now no more than a red surface, on which great furrows stand out like marble..." (*A Doctor at Calvary*, 164; cf. 83–84). Compare the illustrations of the deeper muscles in Vesalius's *Fabrica*, in which the superficial muscles are progressively peeled away and hang from the frame in long strips (see Figure 11).

162 Cf. *Acts of John* 90: "[W]e saw [Jesus] at a distance praying. Then I, since he loved me, went quietly up to him, as if he could not see, and stood looking at his hinder parts; and I saw him not dressed in clothes at all, but stripped of those which we [usually] saw [upon him], and not like a man at all" (trans. here and below from Schneemelcher, ed., *New Testament Apocrypha*).

163 Crossan contests the verdict: "I judge that narrative to be absolutely unhistorical, a creation most likely of Mark himself..." (*Jesus*, 141; cf. Brown, *The Death of the Messiah*, 1:811–14, who disagrees).

164 Conway, *The Rage for Utopia*, 188, quoted in Dutton, *The Perfectible Body*, 278.

early. By late afternoon, he is "holding water," the condition every competitive bodybuilder dreads. Small pockets of water have begun to collect under his skin, blurring his razor-sharp muscularity.[165] The crowd is derisive, hissing and booing as he goes through his posing routine (Mark 15:29–32 and pars.). He is dying on stage.[166] Afterwards, a member of the audience will contemptuously pierce his side with a spear, as we have already seen, releasing the pent-up water, along with some blood (John 19:34; cf. 20:25, 27; 1 John 5:6).

"Holding water" is a condition that the authors of Genesis well understood. Bodybuilding is self-creation. The bodybuilder creates his or her physique, just as God created the cosmos. But note the symbolic function of water in the priestly creation account (Gen. 1:1–2:4a). Prior to creation there was not mere nothingness, we are told, but rather water, or watery chaos: "and darkness covered the face of the deep [wĕḥōšek 'al-pĕnê tĕhôm], while a rûaḥ [wind? breath? spirit?] from God swept over the face of the waters ['al-pĕnê hammāyim]" (1:2).[167] Contained and controlled in the act of creation—"Let there be a dome [rāqî'a] in the midst of the waters, and let it separate the waters from the waters" (1:6–7; cf. Job 38:8–11; Pss. 33:7; 104:5–9; Prov. 8:27–29; 2 Enoch 3:3; Testament of Levi 2:7)—this same chaos is later released to flood the earth and dissolve the work of creation: "all the fountains of the great deep [kol-m'ayĕnôt tĕhôm rabbāh] burst forth, and the windows of the heavens [wa'arubbot haššāmayim] were opened…" (Gen. 7:11–24; cf. 8:2).[168] "Holding water," therefore, is less the *containment* of water than its *release* (the term is misleading), "water" symbolizing everything that threatens to blur the orderly lines, divisions, and separations that creation has so carefully established ("let there be a separation [wîhî mabdîl]"—1:6; cf. 1:7, 14, 18). For the bodybuilder, the lines, definitions, and classifications that constitute his or her symbolic universe are engraved directly on the flesh itself, as we saw earlier, with the crude tools of the iron

165 Indeed, the inconsistency of Jesus' condition generally is hinted at in the *Acts of John* 89: "when I reclined at table he would take me to his breast, and I held him to me; and sometimes his breast felt to me smooth and soft, but sometimes hard as rock…."

166 Jesus also lost his first contest, the Mr. Nazareth: "At the key rhetorical points in the narrative, beginning and ending, Jesus is shamed. His own townspeople of Nazareth deny him honor at his inaugural appearance there ([Luke] 4:16–30)" (Malina and Neyrey, "Honor and Shame in Luke-Acts," 53; cf. Malina and Rohrbaugh, *Social-Science Commentary on the Synoptic Gospels*, 164–65, 308–11).

167 The primeval deep is a commonplace of ancient cosmogonies; see Pritchard, ed., *Ancient Near Eastern Texts*, 60–72; Reymond, *L'eau, sa vie, et sa signification*, 167–98; and Cohn, *Cosmos, Chaos and the World to Come*, esp. 6ff., 45–49, 123–26, 132–34.

168 As commentators have regularly noted; see, e.g., von Rad, *Genesis*, 128; Cassuto, *The Book of Genesis 1–11*, 2:97; Sarna, *Genesis*, 55; and Wenham, *Genesis 1–15*, 181–83. When heaven and earth are recreated in Rev. 21:1, therefore, the threatening deep is abolished: "the sea was no more [hē thalassa ouk estin eti]" (see Caird, *The Revelation of Saint John*, 65–69, 262).

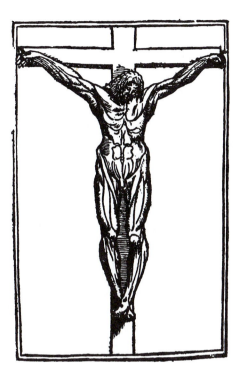

Figure 19: Crucified Christ used to illustrate
the anterior musculature in Berengario da
Carpi, *Isagogae breves* (1523).

trade: the barbell, the dumbell, and the kitchen scales. Hence the pain that
is inseparable from gain.

Jesus is drowning on Golgotha, then. But his posing routine is disinte-
grating in other ways as well. Despite his water retention, he still looks like
a flayed man, or a side of lamb (as the anonymous illustrator of Berengario
da Carpi's 1523 anatomy book, *Isagogae breves*, intuitively recognized; he
used the crucified Christ to illustrate the superficial anterior muscles of the
body [see Figure 19]). But the brutal contest preparations have exacted a
terrible toll on Jesus' system.[169] His body is convulsed by a severe cramping
spasm. He screams in agony and expires (Mark 15:37 and pars.; *Gospel of
Peter* 5.19). He is carried from the stage and placed in a tomb (Mark 15:46
and pars.; John 19:38–42; *Gospel of Peter* 6.23–24).

169 Cf. Edwards, Gabel and Hosmer, "On the Physical Death of Jesus Christ," 1458: "The severe
scourging, with its intense pain and appreciable blood loss, most probably left Jesus in a
preshock state. Moreover, hematidrosis had rendered his skin particularly tender….
Therefore, even before the actual crucifixion, Jesus' physical condition was at least serious
and possibly critical."

Three days later he reemerges, just as he said he would. He has grown beyond all belief: "When they saw him, they worshiped him; but some doubted [*hoi de edistasan*]" (Matt. 28:17; cf. Mark 16:14; Luke 24:38). So transformed is he, indeed, that several of his former training partners fail completely to recognize him (Mark 16:12; Luke 24:15–16; John 20:14; 21:4). In general, however, the evangelists shrink from describing the physical condition of the Risen One. All we are allowed are tantalizing clues, such as Jesus' own proleptic pronouncement, prior to his passion, that "the stone that the [body?]builders rejected has become the cornerstone [*lithon hon ape-dokimasan hoi oikodomountes, houtos egennēthē eis kephalēn gōnias*]" (Mark 12:10 and pars.; cf. Acts 4:11; 1 Pet. 2:7; *Gospel of Thomas* 66), apparently a reference to the risen Lord's rock-hard condition and chiseled muscularity.[170] It is left to the *Gospel of Peter* to suggest the true dimensions of the risen Jesus:

> Now in the night in which the Lord's day dawned, while the soldiers were on guard,…a loud noise came from the sky, and they saw the skies open up and two men come down from there in a burst of light and approach the tomb. The stone that had been pushed against the entrance began to roll by itself and moved away to one side; then the tomb opened up and both young men went inside. Now when these soldiers saw this, they roused the centurion from his sleep, along with the elders…. While they were explaining what they had seen, again they see three men leaving the tomb, two supporting the third, and a cross was following them. The heads of the two reached up to the sky, while the head of the third, whom they led by the hand, reached beyond the skies. (9.1–10.3)[171]

Himself now brobdingnagian in bulk, Jesus has become the new Adam (1 Cor. 15:45, 47; cf. Rom. 5:14).

A certain aphorism of Nietzsche is invoked with mantric regularity in bodybuilding circles: "That which does not kill us, makes us stronger."[172] Jesus has taken this principle to its logical extreme, adding, in effect: "And that which *does* kill us, makes us stronger still."[173] Thus it is that when the Risen One finally comes to contend for the Mr. Universe title, he is the only contestant on stage (nobody dares to stand beside him), and has the title conferred upon him by the Supreme Judge before a vast audience:

170 Gundry speaks of the "vindication of the son, now a stone" (*Mark*, 690).

171 Translation from Miller, ed., *The Complete Gospels*. In the *Acts of John* 90, Jesus' head also "stretche[s] up to heaven," and his strength is such that when he tweaks John's beard, the apostle suffers pain for thirty days. "Lord, if your playful tug has caused such pain, what [would it be] if you had dealt me a blow?" groans John. A second-century carving on a carnelian similarly "shows a superhuman Christ on the cross almost twice as tall as the surrounding twelve apostles" (Brown, *The Death of the Messiah*, 2:947).

172 See Fussell, *Muscle*, 122, and Klein, *Little Big Men*, 261.

173 Cf. *Apoc. James* 6.17–18: "For the kingdom of God belongs to those who kill themselves."

"Therefore God has highly exalted him and given him the name that is above every name [*to onoma to hyper pan onoma*], so that at the name of Jesus every knee should bend, in heaven and on earth and under the earth, and every tongue should confess that Jesus Christ is Lord, to the glory of God the Father" (Phil. 2:9–11).[174] Jesus has joined Yahweh on the celestial posing dais.[175]

We are ready for the vision of God.

Heaven Can Be Hell

And the throne of God and of the Lamb shall be
in it, and his slaves shall serve him. . . .

—REVELATION 22:3

In *The Vision of God*, an extraordinarily erudite tome first published in 1931, Kenneth E. Kirk, Bishop of Oxford, set out to demonstrate that the dictum, "the end of life is the vision of God," which he takes to be a New Testament doctrine, has, through the ages, "been interpreted by Christian thought at its best as implying in practice that the highest prerogative of the Christian in this life as well as hereafter, is the activity of *worship*...."[176] And Kirk does succeed admirably in showing that elite Christian theologians, at least until the Reformation, tended overwhelmingly to view the vision of God as being indissolubly bound up with the worship of God.

But what is the New Testament basis for the belief that "the end of life is the vision of God"? Having disposed of various "Old Testament anticipations" of the dictum, along with sundry pagan anticipations of it, Kirk proceeds to survey the New Testament at some length, before turning into the daunting expanse of post-biblical Christian theology and following selected currents upstream to his own time.[177] But although he devotes stretches of text to the

174 "If he decided to spread his lats, he could hide any two of [his competitors]," as Gaines and Butler remarked of former Mr. World, Mike Katz (*Pumping Iron*, 80). But who are these would-be contestants "compelled to admit that He [Jesus] is the victor" (Martin, *Carmen Christi*, 261)? They are "the mighty angelic powers" in general, and the demonic powers in particular, as Martin persuasively argues (258–64).

175 Lohmeyer has remarked how Phil. 2:9–11 is identical in its symbolic meaning with the throne-room scene in Rev. 4–5 (*Die Offenbarung des Johannes*, 52–53). The latter scene, in which the supreme embodiment of absolute power—a male body, as it turns out—demands and receives abject worship, will be the focus of the two final sections.

176 Kirk, *The Vision of God*, ix, his emphasis. The phrase "the end of life is the vision of God" is adapted from Irenaeus, *Against Heresies* 4.20.7.

177 A more restricted perusal of the vision of God in the New Testament, confined mainly to the Synoptic Gospels (and frequently critical of Kirk), can be found in George, *Communion with God in the New Testament*, 93–122.

Synoptic Gospels and the Fourth Gospel, the letters of Paul and the letter to the Hebrews, and even the letter of James, he hardly mentions the book of Revelation except in passing—a curious omission indeed, for in what other New Testament text are the vision and worship of God so fully fused? Celestial life, according to Revelation, is the beholding of God, and the beholding of God irresistibly induces the unending worship of God (4:8–11; 5:13–14; 7:9–12, 15; 8:3–4; 11:15–18; 14:1–3; 15:2–4; 19:1–8; 21:22–23; 22:3–5).[178]

What does it mean to worship God? The essence of divine worship, for Kirk, is an overwhelming sense of one's own smallness, a profound sense of one's own insignificance, a painful sense of one's own imperfection, relative to the immensity, power, and perfection of the deity. Gazing at God, the worshiper "sees himself to be nothing.... Worship tells us much good of God, but little good of ourselves.... For that we may praise Him, but it leaves us nothing upon which to pride ourselves."[179]

A more recent book by Richard Bauckham, an authority on ancient Jewish and Christian apocalyptic literature, returns repeatedly to the topic of worship in Revelation.[180] Bauckham's understanding of worship echoes that of Kirk (and innumerable other theologians). Commenting on the vision of the heavenly throne room in Revelation 4, for example,[181] Bauckham remarks:

> Especially prominent in the vision is the continuous worship by the four living creatures and the twenty-four elders. It is a scene of worship into which the reader who shares John's faith in God is almost inevitably drawn. We are thereby reminded that true knowledge of who God is is inseparable from worship of God. The song of the four living creatures and the hymn of the twenty-four elders express the two most primary forms of awareness of God: the awed perception of his numinous holiness (4:8; cf. Isa. 6:3), and the consciousness of utter dependence on God for existence itself that is the nature of all created things (4:11). These

178 Cf. 5:8–12; 12:10–12; 14:7; 16:5–7; 19:10; 22:8–9. Unending worship is a frequent feature of apocalyptic depictions of heaven (see, e.g., *1 Enoch* 39:12–14; 40:2; 71:7; *2 Enoch* 21:1; *Testament of Levi* 3:8).

179 Kirk, *The Vision of God*, 448.

180 Bauckham, *The Theology of the Book of Revelation*. This slim book is a companion to Bauckham's bulkier *The Climax of Prophecy*. The former is distinguished from the latter by a strong apologetic thrust. It attempts to argue the relevance of Revelation for the current theological scene, one frequently inimical to it.

181 A scene that Jürgen Roloff rightly describes as "the theological center of the book" (*The Revelation of John*, 68).

most elemental forms of perception of God not only require expression in worship: they cannot be truly experienced except as worship.[182]

There was a time when I would have endorsed such sentiments enthusiastically, indeed gambled heavily on their veracity. For what do the Pentecostal prayer meeting, with its ecstatic cacophony of tongues, or the Cistercian cloister, with its ethereal chorus of plainsong, purport to be if not antechambers to the celestial throne room, and I have lingered long in both waiting rooms. But I must confess that my reactions to such sentiments have since been refashioned by a series of texts (what can one do in a waiting room but read?), subtle philosophical texts and not-so-subtle psychoanalytic texts, texts as ingenious and insidious as Derrida's "Différance," or as crude and rude as Freud's *The Future of an Illusion*. I must be a simple fellow, for the latter in particular spoke to me powerfully, or rather roared in my ear. Hurriedly honing a blunted blade that had once belonged to Feuerbach, Freud argues that the worshiper in his or her relationship to the divine Parent faithfully mirrors the child's relationship to its own all-too-human parents—its pervasive sense of its own smallness relative to the towering stature of its parents, its painful sense of its own powerlessness relative to the apparent omnipotence of its parents, its profound sense of its own dependence on its parents for its day-to-day survival, indeed for its very existence.[183] If God has so often been regarded as a Father in our culture, Freud slyly implies, it is because the father has so often been regarded as a god in our homes. Issuing from such a domestic shrine myself, this line of argument proved extremely seductive to me.

Bauckham may come from a happier home. Dubiously he cites the tendency of some recent theologians, feminist theologians in particular, to castigate traditional images of the sovereignty of God as projections of

182 Bauckham, *The Theology of the Book of Revelation*, 32–33. Revelation's heavenly liturgy, frequently seen as a projection of early Christian liturgy, has been a frequent focus of scholarly attention; see, e.g., Mowry, "Revelation 4–5 and Early Christian Liturgical Usage"; Shepherd, *The Paschal Liturgy and the Apocalypse*; Peterson, *The Angels and the Liturgy*, 1–13; and Thompson, *The Book of Revelation*, 53–73.

183 Freud, *The Future of an Illusion*, 17ff., an argument anticipated in *Leonardo da Vinci and a Memory of His Childhood*, 123, and a 1910 letter to Jung (Freud, *The Freud/Jung Letters*, 283–84), and reechoed in *New Introductory Lectures in Psycho-Analysis*, 168. The "illusion" of the title alludes to Feuerbach's famous claim that the relation of reason to religion "amounts only to the destruction of an *illusion*" (*Das Wesen des Christenthums*, 408, his emphasis). In later years Freud recanted, suggesting that his view of Jewish and Christian religion as the infantile projection of omnipotence onto a divine Father had been ill-founded ("Postscript" to *An Autobiographical Study*, 72). But here Freud is merely preparing the way for his own deeply personal and largely positive revaluation of Judaism in *Moses and Monotheism* (see the reading of the latter presented in the Bible and Culture Collective, *The Postmodern Bible*, esp. 192ff.).

patriarchal domination.[184] For Bauckham, Revelation is entirely innocent
of such charges:

> Revelation, by avoiding anthropomorphism, suggests the incomparability of God's
> sovereignty. In effect, the image of sovereignty is being used to express an aspect
> of the relation between God and his creatures which is unique, rather than one
> which provides a model for relationships between humans. Of course, the image
> of the throne derives from the human world, but it is so used as to highlight the
> difference, more than the similarity, between divine sovereignty and human sov-
> ereignty. In other words, it is used to express transcendence. Much of the modern
> criticism of images of this kind seems unable to understand real transcendence.
> It supposes that the relation between God and the world must be in every respect
> comparable with relations between creatures and that all images of God must
> function as models for human behaviour. It is critical of images of transcendence,
> such as sovereignty, but *it takes transcendence to mean that God is some kind of*
> *superhuman being alongside other beings.* Real transcendence, of course, means
> that God transcends all creaturely existence. As the source, ground and goal of all
> creaturely existence, the infinite mystery on which all finite being depends, his
> relation to us is unique.[185]

And yet my suspicions persist. What if at the core of all these subtle
scholastic formulations there were nothing but a superhuman being after
all—an embarrassingly muscular being, insatiably hungry for adulation,
but subjected to a stringent diet throughout centuries of (unsuccessful)
Christian apologetics aimed at stripping away its all-too robust flesh? The
God of Revelation might be just such a being, just such a creature, just such
a projection.

To begin with, Revelation is not as free of anthropomorphism as
Bauckham suggests. After all, the being seated on the throne *is* human in
form: "Then I saw in the right hand [*epi tēn dexian*] of the one seated on the
throne a scroll" (5:1; cf. 5:7).[186] "Revelation 5:1 is closely modelled on
Ezekiel 2:9–10," as Bauckham himself observes.[187] The latter passage
begins: "I looked, and a hand [*yad*; LXX: *cheir*] was stretched out to me, and
a written scroll was in it." What is more, John's general "account of his vision
of God [Rev. 4] is considerably indebted to Ezekiel's vision of the divine

184 He singles out Hampson, *Theology and Feminism*, 151–53, and McFague, *Models of God*,
63–69, in particular.

185 Bauckham, *The Theology of the Book of Revelation*, 44–45, emphasis added.

186 R.H. Charles, having twice noted how John "avoids anthropomorphic details" (*The Revelation
of St. John*, 1:113; cf. 115), ironically goes on to elucidate *epi tēn dexian* in the following terms:
"The book-roll lies on the open palm of the right hand, not in the hand" (136).

187 Bauckham, *The Climax of Prophecy*, 246; cf. 248–49.

throne (Ezek. 1)."[188] What are we to conclude? That the enthroned figure that John "saw" in his vision was one and the same as the enthroned figure that Ezekiel "saw" in his? Isn't that what John would want us to conclude?[189] And what Ezekiel saw, seated upon the throne, was *děmût kěmarēh 'ādām* (literally, "a likeness like the appearance of a man"—1:26).[190]

In fairness to Bauckham, however, it must be admitted that John does refrain from attempting to describe the divine physique, preferring to focus attention instead on the adulation and self-abasement of the celestial audience eternally privileged to behold it (4:8–11). Among contemporary cultural and subcultural spectacles, it is the bodybuilding posing routine that best encapsulates the surreal scenario that Revelation sets before us. Note, for example, the static quality of the figure who is the principal focus of worship in Revelation.[191] From his first to his last appearance in the book, he sits immobile and almost aphasic on his throne (he speaks only in 1:8 and 21:5–8).[192] Alan Klein has remarked on the "static, statuesque nature of bodybuilders in competition...."[193] The typical posing routine is less a spectacle of motion than a succession of stills; the bodybuilder hits and holds a pose, wringing every last drop from it, massive muscles straining, face frozen in a grimace posing as a smile, before proceeding to the next pose. The God of Revelation is similarly engaged in a posing exhibition. He is the static, statuesque embodiment of absolute power, and his celestial audience cannot get enough of him. His silence further accentuates his statuesque demeanor. Indeed, seen in this (heavenly) light, he looks very much like an idol (a matinee idol?), despite the author's iconophobic attempts to prevent this very thing from happening.

188 Ibid., 246. For a more detailed discussion of the relationship between Ezek. 1 and Rev. 4, see Rowland, *The Open Heaven*, 222–26.

189 Cf. Rowland, *The Open Heaven*, 226–27.

190 Which the Septuagint renders as *homoiōma hōs eidos anthrōpou*. M. Eugene Boring offers a different, but not unrelated, interpretation of "the one seated on the throne": "John intentionally withholds any description of the central figure on the throne, leaving a blank center in the picture to be filled in by the figure of the Lamb—yet another means of affirming that God is the one who defines himself by Christ" (*Revelation*, 103). By implication, then, the dimly described figure on the throne points us back, not only to Ezek. 1, but also to Rev. 1:13–16, the dazzlingly described figure of the "one like a Son of Man."

191 Jesus is the secondary focus of legitimate worship in the book (see esp. 5:8–14). See further Bauckham, *The Theology of the Book of Revelation*, 58–63, and *The Climax of Prophecy*, 118–49, esp. 139.

192 Unless the anonymous interjections in 11:12 ("Come up here!") and 16:7 ("It is done!") can also be attributed to God.

193 Klein, *Little Big Men*, 257. It is not for nothing that the (Caucasian) bodybuilder's tan-in-a-bottle is known as "bronzer," for the bodybuilder is a bronze statue (Fussell, "Bodybuilder Americanus," 45). Cf. Rev. 1:15 and 2:18 where the awesome figure of the risen Christ has "feet like burnished bronze [*chalkolibanos*]." The model for the statue that Jesus has become (the angel of Dan. 10:4ff.) is similarly said to have "arms and legs like the gleam of burnished bronze [*neḥōšet qālāl*; LXX: *chalkou stilbonta*]" (cf. Dan. 2:32; Ezek. 1:7).

God's silence also accentuates his likeness to the bodybuilder. "Like the cartoon without a caption, the hypermuscular body...is supposed to communicate without an act; its presence is its text."[194] Klein quotes an unnamed bodybuilder who confides: "I wanna be the biggest thing. I wanna walk on stage...without even posing, and people would just—(opens eyes in wonder).... I won't even have to pose, I'll be so awesome."[195] Presumably the one seated on the great white throne (20:11) is himself beyond posing, although he would have ample room to strut and flex should he choose to. In the East, as Joan Massyngberde Ford reminds us, "the absolute ruler sat on an ornate throne. Archeological discoveries show such thrones with a high back, a base decorated with pictures of conquered peoples and several steps leading up to it...."[196] As such, Revelation's representation of the deity anticipates the publicity poster for the 1984 sword-and-sandal epic *Conan the Barbarian*, which showed a brooding Arnold Schwarzenegger slumped on a massive throne, his equally massive bulk artfully draped over its contours.[197] Certainly, Schwarzenegger was not stretched in the role. "My relationship to power and authority," confessed the off-screen colossus, with disconcerting candor, "is that I'm all for it.... Ninety-five percent of the people in the world need to be told what to do and how to behave"—by the remaining five percent, presumably.[198]

"It's Dorian's world; we're just visiting it," reads the caption to a recent article in *Flex*.[199] Dorian Yates, who has dominated professional bodybuilding in the 1990s much as Arnold dominated it in the 1970s, has also deployed the image of the throne to represent the (made-in-heaven?) marriage of absolute power and utter submission. "The evening's entertainment highlight at the 1995 Night of Champions in New York was the guest appearance of a near 300-pound Dorian Yates," the article begins.[200] The curtain drew

194 Klein, *Little Big Men*, 274. "No inane comments, only total majestic silence" is Gerhard A. Krodel's admiring remark on the taciturn figure on the throne (*Revelation*, 155).

195 Klein, *Little Big Men*, 273.

196 Ford, *Revelation*, 70. From chap. 4 on, the throne is ubiquitous in Revelation (e.g., 5:6; 7:9; 8:3; 12:5; 14:3; 16:7; 19:5; 20:11; 21:3; 22:1, 3). Caird remarks: "The final reality which will still be standing when heaven and earth have disappeared is the great white throne (xx. 11)" (*The Revelation of Saint John*, 62).

197 Arnold's early action movies, along with those of Sylvester Stallone, portrayed the male bodybuilder as the ultimate warrior. "The more exaggerated the musculature, the more it had to explain itself in mounds of dead bodies" (Simpson, *Male Impersonators*, 24; cf. Tasker, *Spectacular Bodies*, 77–83, 118–23, and Warner, "Spectacular Action"). Compare the mountains of dead bodies that litter the landscape of Revelation (6:4, 8; 8:9, 11; 9:15, 18; 11:13; 14:19–20; 15:2–10; 16:18–21; 19:11–21; 20:9, 15; 21:8; cf. 6:15–17; 8:4–6; 11:18; 14:9–11; 18:8, 19, 21; 19:2–3; 22:18), irrefutable proofs that the exaggerated majesty of the one seated on the throne is warranted: he can kill at will without lifting a finger—or moving a muscle.

198 Quoted in Butler, *Arnold Schwarzenegger*, 34.

199 McGough, "At the Court of King Dorian" (the caption occurs in the issue's table of contents).

200 Ibid., 197.

back to reveal Dorian pensively perched on an ornate throne, and resplendent in an ermine-trimmed crown and robe. Other accessories included a pair of angelic attendants who abased themselves at Dorian's feet. "The girls then divested the three-time Mr. Olympia of his imperial accouterments, as a prelude to Dorian posing before a raucous 3,000 strong standing-room-only crowd."[201] Hardly the "myriads of myriads and thousands of thousands" of which Revelation speaks (5:11), but then Dorian does not (yet) claim to be God.

For Klein, there is something profoundly disturbing, indeed fascist, about the spectacle of the bodybuilder on the posing dais. "Bodybuilding leads in various sociocultural directions," he writes, "but none is quite so disturbing or dramatic as its connection to fascist aesthetics and cultural politics. The fetishism for spectacle, worship of power, grandiose fantasies,... dominance and submission in social relations are all essential characteristics shared by bodybuilding and fascism...."[202] But these are also the essential characteristics of Revelation (if "dominance and submission in social relations" is extended to embrace divine-human relations), each so ubiquitous in that book as to beggar documentation.

The avoidance of anachronism is not, perhaps, my strong suit as an exegete. Indeed, I have deliberately employed anachronism throughout this book (taking my cue from the fact that anachronism is what biblical scholars fear most, that fear is but the obverse of fascination, and that the fascinating merits pursuit more than flight). And yet my description of Revelation as fascist is not intended anachronistically. We should not presume on too narrow a definition of this singularly useful term. The *New Webster's Dictionary*, for example, having outlined the historical roots of the term ("the ideological outlook and its extremist manifestations in Mussolini's Italian counterrevolutionary movement...and in his dictatorship"), goes on to define it more generally as "any political or social ideology...which relies on a combination of pseudo-religious attitudes and the brutal use of force for getting and keeping power." It may, of course, be objected that if this profile were to fit any political or social ideology of the first-century Mediterranean world, it would surely be that of the Roman state and not that of the fledgling Christian communities squirming under its sandal—such as those from which Revelation itself emerged, and to which it is addressed.[203] And yet the

201 Ibid., 197–98.

202 Klein, *Little Big Men*, 254; cf. 253–67 passim, also Dutton, *The Perfectible Body*, 206–209.

203 The degree of persecution with which John's target audience was faced, and the general situation in which it found itself, has long been a matter of debate. Recent contributions include Sweet, *Revelation*, 27–35; Aune, "The Social Matrix of the Apocalypse of John"; Yarbro Collins, *Crisis and Catharsis*, 84–110; Boring, *Revelation*, 9–23; and Thompson, *The Book of Revelation*, esp. 15–17, 171–97, 202–10.

theology or ideology of Revelation is anything but a simple inversion, reversal, or renunciation of the political and social ideology of imperial Rome. Instead it represents the apotheosis of this imperial ideology, its ascension to a transhistorical site.

This conclusion is implicit in much of what critical commentators write on Revelation, although some work hard to circumvent it. M. Eugene Boring, for example, claims that the repeated accolade, "Worthy art thou [*axios ei*]" (4:11; 5:9; cf. 5:12), directed to God and the Lamb "reflects the acclamation used to greet the [Roman] emperor during his triumphal entrance," while the title "our Lord and God [*ho kyrios kai ho theos hēmōn*]" (4:11; cf. 4:8; 11:17; 15:3; 16:7; 19:6) "is paralleled by Domitian's insistence that he be addressed by this title."[204] David E. Aune, for his part, claims that the detail of the twenty-four elders casting their crowns before the divine throne (4:10) "has no parallel in Israelite-Jewish literature," but is comprehensible only in light of the custom of presenting crowns to a sovereign, which was "inherited by the Romans from the traditions of Hellenistic kingship."[205] And Boring cites Tacitus's description of how the Parthian King Tiridates laid his diadem at the feet of Nero's seated effigy in order to offer suitably obsequious homage to the Roman emperor.[206]

What of the number twenty-four itself? Aune has an intriguing suggestion to make. "Roman magistrates were permitted to be accompanied by the number of lictors bearing fasces which corresponded to the degree of imperium which they had been granted," he begins. (As it happens, the fasces, a bundle of rods bound together with the blade of an ax projecting, later gave Italian *Fascismo*, which adopted it as an insignia, its name.)

> Consuls were permitted twelve lictors. Augustus apparently had twelve lictors from Actium…, though it is possible that he had twenty-four lictors until 27 B.C.E. At

204 Boring, *Revelation*, 103; cf. 21. Although Boring does not mention it, the argument that the "Worthy art thou" acclamation was used in the imperial cult goes back at least to Peterson, *Heis Theos*, 176–80. Most New Testament scholars believe that Revelation was written during the latter part of Domitian's reign (more on this below). Did Domitian really insist on being addressed as "Lord and God," as commentators on Revelation routinely claim? (The only exceptions that I am aware of are Yarbro Collins, *Crisis and Catharsis*, 71–72; Krodel, *Revelation*, 36–37; Thompson, *The Book of Revelation*, 104–7; and Harrington, *Revelation*, 9–10.) Probably not, as we shall see, although the title does seem to have been applied to him nonetheless.

205 Aune, "Roman Imperial Court Ceremonial," 12–13. See further Klauser, "Aurum Coronarium," and Millar, *The Emperor in the Roman World*, 140–43.

206 Boring, *Revelation*, 103, adducing Tacitus, *Annals* 15.29. Similar lists of parallels are frequent in the scholarly literature on Revelation; see, e.g., Charles, *The Revelation of St. John*, 1:133; Cuss, *Imperial Cult and Honorary Terms*, 62–63; Hemer, *The Letters to the Seven Churches*, 86–87; Lohse, *Die Offenbarung des Johannes*, 36; Roloff, *The Revelation of John*, 72; Schüssler Fiorenza, *Invitation to the Book of Revelation*, 76; Thompson, *The Book of Revelation*, 58; and esp. Stauffer, *Christ and the Caesars*, 166ff.

any rate the standard number of twelve lictors, indicative of the degree of imperium, was doubled by Domitian to twenty four. These lictors, of course, were not crowned, nor did they wear white robes. They did, however, constitute part of the official crowd of public servants which constantly surrounded the emperor.[207]

Self-abasing celestial officials, the twenty-four elders prostrate themselves repeatedly before the divine throne (4:10; 5:8; 7:11; 11:16; 19:4). "The practice of the ritual of *proskynesis* [prostration] before early Roman emperors is incontrovertible," adds Aune, and he goes on to substantiate his claim.[208]

Distantly related to Domitian's double allotment of lictors were Nero's Augustiani, an elite corps of presentable young men whose principal function was to lead the applause whenever the emperor deigned to make an appearance—an imperial cheerleading squad, if you will. Suetonius estimates the size of this squad at "more than five thousand."[209] Dominique Cuss has argued that the acclamations led by the Augustiani were designed to "underline the imperial claims to divinity."[210] Paraphrasing Tacitus, she states: "Day and night, the applause and acclamations of these young men echoed around the palace, using such extravagant terms while describing the beauty and voice of the emperor, that they could have been applied to the gods."[211] Or to God. Compare Revelation 4:8ff.: "Day and night without ceasing [*anapausin ouk echousin hēmeras kai nyktos*] they sing"—and the words of the song follow, the singers in question being the "four living creatures," supported by the twenty-four elders (4:8–11). Together they drum up a chorus that swells until it encompasses every voice in the heavenly throne room (5:8–12), and then every voice in the universe (5:13), acclamation after

207 Aune, "Roman Imperial Court Ceremonial," 13; cf. Miller, *The Emperor in the Roman World*, 67. The primary source is Dio Cassius, *Roman History* 67.4.3.

208 Aune, "Roman Imperial Court Ceremonial," 13–14.

209 Suetonius, *Nero* 20.3. The Augustiani are also mentioned in *Nero* 25.1; Tacitus, *Annals* 14.15; and Dio Cassius, *Roman History* 61.20.4–5; cf. 63.8.2–3; 63.15.2; 63.18.3. Nero is a brooding presence in Revelation, as has long been recognized, serving to epitomize the evil that its author sees embodied in Rome. See further Cuss, *Imperial Cult and Honorary Terms*, 88–95; Yarbro Collins, *The Combat Myth in the Book of Revelation*, 176–83; and Müller, *Die Offenbarung des Johannes*, 297–300.

210 Cuss, *Imperial Cult and Honorary Terms*, 77; cf. Aune, "Roman Imperial Court Ceremonial," 16.

211 Cuss, *Imperial Cult and Honorary Terms*, 78. The sentence from Tacitus begins: "Days and nights they thundered applause [*Ii dies ac noctes plausibus personare*], bestowed the epithets reserved for deity upon the imperial form and voice…" (*Annals* 14.15; Moore and Jackson's trans.).

acclamation washing over "the one seated on the throne," and his *Divi Filius*, "the Lamb."[212]

Such parallels could be multiplied; we have not yet emerged from Revelation 4–5, much less examined the extent to which the heavenly throne room in Revelation as a whole (in which it functions as the principal setting) mirrors the Roman imperial court.[213] What do the scholars themselves make of these parallels? Cuss is utterly noncommittal in her conclusions. Aune is less tight-lipped, although also relatively noncommittal:

> John's depiction of the ceremonial in the heavenly throne room has been signifi-cantly influenced in its conceptualization by popular images of Roman imperial court ceremonial. For the most part, the individual constituents of that ceremonial used by John in his depiction of the heavenly ceremonial have been heightened, expanded and given even greater cosmic significance. The result is that the sov-ereignty of God and the Lamb have been elevated so far above all pretensions and claims of earthly rulers that the latter, upon comparison, become only pale, even diabolical imitations of the transcendent majesty of the King of kings and Lord of lords.[214]

Is this Aune's own view of the matter, or merely his rendition of John's view? Aune leaves us guessing. Less guesswork is required in the case of Boring. He states that "the correlation of imagery from the imperial cult with that used to express faith in the sole sovereignty of God simply shows that all earthy claims to sovereignty are only pale imitations and parodies of the One who sits upon the one throne. Christians dare not give this homage to another."[215] Boring's summation does echo Aune's. The difference, however, is that Boring's popularly pitched but splendidly competent commentary on Revelation is everywhere punctuated by professions of faith, generally implicit but frequently explicit, so that Boring's theological viewpoint seems to blend completely with John's. Boring stands staunchly by John's shoulder throughout, not only as his interpreter, faithfully translating even his most alien sentences and sentiments into contemporary theological idiom, but

212 Strangely, Cuss does not appear to have Revelation 4:8ff. in mind as she paraphrases Tacitus. Instead she is in the midst of a lengthy gloss on the "blasphemous names" on the head of the beast from the sea (13:1; cf. 17:3). Aune, however, does connect the Augustiani with the per-petual adorers of Rev. 4–5 ("Roman Imperial Court Ceremonial," 16–18).

213 Nor is the imperial court the only place to look for such parallels. A recent paper argues that Revelation usurped the innovative imagery of Domitian's coinage in order to represent Jesus. "Domitian and Jesus not only shared roles as the divine mediator figures for the Empire and the Christians of Asia Minor, they also shared the wardrobe of empowerment" (Janzen, "The Jesus of the Apocalypse Wears the Emperor's Clothes," 370).

214 Aune, "Roman Imperial Court Ceremonial," 22; cf. 5.

215 Boring, *Revelation*, 103; cf. 185, 187, 192–93, 214–15, 211.

also as his disciple. Boring everywhere apologizes for John, and nowhere criticizes him.[216]

The same is true of Bauckham, at any rate in his *Theology of the Book of Revelation*. Bauckham refrains from attempting to connect the protocol of the divine throne room with imperial court ceremonial. Nevertheless, his view of the relationship between the two thrones, the two empires, matches that of Aune and especially that of Boring:

> The Roman Empire, like most political powers in the ancient world, represented and propagated its power in religious terms. Its state religion, featuring the worship both of the deified emperors and of the traditional gods of Rome, expressed political loyalty through religious worship. In this way it absolutized its power, claiming for itself the ultimate divine sovereignty over the world. And so in effect it contested on earth the divine sovereignty which John sees acknowledged in heaven in chapter 4. The coming of God's kingdom on earth must therefore be the replacement of Rome's pretended divine sovereignty by the true divine sovereignty of the One who sits on the heavenly throne.[217]

What do these parallel claims amount to, these accusations of pretention, these assertions that Roman imperial power is but a parody or pale imitation of divine power? What are Aune, Boring, and Bauckham actually saying? Simply that God's imperial splendor far exceeds that of the Roman emperor, just as the emperor's splendor far exceeds that of any of his six hundred senators, and just as the senator's splendor far exceeds that of any provincial plebeian, and so on down the patriarchal line to the most subdued splendor of the feeblest father of the humblest household? If so, the difference between Roman sovereignty and divine sovereignty would be quantitative rather than qualitative in Revelation.

Bauckham is not unaware of the problem. "[I]t would subvert the whole purpose of John's prophecy," he admits, "if his depiction of the divine sovereignty appeared to be a projection into heaven of the absolute power claimed by human rulers on earth." But this danger "is averted by a kind of apophaticism in the imagery," he claims, "which purges it of anthropomorphism and suggests the incomparability of God's sovereignty."[218] Apophaticism is "negative theology," he explains, and it "radically distinguishes God from all

216 The other pole of current scholarship on Revelation, that which subjects its ideology to stringent critique, is best respresented by Tina Pippin; see, e.g., her *Death and Desire*; "Eros and the End"; "The Heroine and the Whore"; "Peering into the Abyss"; and "The Revelation to John."

217 Bauckham, *The Theology of the Book of Revelation*, 34; cf. 39, 43, 44–45, 59, 143, 159–60, 162–63.

218 Ibid., 43.

creaturely being by conceiving him in negative terms: he is *not* what creatures are."[219]

How does Revelation rate as negative theology? Encumbered by the overt masculinity of its deity, it limps awkwardly indeed beside the consummately restrained and exquisitely delicate theological probings of a Pseudo-Dionysius, a Meister Eckhart, or other Christian thinkers more commonly termed apophatic.[220] Has John really succeeded in "purging" his text, as Bauckham claims? Has he really evacuated it, voided it of whatever modern theological sensibilities might deem unseemly or unsightly, specifically the glorification of absolute power? Has his apophatic purgative not been too mild for that? Has he not merely broken wind at best?

For power of an alarmingly pure kind is what God's reign in Revelation boils down to. Here is Bauckham's (accurate) account of the life awaiting the blessed in the heavenly city (Rev. 21:1–22:5):

> As for the image of God's rule in the eschatological kingdom, what is most notable is the fact that all implication of distance between "the One who sits on the throne" and the world over which he rules has disappeared. His kingdom turns out to be quite unlike the beast's. It finds its fulfilment not in the subjection of God's "servants" (22:3) to his rule, but in their reigning with him (22:5).[221] The point is not that they reign over anyone: the point is that God's rule over them is for them a participation in his rule. The image expresses the eschatological reconciliation of God's rule and human freedom, which is also expressed in the paradox that God's service is perfect freedom (cf. 1 Pet. 2:16). Because God's will is the moral truth of our own being as his creatures, we shall find our fulfilment only when, through our free obedience, his will becomes also the spontaneous desire of our hearts. Therefore in the perfection of God's kingdom theonomy (God's rule) and human autonomy (self-determination) will fully coincide.[222]

A Foucauldian nightmare, this vision of heaven (but whose?) represents the absolute displacement of outward subjection, tangible coercion, by inner self-policing, which is now so deeply implanted in the believer as to be altogether indistinguishable from freedom. Revelation does present the individ-

219 Ibid., 43, n. 8, his emphasis. Boring makes a parallel claim, arguing that Revelation has recourse to "that philosophical tradition which claims that, while we cannot say what the transcendent world of God *is*, we can to some extent truly represent it by saying what it is *not*. John thus sprinkles his 'description' of the new Jerusalem with affirmations of what will *not* be there" (*Revelation*, 216, his emphasis, introducing a section entitled "Via Negativa").

220 Further on negative theology, see Sells, *Mystical Languages of Unsaying*.

221 God's "slaves" (*douloi*) would be a better translation. Bauer remarks on the "soft" rendering of *doulos*: "'servant' for 'slave' is largely confined to Biblical transl. and early American times..." (*Greek-English Lexicon*, s.v. *doulos*). See further, Martin, "Womanist Interpretations of the New Testament," esp. 44–51.

222 Bauckham, *The Theology of the Book of Revelation*, 142–43; cf. 164.

ual with an option, of course—to be "tortured [*basanisthēnai*] with fire and sulfur" instead "in the presence of the holy angels and in the presence of the Lamb," "the smoke of [one's] torment" ascending "for ever and ever" (14:10–11; cf. 9:5; 20:15; 21:8).[223] We have not yet exited the dystopian netherworld of *Discipline and Punish*: on one side, the absolute monarch publicly exacting frightful physical punishment on all who oppose his will; on the other side, a more "benign" realm in which the rack, the stake, and the scaffold have been rendered obsolete—but only because the ruler's subjects are no longer capable of distinguishing his will from their own.[224]

Both these realms coexist in Revelation's "new heaven and new earth" (21:1; cf. 20:11)—not unexpectedly, since the two realms represent the two faces of power, one scowling, the other smiling, and since Revelation's climactic vision (21:1–22:5) is a vision (a projective fantasy?) of power absolutized. On the one hand we read: "Blessed are those who wash their robes, so that they will have the right to the tree of life and may enter the city by the gates" (22:14). Bauckham has told us what awaits them inside. On the other hand we read: "Outside [*exō*] are the dogs [*hoi kynes*] and sorcerers and fornicators and murderers and idolaters, and everyone who loves and practices falsehood" (22:15; cf. 21:27).[225] What is outside? John has already told us that: "But as for the cowardly, the unbelieving [*apistois*], the polluted, the murderers, the fornicators, the sorcerers, the idolaters, and all liars, their place will be in the lake that burns with fire and sulfur [*tē limnē tē kaiomenē pyri kai theiō*], which is the second death" (21:8; cf. 19:20b; 20:14–15; Gen. 19:24).

223 This option is stated even more baldly in *4 Ezra*, a Jewish apocalypse roughly contemporary with Revelation: "Then the pit of torment shall appear, and opposite it shall be the place of rest; and the furnace of Hell shall be disclosed, and opposite it the Paradise of delight. Then the Most High will say to the nations that have been raised from the dead, 'Look now, and understand whom you have denied, whom you have not served, whose commandments you have despised! Look on this side and on that; here are delight and rest, and there are fire and torments!'" (7:36–38, trans. from Charlesworth, ed., *The Old Testament Pseudepigrapha*; cf. *1 Enoch* 62; Matt. 25:31–46).

224 Cf. Krodel's telling remarks on the "four living creatures" (4:6–8): "They are God's pets within the heavenly court.... Readers of this commentary should not be upset that I speak of God's pets. They should remember their own faithful dogs and cats whose joy it is to live in their presence, to please them and adore them. Worship ought to be just that.... God's pets in John's vision are the symbol of harmony and worship yet to come, when God shall dwell among his people (21:1–22:5)" (*Revelation*, 156–57).

225 Who are these "dogs"? "The term 'dog' is used in Scripture for various kinds of impure and malicious persons," contends Robert H. Mounce. He appeals in particular to Deut. 23:17–18, in which "the term designates a male cult prostitute" (*The Book of Revelation*, 394). A more extensive examination of these miserable mutts can be found in Kraft, *Die Offenbarung des Johannes*, 279–80.

The Beatific Vision

> . . . on him, on him alone had I leisure avidly to
> gaze. . . .
>
> —STATIUS (*Silvae* 4.2.40) on Domitian

Who, then, is the God of Revelation? As I have been implying, he is revealed
not through Jesus Christ so much as through the Roman emperor. For many
of the emperors, the temptations of the flesh assumed a unique form: the
temptation to become divinized flesh. To be or not to be a god?[226] Tiberius
sternly rejected the divine honors dangled enticingly before him. So did
Augustus (less energetically, to be sure), and Claudius, and Vespasian,
although all three were deified after death, as was Titus. Caligula greedily
seized the opportunity to become a god, wallowing in divinity. So did Julius
Caesar, to a lesser extent, and Nero, and possibly Domitian.[227]

Domitian's exploits and excesses are of perennial interest to scholars of
Revelation, most of whom date the book to the latter years of his reign, which
began inauspiciously in 81 C.E. and ended ignominiously in 96.[228] Did
Domitian, ravenous for adulation, gluttonous for deification, really gorge on
forbidden fruit, appropriating for himself the title "Lord and God," as his
biographer Suetonius claims? In the *Lives of the Caesars* we read:
"With...arrogance he began as follows in issuing a circular letter in the
name of his procurators, 'Our Lord and God bids that this be done [*Dominus
et deus noster hoc fieri iubet*].' And so the custom arose of henceforth
addressing him in no other way even in writing or in conversation."[229]

226 On the inception of the Roman imperial cult, see Taylor, *The Divinity of the Roman Emperor*
(she limits herself to Julius Caesar and Augustus); Weinstock, *Divus Julius*; and Fishwick,
The Imperial Cult in the Latin West, 1:46–72. Shorter treatments include Cuss, *Imperial Cult
and Honorary Terms*, 27–35, and Müller, *Die Offenbarung des Johannes*, 257–60.

227 See further Jones, "Christianity and the Roman Imperial Cult," 1024–35 (Tiberius to
Domitian; altogether, the article spans Tiberius to Constantine).

228 Here, for once, critical scholarship is in step with church tradition. Irenaeus claimed that John
had his visions "toward the end of the reign of Domitian" (*Against Heresies* 5.30.3; cf.
Eusebius, *Ecclesiastical History* 3.18.1; Victorinus, *Commentary on the Apocalypse* 10.11). For
concise reviews of the (mainly internal) evidence relevant to establishing the date of compo-
sition, see Hemer, *The Letters to the Seven Churches*, 1–12, Mounce, *The Book of Revelation*,
31–36, and Sweet, *Revelation* 21–27; and for a more searching review, see Yarbro Collins,
Crisis and Catharsis, 54–83. The latter in particular builds a highly compelling case for the
Domitianic date. I realize, of course, that the hypothesis is not unassailable (see esp. Robinson,
Redating the New Testament, 221–53; Rowland, *The Open Heaven*, 403–13; and Gentry, *Before
Jerusalem Fell*), but I would prefer to avoid staging yet another rehearsal of a convoluted
debate, and so will proceed to construct a reading based upon the majority opinion.

229 Suetonius, *Domitian* 13.2 (trans. from Rolfe, *Suetonius*, with slight modifications). Similar
claims concerning Domitian occur in Pliny the Younger, *Panegyric on Trajan* 2.33.4; 78.2;
Dio Chrysostom, *Discourses* 45.1; Dio Cassius, *Roman History* 67.4.7; 67.13.4; and Aurelius
Victor, *On the Caesars* 11.2.

This would have been a bold self-designation indeed, even by the standards of the imperial court, for a deified emperor, or *divus*, did not a *deus* make. "The best an emperor could expect after death was to be declared a *divus*, never a *deus*," explains a more recent biographer of Domitian, Brian W. Jones, and "a living one had to make do with even less." And if Domitian could so overcome his natural modesty, "why should he hesitate to proclaim it publicly (and epigraphically)?"[230] But the title has yet to turn up on any inscription, coin, or official document. It does seem to have been applied to Domitian nevertheless; his contemporary, Martial, does so, for one, and clearly implies that others did so as well.[231] Dio Cassius, too, tells of a certain Juventius Celsus, who, accused of conspiring against Domitian, saved his skin by prostrating himself before the emperor and addressing him "as 'Lord and God,' names by which he was already being called by others."[232] Domitian "obviously knew that he was not a God," claims Jones, but "whilst he did not ask or demand to be addressed as one, he did not actively discourage the few flatterers who did."[233]

Of course, the *adulatio* lavished on Domitian by his most fervent flatterers was by no means limited to the hyperbole *Dominus et Deus*. Witness, for example, the laudatory immoderation of Martial and his fellow court poet, Statius, as reported by Kenneth Scott:

> Statius calls him *sacratissimus imperator*, *sacrosanctus*, *sacer*, and *verendus*. His home is described as *divina*. Indeed all that pertained to the monarch is named sacred.... The emperor's person is sacred, his side, breast, ear [Martial], and feet [Statius], and the rebellion of Saturninus against him is sacrilegious [Martial]. His name is *sacer* [Martial], as are his secrets [Statius]. His banquet is "sacred" or "most sacred"; the golden wreath which he bestows as prize in the Alban contest is "sacred"; the day on which he feasts the people is *sacer*; his fish are "sacred" [Martial]; his treasures are *sanctae*, and the *nectar* which he drinks is *verendum* [Statius].[234]

The devoted duo also insist that Domitian is a *deus praesens*—a Jupiter *praesens*, what is more—proximate, tangible, and approachable, as distinct from

230 Jones, *The Emperor Domitian*, 108.

231 Martial, *Epigrams*, esp. 5.8; 7.34; 8.2; 9.66; 10.72; cf. 5.5; 7.2, 5; 8.82; 9.28. Does *Epigrams* 5.8 lend support to Suetonius's claim that Domitian began an official letter with the self-designation "Lord and God"? The passage reads: "As Phasis in the theater the other day...was praising the edict of our Lord and God [*edictum domini deique nostri*], whereby the benches are more strictly assigned...." (Bailey's trans.).

232 Dio Cassius, *Roman History* 67.13.4.

233 Jones, *The Emperor Domitian*, 109.

234 Scott, *The Imperial Cult under the Flavians*, 100; see further Sauter, *Der römische Kaiserkult bei Martial und Statius*, esp. 105–16.

the distant Olympian.[235] But it was not only in poetry that Domitian was hailed as Jupiter. The compliment occurs in epigraphic finds also, notably an Attic inscription which bestows the title Zeus Eleutherios on the emperor.[236] Various coins, too, struck by Domitian, depict him enthroned as "father of the gods."[237]

What of Asia Minor, the region to which Revelation is addressed (1:4; cf. 1:11; 2:1–3:22)? The province had two temples dedicated to Domitian, one at Ephesus, the other at Laodicea. A massive marble statue of the emperor erected in the Ephesian temple became a focal point of the imperial cult in Asia Minor.[238] "Some impression of the scale [of the statue] is given by the fact that the lower part of an arm is the height of a man," observes S. R. F. Price. "The height of the whole, to the top of the spear which the standing figure was probably holding, was some seven to eight metres"—on the same scale, that is to say, as cult statues of the gods.[239] Statues of Apollo, Artemis, and Leto, for example, each of them seven to eight meters tall, stood in Apollo's temple at Claros, a scant few miles from Ephesus; while Josephus tells of "a colossal statue [*kolossos*] of the emperor [Augustus], no smaller than the Zeus at Olympia, which served as its model," which dominated the temple of Roma and Augustus at Caesarea.[240] Tacitus, for his part, tells how the Senate, following a minor military victory, resolved to present Nero "with a statue of the same size as that of Mars the Avenger, and in the same temple."[241] Of Domitian's Ephesian colossus Price remarks: "This is the most extreme form of the modelling of the emperor on the gods, no doubt with awesome impact on the population."[242]

235 See Sauter, *Der römische Kaiserkult bei Martial und Statius*, 51–54, and Scott, *The Imperial Cult under the Flavians*, 107–108, 137–38.

236 Scott, *The Imperial Cult under the Flavians*, 139.

237 See Stauffer, *Christ and the Caesars*, 167, 173, and Jones, "Christianity and the Roman Imperial Cult," 1033. See further Abaecherli, "Imperial Symbols on Certain Flavian Coins," esp. 136ff.

238 Although the cult's official center was Pergamum, with its temple dedicated to Roma and Augustus. Is the latter the cryptic "throne of Satan" referred to in Rev. 2:13? Many have thought so (e.g., Schüssler Fiorenza, *The Book of Revelation*, 193; Müller, *Die Offenbarung des Johannes*, 110), although others have suggested that Satan's throne is instead the great altar of Zeus Sōtēr that also stood at Pergamum (e.g., Lohmeyer, *Die Offenbarung des Johannes*, 25, drawing on Deissman, *Licht vom Osten*, 238), or even the city itself (e.g., Hemer, *The Letters to the Seven Churches*, 84–87; Roloff, *The Revelation of John*, 51).

239 Price, *Rituals and Power*, 187; cf. 255.

240 Josephus, *Jewish War* 1.21.7 §44 (my trans.); cf. *Antiquities* 15.9.6 §339.

241 Tacitus, *Annals* 13.8 (Moore and Jackson's trans.).

242 Price, *Rituals and Power*, 188. Price, a classicist, suggests that "the establishment of the provincial cult of Domitian at Ephesus, with its colossal cult statue," looms behind Rev. 13:11ff., so that the beast from the land would be "the priesthood of the imperial cult, particularly…in the province of Asia" (197). Many New Testament scholars would concur with Price's identification of this beast; see, e.g., Lohse, *Die Offenbarung des Johannes*, 72; Cuss, *Imperial Cult*

A colossal, hard body—Greco-Roman culture and contemporary body-building subculture converge strikingly in their respective conceptions of the godlike physique. A recent advertisement in the muscle magazines for GIANT MEGA MASS 4000, a weight-gaining product, features a "hard and massive" Dorian Yates flexing alongside the caption, "The Giant That Won This Year's Mr. Olympia...." Further into the four-page advertisement another elite bodybuilder, Gary Strydom, is labeled "A Rock-Solid 260 lbs.," the giant container of GIANT MEGA MASS 4000 that he holds triumphantly aloft suggesting that he owes his statuesque condition to the miraculous product.[243] And what of the Mr. Olympia contest itself? "In 1965 I created the Mr. Olympia contest," explains Joe Weider, princeps of the bodybuilding empire. "The name seemed appropriate. The time had come to enter the hallowed ground of the ancient Greek gods with incarnate image. We live among them."[244] And in the course of a somewhat surreal exchange between former Mr. Olympia Frank Zane and Michael Murphy, founder of Esalen Institute in Big Sur, California and "a leader in the human potential movement," the latter enthuses: "One of the things I've admired about your attitude, Frank, is your experimentation with somatic mutability, which has enabled you to change your body at will. The further reaches of training point to glimpses of divinization of the body, a new kind of flesh."[245]

Of course, the flesh in question is penile flesh; for what does it mean to say that size and hardness are the *sine qua non* of the bodybuilding physique except that the bodybuilder is an outsized penis in a state of permanent erection?[246] "He hones his hard body (to be soft is anathema)...."[247] His body is "'pumped up,' 'rock hard' and 'tight'...."[248] And the current rage for "vascularity" in competitive bodybuilding, calling for minimal subcutaneous fat, means that "the road map of veins is clearly visible, standing out

and Honorary Terms, 96ff.; Müller, *Die Offenbarung des Johannes*, 253ff.; and Scherrer, "Signs and Wonders in the Imperial Cult." Others would take a different view, e.g., Kraft, *Die Offenbarung des Johannes*, 180ff., and Roloff, *The Revelation of John*, 161.

243 Reflecting on his own statuesque physique, Arnold Schwarzenegger remarks: "You don't really see a muscle as part of you.... You look at it as a thing and you say well this thing has to be built a little longer...; or the tricep has to be thicker here in the elbow area.... You form it. Just like sculpture" (quoted in Gaines and Butler, *Pumping Iron*, 52; cf. 106, 108, also Dutton, *The Perfectible Body*, 312–15).

244 Quoted in Klein, *Little Big Men*, 258. Klein also quotes Weider as saying: "The modern body-builder has followed in the footsteps of the Greek Olympian gods. Obsessed with heroic proportions as they were, how far would the Greeks have taken physical development had they our knowledge of weight training?" (259; cf. Dutton, *The Perfectible Body*, 21).

245 Quoted in Zane, "Train with Zane," 247.

246 Cf. Klein, *Little Big Men*, 247: "The fear of size loss...is the converse of the bodybuilder's search for size and hardness...."

247 Fussell, "Bodybuilder Americanus," 46.

248 Simpson, *Male Impersonators*, 33.

from the flesh in a fashion alarmingly reminiscent of an erect penis."[249] On stage, the bodybuilder is "turgid," "constantly at attention, ready to explode," his entire body engorged like an oversized organ.[250] Arnold tells of the "pump" that he gets when the blood is flooding his muscles. "They become really tight with blood. Like the skin is going to explode any minute."[251] Indeed, former Mr. Universe Steve Michalik entertained a fantasy that he would someday literally explode on stage, showering the worshipers with the viscous contents of his phallic physique.[252]

Domitian's cult too was preposterously phallic; how else should we interpret the massive, marble-hard image of his power erected at Ephesus, to cite one of the more Priapean pillars of his cult? Unfortunately for Domitian, his splendid cult did not survive his assasination but swiftly wilted, the Senate according him a *damnatio memoriae* and having his statues—glorious statues, according to his biographers—destroyed or rededicated.[253] It appears that the Ephesian colossus was allowed to stand until late antiquity, however, although the temple housing it was rededicated to Vespasian (Domitian's deceased, deified father), and the statue itself passed off as a representation of Vespasian, the Flavian paterfamilias strapping the monstrous monument onto his own withered loins.[254] Indeed, were it not for the author of Revelation, Domitian's divinity might well have died with him.

For in and through Revelation, the emperor ascends into heaven and becomes a god, and the god he becomes is none other than Yahweh. John's attempt to counter the magnificent imperial cult with the image of a yet more magnificent heavenly cult (the latter modeled in part upon the former) has resulted in a fascinating (con)fusion of figures, the Roman emperor coalescing with the Jewish-Christian God. And so Domitian is assumed into heaven, together with all his court. He is decked out for battle, for Revelation is a military epic.[255] But his body armor or cuirass, sculpted in the Roman manner

249 Ibid.

250 Fussell, "Bodybuilder Americanus," 46–47; cf. Dutton, *The Perfectible Body*, 43; Miles, *The Rites of Man*, 111; and Simpson, *Male Impersonators*, 22.

251 Quoted in Butler, *Arnold Schwarzenegger*, 124. Hence Arnold's famous dictum, "a good pump is better than coming" (see Gaines and Butler, *Pumping Iron*, 48).

252 Recounted in Fussell, "Bodybuilder Americanus," 50.

253 On the magnificence of the statues, see Suetonius, *Domitian* 13.2; Dio Cassius, *Roman History* 67.8.1; cf. Pliny, *Panegyric on Trajan* 52.3.

254 See Scott, *The Imperial Cult under the Flavians*, 97, and Price, *Rituals and Power*, 178, 255.

255 "A Christian war scroll" is how Bauckham describes it (*The Climax of Prophecy*, 210–37).

to simulate a heavily muscled male torso, has vanished.[256] In its place is divinized flesh, the unimaginably muscular and exquisitely sculpted physique of the God of Israel, whose appearance is of precious stones: "And the one seated there looks like jasper [*iaspis*] and carnelian [*sardion*]" (4:3).

Why precious stones? Because precious stones are hard, and (phallic?) hardness is the *sine qua non* of a godlike physique, as we have seen. But why these precious stones in particular? G. R. Beasley-Murray explains: "The appearance of God was as jasper and carnelian. The former could vary in appearance from a dull yellow to red or green, or even translucent like glass (as apparently in 21:11). In view of the later passage we may take the last to be in view. Carnelian, or sardius (originating from Sardis), was red. The divine appearance, therefore, was as it were transparent 'white' and red."[257] The divine physique is characterized both by transparence and redness, meaning that the raw musculature of the deity is entirely visible through the skin. "[T]hin as Bible paper," the latter is "so translucent one can visibly see raw tissue and striated muscle swimming in a bowl of veins beneath."[258] The Heavenly Bodybuilder is thus the myological figure, the Vesalian muscleman, that all earthly bodybuilders aspire to be. "When you hit a most-muscular pose," Arnold advises the bodybuilding neonate, "[you] should look like an anatomy chart—every area developed, defined, separated, and striated."[259]

"He was tall of stature," Suetonius writes of Domitian, "handsome and graceful too [*praeterea pulcher ac decens*], especially when a young man," although "in later life he had...a protruding belly, and spindling legs,...thin from a long illness."[260] Yet the deified Domitian could hardly have been astonished at the physical metamorphosis that came with his apotheosis. After all, in the temple to Hercules that he had erected on the Appian Way, the cult statue of the massively muscled god had been fashioned with the facial features of the emperor himself.[261] And prescient Martial, noting how Hercules had ascended to the "starry heaven" by virtue of the punishment

256 "It is highly likely that the statue of Domitan at Ephesus, of which numerous fragments survive, was cuirassed" (Price, *Rituals and Power*, 182). Cuirassed statues of the Roman emperors were extremely common (cf. Taylor, *The Divinity of the Roman Emperor*, 179–80; Dutton, *The Perfectible Body*, 49). Nude statues of the emperors were also common—fat-free, needless to say, and with excellent muscle tone, symmetry, and definition—evoking more overtly than cuirassed statues the traditional representations of the gods (Price, *Rituals and Power*, 183).

257 Beasley-Murray, *Revelation*, 113.

258 Fussell, "Bodybuilder Americanus," 49.

259 Schwarzenegger and Dobbins, *Encyclopedia of Modern Bodybuilding*, 291. In the "most-muscular" pose, the bodybuilder leans forward, brings his or her clenched fists together in front of his or her crotch, bares his or her teeth, and flexes every muscle group simultaneously (see Figure 12).

260 Suetonius, *Domitian* 18.1 (Rolfe's trans.).

261 Scott, *The Imperial Cult under the Flavians*, 143.

he had inflicted "on the wrestler of the Libyan palaestra, and by the throwing of ponderous Eryx in the Sicilian dust," had exclaimed how insignificant such feats appear when measured against Domitian's own prodigious prowess: "How many weights heavier than the Nemean monster fall! How many Maenalian boars does your spear lay low!"[262] For these and other heroic deeds—"three times he shattered the treacherous horns of Sarmatian Hister; he three times bathed his sweating steed in Gethic snow"—Domitian shows himself to be a *maior Alcides* (a "greater Hercules"), far outstripping the *minor Alcides*, and deigning to supplement the latter's brutish physique with his own effulgent features.[263]

A mighty warrior needs a mighty weapon. "Around the throne is a rainbow [*iris*]" (Rev. 4:3; cf. Ezek. 1:28), we read, and this turns out to be Domitian's weapon. As numerous commentators have noted, this rainbow evokes that of Genesis 9:13: "I have set my bow [*qešet*] in the clouds, and it shall be a sign of the covenant between me and the earth."[264] A common interpretation of the latter passage, in turn, suggests that the bow set in the clouds after the Flood represents the war bow (also *qešet*) with which Yahweh wages his battles (cf. Deut. 32:23, 42; 2 Sam. 22:15; Pss. 7:12; 18:15 [14]; 77:18; 144:6; Lam. 2:4; 3:12; Hab. 3:9–11; Zech. 9:14), so that his placing it in the clouds would signify the cessation of his warlike hostilities against humanity.[265] Thus it is that the deified Domitian, fortuitously fused with the figure of Yahweh, suddenly finds himself in possession of the latter's awesome weapon.

Now, the bow also happened to be the mortal Domitian's weapon of choice, according to Suetonius:

262 Martial, *Epigrams* 5.65; cf. his *Spectacles* 6B, 15, 27. Here and in what follows I am quoting Scott's translation of the *Epigrams* (*The Imperial Cult under the Flavians*, 142ff.), which often reads better than Bailey's.

263 Martial, *Epigrams* 9.101; cf. 9.64. Statius, too, casts Domitian in the role of a *maior Alcides* (*Silvae* 4.2.50ff.; cf. 4.3.155ff.). See further Sauter, *Der römische Kaiserkult bei Martial und Statius*, 78–85.

264 See, e.g., Caird, *The Revelation of Saint John*, 63; Beasley-Murray, *Revelation*, 113; Ford, *Revelation*, 71; Mounce, *The Book of Revelation*, 135; Sweet, *Revelation*, 117–18; Boring, *Revelation*, 105; and Wall, *Revelation*, 92. Oddly enough, although this connection is routinely noted in almost all the recent English-language commentaries on Revelation, one is hard-pressed to find a single German commentary that notes it.

265 Again, all the major commentaries on Genesis routinely note this interpretation, although not all accept it. Those that do include von Rad, *Genesis*, 134, Cassuto, *A Commentary on the Book of Genesis*, 2:136–37 (more tentatively), and Sarna, *Genesis*, 63; and see, in addition, Mendenhall, *The Tenth Generation*, 45–48, and Weinfeld, *Deuteronomy and the Deuteronomic School*, 205–6. The interpretation is by no means a modern one, however; it also occurs in the Midrashim (see Cassuto, *Commentary*, 2:137, for details) and in Ramban (see Leibowitz, *Studies in Bereshit*, 86).

He was...particularly devoted to archery [*sagittarum...praecipuo studio tenebatur*]. There are many who have more than once seen him slay a hundred wild beasts of different kinds on his Alban estate, and purposely kill some of them with two successive shots in such a way that the arrows gave the effect of horns. Sometimes he would have a slave stand at a distance and hold out the palm of his right hand for a mark, with the fingers spread; then he directed his arrows with such accuracy that they passed harmlessly between the fingers.[266]

Now divinized, Domitian's aim is still more deadly—and so are his intentions, as it happens. The rainbow in Revelation 4:3, far from representing the cessation of the deity's warlike hostilities against humanity, signifies instead their resumption, as the ensuing annihilation of the earth and its inhabitants testifies.[267]

Somewhat to his surprise, however, the emperor finds that he has also acquired a pair of female breasts in the course of his apocalyptic apotheosis.[268] Well might he now accept the offer effusively extended to him by extravagant Martial in the seventh book of the *Epigrams*: "Accept the rough breastplate [*crudum thoraca*] of the warrior Minerva, O you whom even the wrathful locks of Medusa fear."[269] Domitian's ample Minervan bosom does prohibit him from exhibiting himself topless, but otherwise it does not affect the eternal posing routine that his life has now, blessedly, become. Certainly, it does not deter his audience. He is draped in the *ḥālûk*, which has been artfully cut to display his torso, arms, and thighs to maximum advantage.[270] His accessories include a rainbow, as we have seen, but the latter's purpose is cosmetic as well as military. The rainbow "looks like *smaragdos*," we are told (4:3). *Smaragdos* (emerald?) "varied in color from green to a colorless state," as Beasley-Murray notes. "John may wish to indicate that about the Lord on the throne was a halo, green in colour, which served alike to suggest and conceal his glory from his creatures."[271]

266 Suetonius, *Domitian* 19 (Rolfe's trans.). Domitian apparently inherited his father's prowess with the bow (cf. Suetonius, *Titus* 5.2).

267 I find Caird's caveat unconvincing: the rainbow "warns us not to interpret the visions of disaster that follow as though God had forgotten his promise to Noah" (*The Revelation of Saint John*, 63), a sentiment echoed by all the other commentators listed in n. 264 above, with the exception of Ford.

268 Yahweh's breasts, needless to say. Hercules, too, despite being a super-male—or perhaps because of it—evinces a compromised masculinity: certain traditions depict him dressed up in women's clothes (see Loraux, "Herakles," 33-40).

269 Martial, *Epigrams* 7.1.

270 The *ḥālûk* is Yahweh's muscle-shirt, as we saw earlier.

271 Beasley-Murray, *Revelation*, 113; cf. Roloff, *The Revelation of John*, 69. The three gems that feature in this vision—jasper, carnelian, and emerald(?)—are also found on yet another breastplate, that of the high priest in Exod. 28:17-20; 39:8-21; cf. Rev. 21:18-20 (Ford, *Revelation*, 71).

The beholding even of his partially clothed, partially clouded, but altogether Priapean form elicits utter adulation, indeed outright adoration, in the vast audience (the myriad of Martials, the slew of Statiuses) that eternally throngs the heavenly temple.[272] For just as the temple is, or might as well be, Go(l)d's, the worship that resounds within it is, or might as well be, hero worship.[273] And that is precisely what the God of Revelation craves. Indeed, this vast audience of idolizers—nameless, faceless, countless (cf. 5:11–13; 7:9–10; 19:1–8)—is actually nothing more than an infinite row of mirrors lining the interior walls of the heavenly city, which turns out to be a perfect cube some 12,000 stadia (approx. 1,500 miles) high, broad and long (21:16; cf. 1 Kings 6:20). And the sole purpose of this vast mirrored enclosure is eternally to reflect the divine perfection back to the divinity himself. The emperor has become his own love object.

272 The throne room in Revelation doubles as a temple (see esp. 14:15, 17). In the East, palace and temple were often closely connected (see Peterson, *The Angels and the Liturgy*, 54, n. 14).

273 Or better, *superhero* worship. Jesus, in particular, is a superhero throughout the New Testament. "The Hulk, Superman, and their counterparts are definitely embodiments of hegemonic masculinity" (Klein, *Little Big Men*, 267; cf. Dutton, *The Perfectible Body*, 154). As such, they can be regarded as contemporary incarnations of *the* incarnation, Jesus, who himself possesses hypermasculine traits. Not only do superheroes have superhuman powers, as does Jesus, they are "stoic in the face of pain, unemotional" (Klein, *Little Big Men*, 267). Note how Jesus tends to shed his emotions as we move from the "low" christology of Mark to the "high" (heroic?) christology of the Fourth Gospel. "What makes [these superheroes] even more masculine are their alter egos, all of whom are ordinary" (ibid.; cf. Simpson, *Male Impersonators*, 25–26). Mild-mannered Clark Kent is secretly Superman, for example, while egghead Bruce Banner is secretly the Hulk, and the carpenter from Nazareth is secretly the Son of God (especially in Mark; see further Aichele, "Rewriting Superman"). The recent death and resurrection of the Man of Steel (*Superman* #75, 76) only serves to put a cap on the resemblance.

GOOD FRIDAY
THE THIRTEENTH?

I cannot claim that this book is a tightly integrated whole, a single organism whose three components could not function independently of each other. Instead there are three organisms locked in an intimate embrace—three organisms, and hence three organs and three orgasms.

I must confess that these three orgasms have nothing to do with romantic love, much less divine love, and everything to do with submission and control (biblical criticism can be a sordid business). Each climax, each conclusion, is precipitated by a process of uncovering. The first essay uncovers the extent to which the cross has been deployed as a "disciplinary technology," a strategy of subjection, in Christian theology, thereby replicating its original function in the Roman state. The second essay uncovers the extent to which biblical criticism is an exercise in violence. The more incisive, the more penetrating the criticism, the deeper the damage it inflicts on its object, that body of texts, which, for billions of human beings over thousands of years, has been the ultimate fantasy object: a book that can only tell the truth. And the third essay uncovers the extent to which the biblical God in all his incarnations—Yahweh, the Father of Jesus Christ, Jesus himself—is a projection of male narcissism. Caricature is the necessary instrument of this uncovering, serving to bring the projection into sharper focus.

These three conclusions are not unrelated. The biblical God is the supreme embodiment of hegemonic hypermasculinity, and as such the object of universal adoration. The ultimate purpose attributed to this God is total control: All must be subject to his absolute rule, and the cross of Jesus Christ provides a surprisingly subtle and therefore effective instrument of subjection, as we have seen. Just how subtle, how sublime, is shown by the fact that it can be wielded equally effectively by the most unlettered televangelist and the most erudite biblical scholar, by a Bakker or a Swaggart no less than a Bultmann or a Sanders, adapting to the clumsy grip of the former as easily as to the delicate grip of the latter.

But all of this merely returns us to the second essay. For if what I have been arguing about the Bible is indeed the case—that its God is a singularly pure projection of the will to power—then the biblical critic might have no choice but to clutch his or her scalpel defensively, to brandish it threateningly, as the hypermasculine hulk that is the biblical God lumbers across the examining room, an imperious frown furrowing his perfectly handsome fea-

tures, and a pair of handcuffs dangling ominously from his weight-lifting belt, which is cinched around his bloodstained butcher's apron, from the pocket of which a blindfold protrudes. "You do not believe because you have seen me," he intones. "Blessed are those who have not seen and therefore believe."

works cited

Abaecherli, Aline L. "Imperial Symbols on Certain Flavian Coins." *Classical Philology* 30 (1935): 131–40.

Ackroyd, Peter R. *Exile and Restoration: A Study of Hebrew Thought of the Sixth Century B.C.* The Old Testament Library. Philadelphia: The Westminster Press, 1968.

Adams, Dickenson W., and Ruth W. Lester, eds. *Jefferson's Extracts from the Gospels: "The Philosophy of Jesus" and "The Life and Morals of Jesus."* The Papers of Thomas Jefferson, Second Series. Princeton, NJ: Princeton University Press, 1983.

Aichele, George. "Rewriting Superman: 'Lois and Clark,' the Monomyth, and the Messianic Secret." In *AAR/SBL Abstracts 1995*, 123. Atlanta: Scholars Press, 1995.

Almond, Philip C. *Heaven and Hell in Enlightenment England.* Cambridge: Cambridge University Press, 1994.

Anderson, Gary A. "Sacrifice and Sacrificial Offerings (Old Testament)." In *The Anchor Bible Dictionary*, edited by David Noel Freedman et al, 5:870–86. New York: Doubleday, 1992.

———. *Sacrifices and Offerings in Ancient Israel: Studies in Their Social and Political Importance.* Harvard Semitic Monographs 41. Atlanta: Scholars Press, 1987.

Anon. *Catechism of the Catholic Church.* Liguori, MO: Liguori Publications, 1994.

Anon. "The Jesus Seminar: Voting Records Sorted by Gospel, Chapter, and Verse." *Forum* 6 (1990): 3–55.

Anselm, Saint. *Saint Anselm: Basic Writings. Proslogium; Monologium; Gaunilon's On Behalf of the Fool; Cur Deus Homo.* Open Court Classics 54. Translated by S. N. Deane. 2d ed. LaSalle, IL: Open Court, 1966.

Anson, Barry J., and Chester B. McVay. *Surgical Anatomy.* 2 vols. 6th ed. Philadelphia: W. B. Saunders Company, 1984.

Ashton, John. *Studying John: Approaches to the Fourth Gospel.* Oxford: Clarendon Press, 1994.

———. *Understanding the Fourth Gospel.* Oxford: Clarendon Press, 1991.

Aulén, Gustaf. *Christus Victor: An Historical Study of the Three Main Types of the Idea of the Atonement.* Translated by A. G. Herbert. New York: Macmillan, 1940.

Aune, David E. "The Influence of Roman Imperial Court Ceremonial on the

Apocalypse of John." *Papers of the Chicago Society of Biblical Research* 28 (1983): 5–26.

———. "The Social Matrix of the Apocalypse of John." *Papers of the Chicago Society of Biblical Research* 26 (1981): 16–32.

Bailey, D. R. Shackleton, ed. and trans. *Martial: Epigrams*. 3 vols. The Loeb Classical Library. Cambridge, MA: Harvard University Press, 1993.

Baird, William. *History of New Testament Research*. Vol. 1, *From Deism to Tübingen*. Minneapolis: Fortress Press, 1992.

Bal, Mieke. *Lethal Love: Feminist Literary Readings of Biblical Love Stories*. Indiana Studies in Biblical Literature. Bloomington and Indianapolis: Indiana University Press, 1987.

Barbet, Pierre. *A Doctor at Calvary: The Passion of Our Lord Jesus Christ as Described by a Surgeon*. Translated by the Earl of Wicklow. New York: P. J. Kenedy & Sons, 1953.

Barr, James. "Theophany and Anthropomorphism in the Old Testament." *Vetus Testamentum Supplements* 7 (1959): 31–38.

Barrett, C. K. *A Critical and Exegetical Commentary on the Acts of the Apostles*. Vol. 1, *Preliminary Introduction and Commentary on Acts I–XIV*. The International Critical Commentary. Edinburgh: T. & T. Clark, 1994.

———. *The Gospel According to St. John*. 2d ed. Philadelphia: The Westminster Press, 1978.

Barth, Gerhard. *Der Tod Jesu Christi im Verständnis des Neuen Testaments*. Neukirchen-Vluyn: Neukirchener Verlag, 1992.

Barth, Karl. *Anselm: Fides Quaerens Intellectum*. Translated by Ian W. Robertson. London: SCM Press, 1960.

———. *Church Dogmatics*. Vol. 4, *The Doctrine of Reconciliation*. 3 pts. Edited by G. W. Bromiley and T. F. Torrance. Translated by G. W. Bromiley. Edinburgh: T. & T. Clark, 1956–61.

———. *The Epistle to the Romans*. Translated by Edwyn C. Hoskyns. Oxford: Oxford University Press, 1933.

Bauckham, Richard. *The Climax of Prophecy: Studies on the Book of Revelation*. Edinburgh: T. & T. Clark, 1993.

———. *The Theology of the Book of Revelation*. New Testament Theology. Cambridge: Cambridge University Press, 1993.

Bauer, Walter. *A Greek-English Lexicon of the New Testament and Other Early Christian Literature*. Translated and adapted by William F. Arndt and F. Wilbur Gingrich. Revised by F. Wilbur Gingrich and Frederick W. Danker. Chicago: University of Chicago Press, 1979.

Beasley-Murray, George R. *John*. The Word Biblical Commentary 36. Waco, TX: Word Books, 1987.

———. *Revelation*. The New Century Bible Commentary. 2d ed. Grand Rapids, MI: William B. Eerdmans, 1978.

Bernstein, Alan E. *The Formation of Hell: Death and Retribution in the Ancient and Early Christian Worlds*. Ithaca, NY: Cornell University Press, 1993.

Betz, Otto. "Stigma." In *Theological Dictionary of the New Testament*, edited by Gerhard Kittel and Gerhard Friedrich, and translated by Geoffrey W. Bromiley, 7:657–64. Grand Rapids, MI: William B. Eerdmans, 1964–74.

Biale, David. "The God with Breasts: El Shaddai in the Bible." *History of Religions* 21 (1982): 240–56.

The Bible and Culture Collective. *The Postmodern Bible*. New Haven, CT: Yale University Press, 1995.

Bickerman, Elias J. "The Date of Fourth Maccabees." In *Studies in Jewish and Christian History*, 275–81. Arbeiten zur Geschichte des antiken Judentums und Urchristentums 9. Leiden, Netherlands: Brill, 1976.

Bledstein, Adrien Janis. "Are Women Cursed in Genesis 3.16?" In *A Feminist Companion to Genesis*, edited by Athalya Brenner, 142–45. Feminist Companion to the Bible 2. Sheffield, U.K.: JSOT Press, 1993.

Blinzler, Josef. *The Trial of Jesus: The Jewish and Christian Proceedings against Jesus Christ Described and Assessed from the Oldest Accounts*. Translated by Isabel McHugh and Florence McHugh. Westminster, MD: Newman Press, 1959.

Boff, Leonardo. *Passion of Christ, Passion of the World: The Facts, Their Interpretation, and Their Meaning Yesterday and Today*. Translated by Robert R. Barr. Maryknoll, NY: Orbis Books, 1987.

Bolin, Anne. "Vandalized Vanity: Feminine Physiques Betrayed and Portrayed." In *Tattoo, Torture, Mutilation, and Adornment: The Denaturalization of the Body in Culture and Text*, edited by Frances E. Mascia-Lees and Patricia Sharpe, 79–99. SUNY Series on the Body in Culture, History, and Religion. Albany: State University of New York Press, 1992.

Borg, Marcus J. *Jesus: A New Vision. Spirit, Culture, and the Life of Discipleship*. San Francisco: Harper & Row, 1987.

———. *Meeting Jesus Again for the First Time: The Historical Jesus and the Heart of Contemporary Faith*. San Francisco: Harper San Francisco, 1994.

Boring, M. Eugene. *Revelation*. Interpretation: A Bible Commentary for Teaching and Preaching. Louisville, KY: John Knox Press, 1989.

Boyarin, Daniel. *Carnal Israel: Reading Sex in Talmudic Culture*. The New Historicism: Studies in Cultural Poetics 25. Berkeley and Los Angeles: University of California Press, 1993.

———. "The Eye in the Torah: Ocular Desire in Midrashic Hermeneutic." *Critical Inquiry* 16 (1990): 532–50.

———. *A Radical Jew: Paul and the Politics of Identity*. Contraversions:

Critical Studies in Jewish Literature, Culture and Society. Berkeley and Los Angeles: University of California Press, 1994.

Brainum, Jerry. "Spank That Baby Fat!" *Flex* (July 1994): 211.

Bronner, Leila Leah. *From Eve to Esther: Rabbinic Reconstructions of Biblical Women*. Louisville, KY: Westminster/John Knox Press, 1994.

————."Gynomorphic Imagery in Exilic Isaiah (40–66)." *Dor le Dor* 12 (1983–84): 71–83.

Brown, Joanne Carlson, and Rebecca Parker. "For God So Loved the World?" In *Christianity, Patriarchy, and Abuse: A Feminist Critique*, edited by Joanne Carlson Brown and Carole R. Bohn, 1–30. New York: Pilgrim Press, 1989.

Brown, Peter. *The Body and Society: Men, Women, and Sexual Renunciation in Early Christianity*. Lectures on the History of Religions; New Series 13. New York: Columbia University Press, 1988.

Brown, Raymond E. *The Death of the Messiah: From Gethsemane to the Grave. A Commentary on the Passion Narratives in the Four Gospels*. 2 vols. The Anchor Bible Reference Library. New York: Doubleday, 1994.

————. *The Gospel According to John XIII–XXI: A New Translation with Introduction and Commentary*. The Anchor Bible 29A. New York: Doubleday, 1970.

Bultmann, Rudolf. *The Gospel of John: A Commentary*. Translated by G. R. Beasley-Murray, R. W. N. Hoare and J. K. Riches. Philadelphia: The Westminster Press, 1971.

————. "New Testament and Mythology." In *Kerygma and Myth: A Theological Debate*, edited by Hans Werner Bartsch and translated by Reginald H. Fuller, 1–44. New York: Harper & Row, 1961.

————. "The Task of Theology in the Present Situation." In *Existence and Faith: Shorter Writings of Rudolf Bultmann*, edited and translated by Schubert M. Ogden, 158–65. New York: Living Age Books, 1960.

————. *The Theology of the New Testament*. 2 vols. Translated by Kendrick Grobel. New York: Charles Scribner's Sons, 1952–55.

Burgess, Anthony. *The Kingdom of the Wicked*. New York: Pocket Books, 1985.

Butler, George. *Arnold Schwarzenegger: A Portrait*. New York: Simon & Schuster, 1990.

Bynum, Caroline Walker. "The Female Body and Religious Practice in the Later Middle Ages." In *Fragments for a History of the Human Body*, edited by Michel Feher with Ramona Naddaff and Nadia Tazi, 1:161–219. New York: Zone, 1989.

————. *Jesus as Mother: Studies in the Spirituality of the High Middle Ages*. Publications of the Center for Medieval and Renaissance Studies, UCLA, 16. Berkeley nad Los Angeles: University of California Press, 1982.

Caird, G. B. *The Revelation of Saint John*. Black's New Testament Commentary. London: A. & C. Black, 1966.

Calvin, John. *Commentaries on the First Book of Moses, Called Genesis*. 2 vols. Translated by John King. Grand Rapids, MI: William B. Eerdmans, 1948.

Cassuto, Umberto. *A Commentary on the Book of Genesis*. Part I, *From Adam to Noah: Genesis I–VI.8*. Part II, *From Noah to Abraham: Genesis VI.9–XI.32*. Translated by Israel Abrahams. Publications of the Perry Foundation for Biblical Research. Jerusalem: The Magnes Press, 1961–64.

Castelli, Elizabeth A. *Imitating Paul: A Discourse of Power*. Literary Currents in Biblical Interpretation. Louisville, KY: Westminster/John Knox Press, 1991.

———. "Interpretations of Power in 1 Corinthians." *Semeia* 54 (1991): 197–222.

Castiglioni, Arturo. *A History of Medicine*. Translated and edited by E. B. Krumbhaar. 2d ed. New York: Alfred A. Knopf, 1958.

Charles, R. H. *A Critical and Exegetical Commentary on the Revelation of St. John*. 2 vols. The International Critical Commentary. Edinburgh: T. & T. Clark, 1920.

Charlesworth, James H., ed. *The Old Testament Pseudepigrapha*. Vol. 1, *Apocalyptic Literature and Testaments*. Vol. 2, *Expansions of the "Old Testament" and Legends, Wisdom and Philosophical Literature, Prayers, Psalms, and Odes, Fragments of Lost Judeo-Hellenistic Works*. Garden City, NY: Doubleday, 1983–85.

Chatman, Seymour. *Story and Discourse: Narrative Structure in Fiction and Film*. Ithaca, NY: Cornell University Press, 1978.

Cherbonnier, E. LaB. "The Logic of Biblical Anthropomorphism." *Harvard Theological Review* 55 (1962): 187–206.

Childs, Brevard S. *The Book of Exodus: A Critical, Theological Commentary*. The Old Testament Library. Philadelphia: The Westminster Press, 1974.

Christensen, Duane L. *Deuteronomy 1–11*. The Word Biblical Commentary 6A. Dallas: Word Books, 1991.

Clines, David J.A. *Interested Parties: The Ideology of Writers and Readers of the Hebrew Bible*. Gender, Culture, Theory 1. Sheffield, U.K.: Sheffield Academic Press, 1995.

Cohen, Martin S. *The Shi'ur Qomah: Liturgy and Theurgy in Pre-Kabbalistic Jewish Mysticism*. Lanham, MD: University Press of America, 1983.

———. *The Shi'ur Qomah: Texts and Recensions*. Tübingen: J.C.B. Mohr (Paul Siebeck), 1985.

Cohn, Norman. *Cosmos, Chaos and the World to Come: The Ancient Roots of Apocalyptic Faith*. New Haven, CT: Yale University Press, 1993.

Colson, F. H., and G. H. Whitaker. *Philo.* 10 vols. and 2 supp. vols. The Loeb Classical Library. Cambridge, MA: Harvard University Press, 1929–62.

Conway, Ronald. *The Rage for Utopia.* Sydney, Australia: Allen & Unwin, 1992.

Cranfield, C. E. B. "The Cup Metaphor in Mark xiv. 36 and Parallels." *Expository Times* 59 (1947–48): 137–38.

———. *A Critical and Exegetical Commentary on the Epistle to the Romans.* 2 vols. The International Critical Commentary. Edinburgh: T. & T. Clark, 1975–79.

Cross, Frank Moore. *Canaanite Myth and Hebrew Epic.* Cambridge, MA: Harvard University Press, 1973.

Crossan, John Dominic. *The Essential Jesus: Original Sayings and Earliest Images.* San Francisco: Harper San Francisco, 1994.

———. *The Historical Jesus: The Life of a Mediterrainean Jewish Peasant.* San Francisco: Harper San Francisco, 1991.

———. *Jesus: A Revolutionary Biography.* San Francisco: Harper San Francisco, 1994.

———. *Who Killed Jesus? Exposing the Roots of Anti-Semitism in the Gospel Story of the Death of Jesus.* San Francisco: Harper San Francisco, 1995.

Culpepper, R. Alan. *Anatomy of the Fourth Gospel: A Study in Literary Design.* 2d ed. Philadelphia: Fortress Press, 1987.

———. *John, the Son of Zebedee: The Life of a Legend.* Studies on Personalities of the New Testament. Columbia: University of South Carolina Press, 1994.

Cuss, Dominique. *Imperial Cult and Honorary Terms in the New Testament.* Paradosis 23. Fribourg: Fribourg University Press, 1974.

Daly, Robert J. *Christian Sacrifice: The Judaeo-Christian Background Before Origen.* The Catholic University of America Studies in Christian Antiquity 18. Washington, D.C.: The Catholic University of America Press, 1978.

Davidson, Robert. *Genesis 1–11.* Cambridge Bible Commentary. Cambridge: Cambridge University Press, 1973.

Davies, W. D. *Paul and Rabbinic Judaism: Some Rabbinic Elements in Pauline Theology.* 4th ed. Philadelphia: Fortress Press, 1980.

Davies, W. D., and Dale C. Allison, Jr. *A Critical and Exegetical Commentary on the Gospel According to Saint Matthew.* Vol. 1, *Introduction and Commentary on Matthew I–VII.* The International Critical Commentary. Edinburgh: T. & T. Clark, 1988.

Deissman, Adolf. *Licht vom Osten.* 4th ed. Tübingen: J. C. B. Mohr, 1923.

Denzinger, Heinrich, et al. *Enchiridion symbolorum: definitionum et declarationum de rebus fidei et morum.* 32nd ed. Freiburg: Herder, 1963.

Derrida, Jacques. "Différance." In *Margins of Philosophy*, translated and annotated by Alan Bass, 1–27. Chicago: University of Chicago Press, 1982.

De Vaux, Roland. *Studies in Old Testament Sacrifice*. Cardiff: University of Wales Press, 1964.

Dodd, C. H. *The Epistle of Paul to the Romans*. Moffatt New Testament Commentary. London: Hodder & Stoughton, 1932.

———. *The Interpretation of the Fourth Gospel*. Cambridge: Cambridge University Press, 1953.

Donfried, Karl P. "1 Thessalonians 2:13–16 as a Test Case." *Interpretation* 38 (1984): 242–53.

Douglas, Mary. "The Forbidden Animals in Leviticus." *Journal for the Study of the Old Testament* 59 (1993): 3–23.

———. *Natural Symbols: Explorations in Cosmology*. New York: Pantheon Books, 1970.

———. *Purity and Danger: An Analysis of Concepts of Pollution and Taboo*. London: Routledge & Kegan Paul, 1966.

Downing, F. Gerald. *The Christ and the Cynics*. JSOT Manuals 4. Sheffield: Sheffield Academic Press, 1988.

———. *Cynics and Christian Origins*. Edinburgh: T. & T. Clark, 1992.

Dreyfus, Hubert L., and Paul Rabinow. *Michel Foucault: Beyond Structuralism and Hermeneutics*. 2d ed. Chicago: University of Chicago Press, 1983.

DuBois, Page. *Torture and Truth*. New York: Routledge, 1991.

Duke, Martin. *The Development of Medical Techniques and Treatments: From Leeches to Heart Surgery*. Madison, CT: International Universities Press, 1991.

Dunn, James D. G. *Romans 1–8*. The Word Biblical Commentary 38A. Dallas: Word Books, 1988.

Dutton, Kenneth R. *The Perfectible Body: The Western Ideal of Male Physical Development*. New York: Continuum, 1995.

Edwards, William D., Wesley J. Gabel and Floyd E. Hosmer. "On the Physical Death of Jesus Christ." *Journal of the American Medical Association* 255 (1986): 1455–63.

Eichrodt, Walther. *Theology of the Old Testament*. 2 vols. Translated by J. A. Baker. The Old Testament Library. Philadelphia: The Westminster Press, 1961.

Eilberg-Schwartz, Howard. *God's Phallus and Other Problems for Men and Monotheism*. Boston: Beacon Press, 1994.

———. "The Problem of the Body for the People of the Book." In *People of the Body: Jews and Judaism from an Embodied Perspective*, edited by Howard Eilberg-Schwartz, 17–46. SUNY Series on the Body in Culture, History, and Religion. Albany: State University of New York Press, 1992.

———. *The Savage in Judaism: An Anthropology of Israelite Religion and Ancient Judaism*. Bloomington and Indianapolis: Indiana University Press, 1990.

Eribon, Didier. *Michel Foucault.* Translated by Betsy Wing. Cambridge, MA: Harvard University Press, 1991.

Fee, Gordon D. *God's Empowering Presence: The Holy Spirit in the Letters of Paul.* Peabody, MA: Hendrickson, 1994.

Feuerbach, Ludwig. *Das Wesen des Christenthums.* Leipzig: O. Wigand, 1841.

Fishbane, Michael. "Arm of the Lord: Biblical Myth, Rabbinic Midrash, and the Mystery of History." In *Language, Theology, and the Bible: Essays in Honor of James Barr,* edited by Samuel E. Balentine and John Barton, 271–92. Oxford: Clarendon Press, 1994.

Fishwick, Duncan. *The Imperial Cult in the Latin West: Studies in the Ruler Cult of the Western Provinces of the Roman Empire.* 2 vols. Études préliminaires aux religions orientales dans l'Empire romain 108. Leiden, Netherlands: E.J. Brill, 1987–92.

Fitness, Johnny. "Whoomp! It's Dorian...without the Shadow of a Doubt!" *MuscleMag International* (January 1994): 36–48.

Fitzmyer, Joseph A. *The Gospel According to Luke I–IX: A New Translation with Introduction and Commentary.* The Anchor Bible 28. New York: Doubleday, 1981.

———. *The Gospel According to Luke X–XXIV: A New Translation with Introduction and Commentary.* The Anchor Bible 28A. New York: Doubleday, 1985.

———. *Romans: A New Translation with Introduction and Commentary.* The Anchor Bible 33. New York: Doubleday, 1993.

Forbes, Thomas R. "To Be Dissected and Anatomized." *Journal of the History of Medicine and Allied Sciences* 36 (1981): 490–92.

Ford, Joan Massyngberde. *Revelation.* The Anchor Bible 38. Garden City, NY: Doubleday, 1975.

Fortna, Robert Tomson. *The Gospel of Signs: A Reconstruction of the Narrative Source Underlying the Fourth Gospel.* Cambridge: Cambridge University Press, 1970.

Foucault, Michel. *The Archaeology of Knowledge.* Translated by A. M. Sheridan Smith. New York: Pantheon Books, 1972.

———. *The Birth of the Clinic: An Archaeology of Medical Perception.* Translated by Alan Sheridan. New York: Vintage Books, 1973.

———. *Discipline and Punish: The Birth of the Prison.* Translated by Alan Sheridan. New York: Vintage Books, 1977.

———. "The Discourse of History." In *Foucault Live (Interviews, 1966–84),* edited by Sylvère Lotringer and translated by John Johnston, 11–34. New York: Semiotext(e), 1989.

———. "Governmentality." In *The Foucault Effect: Studies in Governmentality,* edited by Graham Burchell, Colin Gordon, and Peter Miller, 87–104. Chicago: The University of Chicago Press, 1991.

———. *The History of Sexuality*. Translated by Robert Hurley. Vol. 1, *An Introduction*. Vol. 2, *The Use of Pleasure*. Vol. 3, *The Care of the Self*. New York: Vintage Books, 1978–86.

———. *Madness and Civilization: A History of Insanity in the Age of Reason*. Translated by Richard Howard. New York: Pantheon Books, 1965. Abridged trans. of *Histoire de la folie à l'âge classique*. Paris: Plon, 1961.

———. *Maladie mentale et personalité*. 2d ed. Paris: Universitaires de France, 1962.

———. "On Power." In *Politics, Philosophy, Culture: Interviews and Other Writings, 1977–1984*, edited by Lawrence D. Kritzman and translated by Alan Sheridan et al., 96–109. New York: Routledge, 1988.

———. *The Order of Things: An Archaeology of the Human Sciences*. Trans. anon. New York: Vintage Books, 1970.

———. "Politics and Reason." In *Politics, Philosophy, Culture*, 57–85.

———. "Questions of Method." In *The Foucault Effect*, 73–86.

———. "Questions on Geography." In *Power/Knowledge: Selected Interviews and Other Writings, 1972–1977*, edited by Colin Gordon and translated by Colin Gordon et al., 63–77. New York: Pantheon Books, 1980.

———. "The Subject and Power." Afterword to Hubert L. Dreyfus and Paul Rabinow, *Michel Foucault: Beyond Structuralism and Hermeneutics*, 208–26. 2d ed. Chicago: University of Chicago Press, 1983.

———. "Technologies of the Self." In *Technologies of the Self: A Seminar with Michel Foucault*, edited by Luther H. Martin, Huck Gutman, and Patrick H. Hutton, 16–49. Amherst: University of Massachusetts Press, 1988.

Foucault, Michel, ed. *I, Pierre Rivière, Having Slaughtered My Mother, My Sister, and My Brother...: A Case of Parricide in the Nineteenth Century*. Translated by F. Jellinek. New York: Pantheon Books, 1975.

Frei, Hans W. *The Eclipse of Biblical Narrative: A Study in Eighteenth and Nineteenth Century Hermeneutics*. New Haven, CT: Yale University Press, 1974.

Freud, Sigmund. *An Autobiographical Study*. In *The Standard Edition of the Complete Psychological Works of Sigmund Freud*, edited and translated by James Strachey et al., 20:3–76. London: Hogarth Press and the Institute of Psycho-Analysis, 1953–74.

———. *The Future of an Illusion*. In *The Standard Edition*, 21:1–56.

———. *The Interpretation of Dreams*. In *The Standard Edition*, vols. 4 and 5.

———. *Leonardo da Vinci and a Memory of His Childhood*. In *The Standard Edition*, 11:59–137.

———. *Moses and Monotheism: Three Essays*. In *The Standard Edition*, 23:1–137.

————. *New Introductory Lectures on Psycho-Analysis*. In *The Standard Edition*, 22:1–182.

Freud, Sigmund, and C. G. Jung. *The Freud/Jung Letters: The Correspondence between Sigmund Freud and C. G. Jung*. Edited by William McGuire and translated by Ralph Manheim and R. F. C. Hull. Princeton: Princeton University Press, 1974.

Frye, Northrop. *Anatomy of Criticism: Four Essays*. Princeton, NJ: Princeton University Press, 1957.

Funk, Robert W., Roy W. Hoover, and The Jesus Seminar. *The Five Gospels: The Search for the Authentic Words of Jesus*. New York: Macmillan, 1993.

Fussel, Samuel Wilson. "Bodybuilder Americanus." In *The Male Body: Features, Destinies, Exposures*, edited by Laurence Goldstein, 43–60. Ann Arbor: University of Michigan Press, 1994.

————. *Muscle: Confessions of an Unlikely Bodybuilder*. New York: Avon Books, 1991.

Gaines, Charles, and George Butler. *Pumping Iron: The Art and Sport of Bodybuilding*. London: Sphere Books, 1974.

Gamble, Harry Y. *Books and Readers in the Early Church: A History of Early Chrisitan Texts*. New Haven, CT: Yale University Press, 1995.

Gentry, Kenneth L., Jr. *Before Jerusalem Fell: Dating the Book of Revelation. An Exegetical and Historical Argument for a Pre-A.D. 70 Composition*. Tyler, TX: Institute for Christian Economics, 1989.

George, A. Raymond. *Communion with God in the New Testament*. London: The Epworth Press, 1953.

Georgi, Dieter. "Rudolf Bultmann's *Theology of the New Testament* Revisited." In *Bultmann, Retrospect and Prospect: The Centenary Symposium at Wellesley*, edited by Edward C. Hobbs, 75–87. Harvard Theological Studies 35. Philadelphia: Fortress Press, 1985.

Gilly, René. *Passion de Jésus. Les conclusions d'un médicin*. Paris: Fayard, 1985.

Ginzberg, Louis. *The Legends of the Jews*. 7 vols. Translated by Henrietta Szold et al. Philadelphia: The Jewish Publication Society of America, 1909–1959.

Goldstein, Jonathan A. *II Maccabees: A New Translation with Introduction and Commentary*. The Anchor Bible 41A. Garden City, NY: Doubleday, 1983.

Gottstein, Alon Goshen. "The Body as Image of God in Rabbinic Literature." *Harvard Theological Review* 87 (1994): 171–95.

Gray, Henry. *Anatomy of the Human Body*. 30th American edition. Edited by Carmine D. Clemente. Philadelphia: Lea & Febiger, 1985.

Grayston, Kenneth. *Dying, We Live: A New Enquiry into the Death of Christ in the New Testament*. Oxford: Oxford University Press, 1990.

Greenberg, Moshe. *Ezekiel 1–20: A New Translation with Introduction and Commentary*. The Anchor Bible 22. Garden City, NY: Doubleday, 1983.

Greenblatt, Stephen J. *Learning to Curse: Essays in Early Modern Culture*. New York: Routledge, 1990.

Grelot, Pierre. *Péché originel et rédemption examinés à partir de l'Epître aux Romains: Essais théologiques*. Paris: Declée, 1973.

Groden, Michael, and Martin Kreiswirth, eds. *The Johns Hopkins Guide to Literary Theory and Criticism*. Baltimore: The Johns Hopkins University Press, 1994.

Gruber, Mayer I. "The Motherhood of God in Second Isaiah." In *The Motherhood of God and Other Studies*, 3–15. South Florida Studies in the History of Judaism 57. Atlanta: Scholars Press, 1992.

Gundry, Robert H. *Mark: A Commentary on His Apology for the Cross*. Grand Rapids, MI: William B. Eerdmans, 1993.

———. *Sōma in Biblical Theology: With Emphasis on Pauline Anthropology*. Studiorum Novi Testamenti Societas Monograph Series 29. Cambridge: Cambridge University Press, 1976.

Hadas, Moses. *The Third and Fourth Books of Maccabees*. New York: Harper & Row, 1953.

Halperin, David M. *Saint Foucault: Towards a Gay Hagiography*. Oxford: Oxford University Press, 1995.

Hampson, Daphne. *Theology and Feminism*. Oxford: Basil Blackwell, 1990.

Hanson, A. T. *The Wrath of the Lamb*. London: SPCK, 1957.

Hanson, Paul D. *The Dawn of Apocalyptic: The Historical and Sociological Roots of Jewish Apocalyptic Eschatology*. 2d ed. Philadelphia: Fortress Press, 1979.

Harcourt, Glenn. "Andreas Vesalius and the Anatomy of Antique Sculpture." *Representations* 17 (1987): 28–61.

Harrington, Wilfred J. *Revelation*. Sacra Pagina. Collegeville, MN: The Liturgical Press, 1993.

Harvey, Susan Ashbrook. "The Odes of Solomon." In *Searching the Scriptures*. Vol. 2, *A Feminist Commentary*, edited by Elisabeth Schüssler Fiorenza with Ann Brock and Shelly Matthews, 86–98. New York: Crossroad, 1994.

Heller, Scott. "Bodies on Stage." *The Chronicle of Higher Education* (June 12, 1991): A9.

Hemer, Colin J. *The Letters to the Seven Churches of Asia in Their Local Setting*. JSNT Supplement Series 11. Sheffield, U.K.: JSOT Press, 1986.

Hengel, Martin. *The Atonement: The Origins of the Doctrine in the New Testament*. Translated by John Bowden. Philadelphia: Fortress Press, 1981.

———. *Crucifixion in the Ancient World and the Folly of the Message of the Cross*. Translated by John Bowden. Philadelphia: Fortress Press, 1977.

Herion, Gary A. "Wrath of God (Old Testament)." In *The Anchor Bible Dictionary*, edited by David Noel Freedman et al, 6:989–96. New York: Doubleday, 1992.

Herrlinger, Robert. *History of Medical Illustration from Antiquity to A.D. 1600*. Translated by Graham Fulton-Smith. n.p.: Pitman Medical and Scientific Publishing Company, 1970.

Heschel, Abraham J. *The Prophets*. Philadelphia: The Jewish Publication Society of America, 1962.

Heseler, Baldasar. *Andreas Vesalius's First Public Anatomy at Bologna, 1540: An Eyewitness Report*. Edited and translated by Ruben Eriksson. Uppsala and Stockholm: Almqvist & Wiksells, 1959.

Hoffman, David Zvi. *Midrash Tana'im*. Berlin: n.p., 1908.

Hollinshead, W. Henry. *Anatomy for Surgeons*. Vol. 1, *The Head and Neck*. 2d ed. New York: Harper & Row, 1968.

Honer, Anne. "Beschreibung einer Lebenswelt: zur Empirie des Bodybuilding." *Zeitschrift für Soziologie* 14 (1985): 131–39.

Hoskyns, Edwyn C. *The Fourth Gospel*. Edited by F. N. Davey. 2d ed. London: Faber & Faber, 1947.

Humbert, Paul. *Études sur le récit du paradis et la chute dans la Genèse*. Mémoires de l'Université de Neuchâtel 14. Neuchâtel: Secrétariat de l'Université, 1940.

Idel, Moshe. *Kabbalah: New Perspectives*. New Haven, CT: Yale University Press, 1988.

Jacob, Benno. *The First Book of the Bible: Genesis*. Edited and translated by Ernest I. Jacob and Walter Jacob. New York: Ktav Publishing House, 1974.

Jaki, Stanley L. *Genesis 1 through the Ages*. London: Thomas More, 1992.

Janowitz, Naomi. "God's Body: Theological and Ritual Roles of *Shi'ur Komah*." In *People of the Body: Jews and Judaism from an Embodied Perspective*, edited by Howard Eilberg-Schwartz, 183–202. SUNY Series on the Body in Culture, History, and Religion. Albany: State University of New York Press, 1992.

Janzen, Ernest P. "The Jesus of the Apocalypse Wears the Emperor's Clothes." In *AAR/SBL Abstracts 1994*, 370. Atlanta: Scholars Press, 1994.

Jefferson, Thomas. *The Life and Morals of Jesus of Nazareth, Extracted Textually from the Gospels in Greek, Latin, French, and English*. Washington, D.C.: Government Printing Office, 1904.

Johnson, Luke T. *The Acts of the Apostles*. Sacra Pagina. Collegeville, MN: The Liturgical Press, 1992.

Jones, Brian W. *The Emperor Domitian*. New York: Routledge, 1992.

Jones, Donald L. "Christianity and the Roman Imperial Cult." In *Aufstieg und Niedergang der römischen Welt: Geschichte und Kultur Roms im*

Spiegel der neuren Forschung, edited by Hildegard Temporini and Wolfgang Haase, 2.23.2:1023–54. Berlin and New York: Walter de Gruyter, 1972–.

Jones, Gareth. *Bultmann: Towards a Critical Theology*. Cambridge, U.K.: Polity Press, 1991.

Käsemann, Ernst. *Commentary on Romans*. Translated and edited by Geoffrey W. Bromiley. Grand Rapids, MI: William B. Eerdmans, 1980.

———. "The Saving Significance of the Death of Jesus." In *Perspectives on Paul*, translated by Margaret Kohl, 32–59. Philadelphia: Fortress Press, 1971.

Kimber, Tim, Bill Reynolds, Peter Grymkowski, and Ed Connors. *The Gold's Gym Nutrition Bible*. Chicago: Contemporary Books, 1986.

Kirk, Kenneth E. *The Vision of God: The Christian Doctrine of the Summum Bonum*. London: Longmans, Green and Co., 1931.

Klauser, Theodor. "Aurum Coronarium." In *Gesammelte Arbeiten zur Liturgiegeschichte, Kirchengeschichte und Christlichen Archäologie*, edited by Ernst Dassmann, 292–309. Münster Westfalen: Aschendorffsche Verlagsbuchhandlung, 1974.

Klein, Alan M. *Little Big Men: Bodybuilding Subculture and Gender Construction*. SUNY Series on Sport, Culture, and Social Relations. Albany: State University of New York Press, 1993.

———. "Of Muscles and Men." *The Sciences* (November–December, 1993): 32–37.

Koch, Klaus. *The Growth of the Biblical Tradition: The Form-Critical Method*. Translated by S. M. Cupitt. New York: Charles Scribner's Sons, 1969.

Kraft, Heinrich. *Die Offenbarung des Johannes*. Handbuch zum Neuen Testament. Tübingen: J. C. B. Mohr (Paul Siebeck), 1974.

Krodel, Gerhard A. *Revelation*. Augsburg Commentary on the New Testament. Minneapolis: Augsburg Publishing House, 1989.

Kuhn, Heinz-Wolfgang. "Die Kreuzesstrafe während der frühen Kaiserzeit. Ihre Wirklichkeit und Wertung in der Umwelt des Urchristentums." In *Aufsteig und Niedergang der römischen Welt: Geschichte und Kultur Roms im Spiegel der neuren Forschung*, edited by Hildegard Temporini and Wolfgang Haase, 2.25.1:648–793. Berlin and New York: Walter de Gruyter, 1972–.

Kümmel, Werner Georg. *The New Testament: The History of the Investigation of Its Problems*. Translated by S. McLean Gilmour and Howard C. Kee. Nashville: Abingdon Press, 1972.

Laënnec, René Théophile Hyacinthe. *A Treatise on the Diseases of the Chest*. Translated by John Forbes. Philadelphia: J. Webster, 1823.

Lagrange, Marie-Joseph. *Évangile selon Saint Jean*. 8th ed. Paris: Gabalda, 1948.

Langdon, John H. *Human Dissection for the Health Sciences*. Boston: Little, Brown and Company, 1994.

Lassek, A. M. *Human Dissection: Its Drama and Struggle*. Springfield, IL: Charles C. Thomas, 1958.

Leclercq, Henri. "Flagellation (Supplice de la)." In *Dictionnaire d'Archéologie Chrétienne et de Liturgie*, edited by Fernand Cabrol and Henri Leclercq, 5:1638–43. Paris: Letouzey et Ané, 1924–53.

Leibowitz, Nehama. *Studies in Bereshit (Genesis) in the Context of Ancient and Modern Bible Commentary*. 4th ed. Edited and translated by Aryeh Newman. Jerusalem: World Zionist Organization Department for Torah Education and Culture, 1981.

Léon-Dufour, Xavier. *Life and Death in the New Testament*. Translated by Terrence Prendergast. San Francisco: Harper & Row, 1986.

Levine, Lee I., ed. *Ancient Synagogues Revealed*. Jerusalem: The Israel Exploration Society, 1981.

Lieberman, Saul. "Metatron, the Meaning of His Name and His Functions." Appendix to Ithamar Gruenwald, *Apocalyptic and Merkabah Mysticism*, 235–41. Arbeiten zur Geschichte des antiken Judentums und die Urchristentums 14. Leiden, Netherlands: Brill, 1980.

Liddell, Henry George, and Robert Scott. *A Greek-English Lexicon*. Revised by Sir Henry Stuart Jones with Roderick McKenzie. 9th ed. Oxford: Clarendon Press, 1966.

Lindars, Barnabas. *The Gospel of John*. The New Century Bible Commentary. Grand Rapids, MI: William B. Eerdmans, 1972.

Lingis, Alphonso. *Foreign Bodies*. New York: Routledge, 1994.

Lohmeyer, Ernst. *Die Offenbarung des Johannes*. 3d ed. Handbuch zum Neuen Testament. Tübingen: J. C. B. Mohr (Paul Siebeck), 1970.

Lohse, Eduard. *Märtyrer und Gottesknecht: Untersuchungen zur urchristlichen Verkündigung vom Sühntod Jesu Christi*. Forschungen zur Religion und Literatur des Alten und Neuen Testaments 64. Göttingen: Vandenhoeck & Ruprecht, 1955.

———. *Die Offenbarung des Johannes*. 12th ed. Das Neue Testament Deutsch. Göttingen: Vandenhoeck & Ruprecht, 1979.

Loisy, Alfred. *Le Quatrième évangile*. 2d ed. Paris: Émile Nourry, 1921.

Longenecker, Richard N. *Galatians*. The Word Biblical Commentary 41. Dallas: Word Books, 1990.

Loraux, Nicole. "Herakles: The Super-Male and the Feminine." In *Before Sexuality: The Construction of Erotic Experience in the Ancient Greek World*, edited by David M. Halperin, John J. Winkler, and Froma I. Zeitlin, 21–52. Princeton, NJ: Princeton University Press, 1990.

Lüdemann, Gerd. *Die Auferstehung Jesu: Historie, Erfahrung, Theologie.* Göttingen: Vandenhoeck & Ruprecht, 1994. ET: *The Resurrection of Jesus: History, Experience, Theology.* Translated by John Bowden. Minneapolis: Fortress Press, 1995.

Ludwig, Jurgen, et al. *Current Methods of Autopsy Practice.* Philadelphia: W. B. Saunders Company, 1972.

McDonald, H. D., *The New Testament Concept of the Atonement: The Gospel of the Calvary Event.* Grand Rapids, MI: Baker Book House, 1994.

Macey, David. *The Lives of Michel Foucault.* New York: Pantheon Books, 1993.

McFague, Sallie. *Models of God: Theology for an Ecological, Nuclear Age.* Philadelphia: Fortress Press, 1987.

McGough, Peter. "At the Court of King Dorian." *Flex* (September 1995): 197–98.

———. "Hard Times." *Flex* (January 1994): 39, 114, 133, 199.

———. "Brutal Beauty." *Flex* (January 1994): 98–116.

———. "A Shadow of Doubt." *Flex* (January 1995): 134–44, 195, 223.

McGrath, Alister E. *Luther's Theology of the Cross: Martin Luther's Theological Breakthrough.* Oxford: Basil Blackwell, 1985.

McIntyre, John. *St. Anselm and His Critics: A Reinterpretation of the* Cur Deus Homo. Edinburgh: Oliver and Boyd, 1954.

———. *The Shape of Soteriology: Studies in the Doctrine of the Death of Christ.* Edinburgh: T. & T. Clark, 1992.

Mack, Burton L. *The Lost Gospel: The Book of Q and Christian Origins.* San Francisco: Harper San Francisco, 1993.

———. *A Myth of Innocence: Mark and Christian Origins.* Philadelphia: Fortress Press, 1988.

———. *Who Wrote the New Testament? The Making of the Christian Myth.* San Francisco: Harper San Francisco, 1995.

McNamara, Martin. *The Apocrypha in the Irish Church.* Dublin: Dublin Institute for Advanced Studies, 1975.

Malina, Bruce J., and Jerome H. Neyrey. "Honor and Shame in Luke-Acts." In *The Social World of Luke-Acts*, edited by Jerome H. Neyrey, 25–66. Peabody, MA: Hendrickson, 1991.

Malina, Bruce J., and Richard L. Rohrbaugh. *Social-Science Commentary on the Synoptic Gospels.* Minneapolis: Fortress Press, 1992.

Marmorstein, Arthur. *The Old Rabbinic Doctrine of God.* 2 vols. Oxford: Oxford University Press, 1927–37. Rpt. as *The Doctrine of Merits in Old Rabbinic Literature and the Old Rabbinic Doctrine of God.* New York: Ktav Publishing House, 1968.

Martin, Clarice J. "Womanist Interpretation of the New Testament: The Quest for Holistic and Inclusive Translation and Interpretation." *Journal*

of Feminist Studies in Religion 6 (1990): 41–61.

Martin, Dale B. *The Corinthian Body*. New Haven, CT: Yale University Press, 1995.

———. *Slavery as Salvation: The Metaphor of Slavery in Pauline Christianity*. New Haven, CT: Yale University Press, 1990.

Martin, Ralph P. *Carmen Christi: Philippians ii. 5–11 in Recent Interpretation and in the Setting of Early Christian Worship*. 2d ed. Grand Rapids, MI: William B. Eerdmans, 1983.

Matarazzo, Mike. "Pile It On! Thank God for the Offseason." *Flex* (December 1993): 21–24.

Meeks, Wayne A. *The Origins of Christian Morality: The First Two Centuries*. New Haven, CT: Yale University Press, 1993.

Meier, John P. *A Marginal Jew: Rethinking the Historical Jesus*. Vol. 1, *The Roots of the Problem and the Person*. Vol. 2, *Mentor, Message, and Miracles*. The Anchor Bible Reference Library. New York: Doubleday, 1991–94.

Mendenhall, George E. *The Tenth Generation: The Origins of the Biblical Tradition*. Baltimore: The Johns Hopkins University Press, 1973.

Mentzer, Mike. "The Furthest Reaches of the Pain Zone." *Flex* (August 1993): 100–1, 104–5.

———. "Welcome to the Pain Zone." *Muscle & Fitness* (May 1994): 136–38, 189.

Metzger, Bruce M. *The Text of the New Testament: Its Transmission, Corruption, and Restoration*. 3d ed. Oxford: Oxford University Press, 1992.

Meyers, Carol. *Discovering Eve: Ancient Israelite Women in Context*. Oxford: Oxford University Press, 1988.

Meyers, Eric M. "Synagogue." In *The Anchor Bible Dictionary*, edited by David Noel Freedman et al, 6:251–60. New York: Doubleday, 1992.

Miles, Rosalind. *The Rites of Man: Love, Sex and Death in the Making of the Male*. London: Grafton Books, 1991.

Milgrom, Jacob. *Leviticus 1–16: A New Translation with Introduction and Commentary*. The Anchor Bible 3. New York: Doubleday, 1991.

Millar, Fergus. *The Emperor in the Roman World (31 B.C.–A.D. 337)*. Ithaca, NY: Cornell University Press, 1977.

Miller, D. A. *Bringing Out Roland Barthes*. Berkeley: University of California Press, 1992.

Miller, James. *The Passion of Michel Foucault*. New York: Simon & Schuster, 1993.

Miller, Robert J., ed. *The Complete Gospels*. 3d ed. San Francisco: Harper San Francisco, 1995.

Mlakuzhyil, George. *The Christocentric Literary Structure of the Fourth Gospel*. Analecta Biblica 117. Rome: Biblical Institute Press, 1987.

Moberly, R. W. L. *At the Mountain of God: Story and Theology in Exodus 32–34*. JSOT Supplement Series 22. Sheffield, U.K.: JSOT Press, 1983.

Moltmann-Wendel, Elisabeth. "Is There a Feminist Theology of the Cross?" In *The Scandal of a Crucified World: Perspectives on the Cross and Suffering*, edited by Yacob Tesfai, 87–98. Maryknoll, NY: Orbis Books, 1994.

Moo, Douglas. *Romans 1–8*. Wycliffe Exegetical Commentary. Chicago: Moody Press, 1991.

Moore, Clifford H., and John Jackson, eds. and trans. *Tacitus: The Histories and the Annals*. 4 vols. The Loeb Classical Library. Cambridge, MA: Harvard University Press, 1925–37.

Moore, Stephen D. *Literary Criticism and the Gospels: The Theoretical Challenge*. New Haven, CT: Yale University Press, 1989.

———. *Mark and Luke in Poststructuralist Perspectives: Jesus Begins to Write*. New Haven, CT: Yale University Press, 1992.

———. *Poststructuralism and the New Testament: Derrida and Foucault at the Foot of the Cross*. Minneapolis: Fortress Press, 1994.

Mounce, Robert H. *The Book of Revelation*. The New International Commentary on the New Testament. Grand Rapids, MI: William B. Eerdmans, 1977.

Mowry, Lucetta. "Revelation 4–5 and Early Christian Liturgical Usage." *Journal of Biblical Literature* 71 (1952): 75–84.

Müller, Ulrich B. *Die Offenbarung des Johannes*. Gütersloh: Gütersloher Verlagshaus Mohn; Würzburg: Echter Verlag, 1984.

Neusner, Jacob. *Genesis Rabbah: The Judaic Commentary to the Book of Genesis. A New American Translation*. 3 vols. Brown Judaic Studies. Atlanta: Scholars Press, 1985.

Newsom, Carol A. *Songs of the Sabbath Sacrifice: A Critical Edition*. Harvard Semitic Studies 27. Atlanta: Scholars Press, 1985.

Neyrey, Jerome H. "The Symbolic Universe of Luke-Acts: 'They Turn the World Upside Down.'" In *The Social World of Luke-Acts: Models for Interpretation*, edited by Jerome H. Neyrey, 271–304. Peabody, MA: Hendrickson, 1991.

———. "Wholeness." In *Biblical Social Values and Their Meaning: A Handbook*, edited by John J. Pilch and Bruce J. Malina, 180–84. Peabody, MA: Hendrickson, 1993.

Niditch, Susan. "Genesis." In *The Women's Bible Commentary*, edited by Carol A. Newsom and Sharon H. Ringe, 10–25. Louisville, KY: Westminster/John Knox Press, 1992.

Nötscher, Friedrich. *"Das Angesicht Gottes schauen" nach biblischer und babylonischer Auffassung*. Darmstadt: Wissenschaftliche Buchgesellschaft, 1969.

Nygren, Anders. *Commentary on Romans*. Translated by Carl C. Rasmussen. Philadelphia: Muhlenberg Press, 1949.

O'Malley, C. D. *Andreas Vesalius of Brussels, 1514–1564*. Berkeley and Los Angeles: University of California Press, 1964.

Oppenheim, A. Leo. *Ancient Mesopotamia: Portrait of a Dead Civilization* 2d ed. Chicago: University of Chicago Press, 1977.

Origen. *Homilies on Genesis and Exodus*. Translated by Ronald E. Heine. The Fathers of the Church 71. Washington, D.C.: The Catholic University of America, 1982.

Paglia, Camille. "Alice in Muscle Land." In *Sex, Art, and American Culture: Essays*. New York: Vintage Books, 1992.

Pardes, Ilana. *Countertraditions in the Bible: A Feminist Approach*. Cambridge, MA: Harvard University Press, 1992.

Peterson, Erik. *The Angels and the Liturgy*. Translated by Ronald Walls. New York: Herder & Herder, 1964.

———. *Heis Theos: Epigraphische, formgeschichtliche, und religionsgeschichtliche Untersuchungen*. Forschungen zur Religion und Literatur des Alten und Neuen Testaments 41. Göttingen: Vandenhoeck & Ruprecht, 1926.

Pierson, K. Kendall, et al. *Principles of Prosection: A Guide for the Anatomic Pathologist*. New York: John Wiley & Sons, 1980.

Pilch, John J. "Purity." In *Biblical Social Values and Their Meaning: A Handbook*, edited by John J. Pilch and Bruce J. Malina, 151–52. Peabody, MA: Hendrickson, 1993.

Pippin, Tina. *Death and Desire: The Rhetoric of Gender in the Apocalypse of John*. Literary Currents in Biblical Interpretation. Louisville, KY: Westminster/John Knox Press, 1992.

———. "Eros and the End: Reading for Gender in the Apocalypse of John." *Semeia* 59 (1992): 193–210.

———. "The Heroine and the Whore: Fantasy and the Female in the Apocalypse of John." *Semeia* 60 (1992): 67–82.

———. "Peering into the Abyss: A Postmodern Reading of the Biblical Bottomless Pit." In *The New Literary Criticism and the New Testament*, edited by Edgar V. McKnight and Elizabeth Struthers Malbon, 251–67. Sheffield, U.K.: Sheffield Academic Press; Valley Forge, PA: Trinity Press International, 1994.

———. "The Revelation to John." In *Searching the Scriptures*. Vol. 2, *A Feminist Commentary*, edited by Elisabeth Schüssler Fiorenza with Ann Brock and Shelly Matthews, 109–30. New York: Crossroad, 1994.

Powell, Mark Allan. *What Is Narrative Criticism?* Guides to Biblical Scholarship. Minneapolis: Fortress Press, 1990.

Price, S. R. F. *Rituals and Power: The Roman Imperial Cult in Asia Minor.* Cambridge: Cambridge University Press, 1984.

Pritchard, James B., ed. *Ancient Near Eastern Texts Relating to the Old Testament.* 3d ed. Princeton, NJ: Princeton University Press, 1969.

Rahner, Karl, and Herbert Vorgrimler. *Dictionary of Theology.* Translated by Richard Strachan et al. 2nd ed. New York: Crossroad, 1981.

Reimarus, Hermann Samuel. *Apologie oder Schutzschrift für die vernünftigen Verehrer Gottes.* 2 vols. Edited by Gerhard Alexander. Frankfurt: Insel Verlag, 1972.

———. *Reimarus: Fragments.* Edited by Charles H. Talbert and translated by Ralph S. Fraser. Philadelphia: Fortress Press, 1970.

Reindl, Joseph. *Das Angesicht Gottes im sprachgebrauch des Alten Testaments.* Erfurter Theologische Studien 25. Leipzig: St. Benno-Verlag, 1970.

Reymond, Philippe. *L'eau, sa vie, et sa significations dans l'Ancien Testament.* Vetus Testamentum Supplements 6. Leiden, Netherlands: E. J. Brill, 1958.

Robbins, Gregory A., ed. *Genesis 1–3 in the History of Exegesis.* Studies in Women and Religion 27. Lewiston, NY: The Edwin Mellen Press, 1988.

Roberts, Alexander, and James Donaldson, eds. *The Ante-Nicene Fathers: Translations of the Writings of the Fathers down to A.D. 325.* 10 vols. Buffalo, NY: The Christian Literature Publishing Company, 1885–96.

Robinson, James M., ed. *The Nag Hammadi Library in English.* 3d ed. Leiden, Netherlands: E. J. Brill, 1988.

Robinson, John A. T. *The Body: A Study in Pauline Theology.* Studies in Biblical Theology 5. London: SCM Press, 1952.

———. *Redating the New Testament.* Philadelphia: The Westminster Press, 1976.

———. *Wrestling with Romans.* Philadelphia: The Westminster Press, 1979.

Rolfe, J. C., ed. and trans. *Suetonius: The Lives of the Caesars and the Lives of Illustrious Men.* 2 vols. The Loeb Classical Library. Cambridge, MA: Harvard University Press, 1913–14.

Roloff, Jürgen. *The Revelation of John.* Translated by John E. Alsup. Continental Commentaries. Minneapolis: Fortress Press, 1993.

Rowland, Christopher. *The Open Heaven: A Study of Apocalyptic in Judaism and Early Christianity.* New York: Crossroad, 1982.

Rowley, H. H. *The Faith of Israel.* London: SCM Press, 1956.

Sáez, Ñacuñán. "Torture: A Discourse on Practice." In *Tattoo, Torture, Mutilation, and Adornment: The Denaturalization of the Body in Culture and Text,* edited by Frances E. Mascia-Lees and Patricia Sharpe, 126–44.

SUNY Series on the Body in Culture, History, and Religion. Albany: State University of New York Press, 1992.

Sanders, E. P. *The Historical Figure of Jesus*. New York: Penguin Books, 1993.

———. *Jesus and Judaism*. Philadelphia: Fortress Press, 1985.

———. *Paul and Palestinian Judaism: A Comparison of Patterns of Religion*. Philadelphia: Fortress Press, 1977.

Sarna, Nahum M. *Genesis/Berē 'šît: The Traditional Hebrew Text with the New JPS Translation*. The JPS Torah Commentary. Philadelphia and New York: The Jewish Publication Society, 1989.

Sarup, Madan. *An Introductory Guide to Post-Structuralism and Postmodernism*. 2d ed. Athens: University of Georgia Press, 1993.

Saunders, J. B. deC. M., and Charles D. O'Malley, eds. *The Illustrations from the Works of Andreas Vesalius of Brussels: With Annotations and Translations, a Discussion of the Plates and Their Background, Authorship and Influence, and a Biographical Sketch of Vesalius*. Cleveland and New York: The World Publishing Company, 1950.

Sauter, Franz. *Der römische Kaiserkult bei Martial und Statius*. Tübinger Beiträge zum Altertumswissenschaft 21. Stuttgart and Berlin: W. Kohlhammer, 1934.

Sava, A. F. "The Blood and Water from the Side of Christ." *American Ecclesiastical Review* 138 (1958): 341–45.

———. "The Wound in the Side of Christ." *The Catholic Biblical Quarterly* 19 (1957): 343–46.

———. "The Wounds of Christ." *The Catholic Biblical Quarterly* 16 (1954): 438–43.

Sawday, Jonathan. *The Body Emblazoned: Dissection and the Human Body in Renaissance Culture*. New York: Routledge, 1995.

Scarry, Elaine. *The Body in Pain: The Making and Unmaking of the World* Oxford: Oxford University Press, 1985.

Schäfer, Peter. *Hekhalot-Studien*. Tübingen: J.C.B. Mohr (Paul Siebeck), 1988.

———. "*Shiʻur Qoma*: Rezensionen und Urtext." In *Hekhalot-Studien*, 75–83.

———. "Zum Problem der redaktionellen Identität der *Hekhalot Rabbati*." In *Hekhalot-Studien*, 63–74.

Schaff, Philip, and Henry Wace, eds. *A Select Library of Nicene and Post-Nicene Fathers of the Christian Church*. 28 vols. in 2 series. New York: The Christian Literature Company, 1886–1900.

Scherrer, Steven J. "Signs and Wonders in the Imperial Cult: A New Look at a Roman Religious Institution in the Light of Rev. 13:13–15." *Journal of Biblical Literature* 103 (1984): 599–610.

Schmidt, Sonny. "A Chest Full of Miracles." *Flex* (August 1994): 134–40.

Schmittlein, Raymond. *Circonstances et cause de la mort du Christ*. Bade: Éditions art et science, 1950.

Schnackenburg, Rudolf. *The Gospel According to St. John*. 3 vols. Translated by Kevin Smyth et al. New York: Crossroad, 1990.

Schneemelcher, Wilhelm, ed. *New Testament Apocrypha*. 2d ed. English translation edited by R. McL. Wilson. Vol. 1, *Gospels and Related Writings*. Vol. 2, *Writings Relating to the Apostles; Apocalypses and Related Subjects*. Louisville, KY: Westminster/John Knox Press, 1991–92.

Scholem, Gershom. *Jewish Gnosticism, Merkabah Mysticism, and Talmudic Tradition*. 2nd ed. New York: The Jewish Theological Seminary of America, 1965.

———. *Major Trends in Jewish Mysticism*. 3rd ed. New York: Schocken Books, 1971.

———. *Origins of the Kabbalah*. Edited by R. J. Zwi Werblowsky and translated by Allan Arkush. Philadelphia: The Jewish Publication Society; Princeton, NJ: Princeton University Press, 1987.

Schüssler Fiorenza, Elisabeth. *The Book of Revelation: Justice and Judgment*. Philadelphia: Fortress Press, 1985.

———. *Invitation to the Book of Revelation: A Commentary on the Apocalypse with Complete Text from The Jerusalem Bible*. Garden City, NY: Image Books, 1981.

———. *Jesus: Miriam's Child, Sophia's Prophet. Critical Issues in Feminist Christology*. New York: Continuum, 1994.

Schwan, Alexander. *Geschichtstheologie Konstitution und Destruktion der Politik: Friedrich Gogarten und Rudolf Bultmann*. Berlin: Walter de Gruyter, 1976.

Schwarzenegger, Arnold, and Bill Dobbins. *Encyclopedia of Modern Bodybuilding*. New York: Simon & Schuster, 1985.

Schwarzenegger, Arnold, and Douglas Kent Hall. *Arnold: The Education of a Bodybuilder*. New York: Simon & Schuster, 1977.

Schweitzer, Albert. *Deutsche und französische Orgelbaukunst und Orgelkunst*. Leipzig: Breitkopf & Härtel, 1906.

———. *Out of My Life and Thought: An Autobiography*. Translated by Antje Bultmann Lemke. New York: Henry Holt and Company, 1990.

———. *Von Reimarus zu Wrede*. Tübingen: J. C. B. Mohr, 1906. ET: *The Quest of the Historical Jesus: A Critical Study of Its Progress from Reimarus to Wrede*. Translated by W. Montgomery. New York: Macmillan, 1968.

Scott, Kenneth. *The Imperial Cult under the Flavians*. Stuttgart and Berlin: W. Kohlhammer, 1936.

Sedgwick, Eve Kosofsky. *Tendencies*. Series Q. Durham, NC: Duke University Press, 1993.

Seeley, David. *The Noble Death: Graeco-Roman Martyrology and Paul's Concept of Salvation.* JSNT Supplement Series 28. Sheffield: Sheffield Academic Press, 1990.

Sells, Michael. *Mystical Languages of Unsaying.* Chicago: University of Chicago Press, 1994.

Shepherd, M. H. *The Paschal Liturgy and the Apocalypse.* London: Lutterworth, 1960.

Simpson, Mark. *Male Impersonators: Men Performing Masculinity.* New York: Routledge, 1994.

Singer, Charles. *A Short History of Anatomy and Physiology from the Greeks to Harvey.* 2d ed. of *The Evolution of Anatomy.* New York: Dover Publications, 1957.

Singer, Charles, and E. Ashworth Underwood. *A Short History of Medicine.* 2d ed. Oxford: Oxford University Press, 1962.

Slotki, Judah J., ed. *Midrash Rabbah.* Vol. 4, *Leviticus.* London: The Soncino Press, 1939.

Sloyan, Gerard S. *The Crucifixion of Jesus: History, Myth, Faith.* Minneapolis: Fortress Press, 1995.

Smith, Dennis E. "An Autopsy of an Autopsy: Biblical Illiteracy Among Medical Doctors." *Westar Magazine* 1 (1987): 3–6, 14–15.

Song, Choan Seng. "Christian Mission toward Abolition of the Cross." In *The Scandal of a Crucified World: Perspectives on the Cross and Suffering,* edited by Yacob Tesfai, 130–48. Maryknoll, NY: Orbis Books, 1994.

South, James T. *Disciplinary Practices in Pauline Texts.* Lewiston, NY: The Edwin Mellen Press, 1992.

Spivey, Robert A., and D. Moody Smith. *Anatomy of the New Testament: A Guide to Its Structure and Meaning.* 5th ed. Englewood Cliffs, NJ: Prentice Hall, 1995.

Stafford, Barbara Maria. *Body Criticism: Imaging the Unseen in Enlightenment Art and Medicine.* Cambridge, MA: The MIT Press, 1991.

Stanton, Elizabeth Cady . *The Woman's Bible.* 2 vols. New York: European Publishing Company, 1895–98.

Starobinski, Jean. *A History of Medicine.* Translated by Bernard C. Swift. New York: Hawthorn, 1964.

Stauffer, Ethelbert. *Christ and the Caesars: Historical Sketches.* Translated by K. Gregor Smith and R. Gregor Smith. London: SCM Press, 1955.

Stern, David. *Parables in Midrash: Narrative and Exegesis in Rabbinic Literature.* Cambridge, MA: Harvard University Press, 1991.

Strauss, David Friedrich. *Das Leben Jesu, kritisch bearbeitet.* 2 vols. Tübingen: C. F. Osiander, 1835–36. ET: *The Life of Jesus, Critically Examined.* Translated by George Eliot (Marian Evans) and edited by Peter C. Hodgson. Philadelphia: Fortress Press, 1973.

Stroud, William. *Treatise on the Physical Cause of the Death of Christ and Its Relations to the Principles and Practice of Christianity*. London: Hamilton & Adams, 1871.

Sweet, J. P. M. *Revelation*. Westminster Pelican Commentaries. Philadelphia: The Westminster Press, 1979.

Tambasco, Anthony J. *A Theology of Atonement and Paul's Vision of Christianity*. Zacchaeus Studies. Collegeville, MN: Liturgical Press, 1991.

Tasker, Yvonne. *Spectacular Bodies: Gender, Genre and the Action Cinema*. New York: Routledge, 1993.

Taylor, Lily Ross. *The Divinity of the Roman Emperor*. Middletown, CT: American Philogical Association, 1931.

Taylor, Vince. "Penance Shocks." *Flex* (July 1994): 249–51.

Taylor, Vincent. *The Atonement in New Testament Teaching*. London: The Epworth Press, 1940.

Tesfai, Yacob. "Introduction." In *The Scandal of a Crucified World: Perspectives on the Cross and Suffering*, edited by Yacob Tesfai, 1–16. Maryknoll, NY: Orbis Books, 1994.

Thackeray, H. St. J., et al., eds. and trans. *Josephus*. 9 vols. The Loeb Classical Library. Cambridge, MA: Harvard University Press, 1926–65.

Thompson, Leonard L. *The Book of Revelation: Apocalypse and Empire*. Oxford: Oxford University Press, 1990.

Thompson, W. E., and J. H. Bair. "A Sociological Analysis of Pumping Iron." *Free Inquiry in Creative Sociology* 10 (1982): 192–96.

Trible, Phyllis. *God and the Rhetoric of Sexuality*. Overtures to Biblical Theology. Philadelphia: Fortress Press, 1978.

———. "God, Nature of, in the OT." In *The Interpreter's Dictionary of the Bible*, Supplementary Volume, edited by Keith Crim et al., 368–69. Nashville: Abingdon Press, 1976.

Urbach, Ephraim E. *The Sages: Their Concepts and Beliefs*. 2 vols. Translated by Israel Abrahams. Jerusalem: The Magnes Press, 1975.

Vawter, Bruce. *On Genesis: A New Reading*. New York: Doubleday, 1977.

Von Rad, Gerhard. *Genesis: A Commentary*. Translated by John H. Marks. The Old Testament Library. Philadelphia: Westminster Press, 1972.

Walker, D. P. *The Decline of Hell: Seventeenth-Century Discussions of Eternal Torment*. Chicago: University of Chicago Press, 1964.

Wall, Robert W. *Revelation*. New International Biblical Commentary 18. Peabody, MA: Hendrickson, 1991.

Walters, Margaret. *The Nude Male: A New Perspective*. New York: Paddington Press, 1978.

Warner, William. "Spectacular Action: Rambo and the Popular Pleasures of Pain." In *Cultural Studies*, edited by Lawrence Grossberg, Cary Nelson, and Paula A. Treichler, 672–88. New York: Routledge, 1992.

Weider, Joe, with Bill Reynolds. *The Weider System of Bodybuilding*. Chicago: Contemporary Books, 1983.

Weinfeld, Moshe. *Deuteronomy 1–11: A New Translation with Introduction and Commentary*. The Anchor Bible 5. New York: Doubleday, 1991.

———. *Deuteronomy and the Deuteronomic School*. Oxford: Clarendon Press, 1972.

Weinstock, Stefan. *Divus Julius*. Oxford: Clarendon Press, 1971.

Weissler, Chava. "*Mizvot* Built into the Body: *Tkhines* for *Niddah*, Pregnancy, and Childbirth." In *People of the Body: Jews and Judaism from an Embodied Perspective*, edited by Howard Eilberg-Schwartz, 101–16. SUNY Series on the Body in Culture, History, and Religion. Albany: State University of New York Press, 1992.

Wenham, Gordon J. *The Book of Leviticus*. The New International Commentary on the Old Testament 3. Grand Rapids, MI: William B. Eerdmans, 1979.

———. *Genesis 1–15*. The Word Biblical Commentary 1. Waco, TX: Word Books, 1987.

Westermann, Claus. *Genesis 1–11*. Translated by J. J. Scullion. Continental Commentaries. Minneapolis: Augsburg, 1984.

Whiston, William, ed. and trans. *The Works of Josephus: Complete and Unabridged*. Peabody, MA: Hendrickson, 1987.

White, Hayden. "Michel Foucault." In *Structuralism and Since: From Lévi-Strauss to Derrida*, edited by John Sturrock, 81–115. Oxford: Oxford University Press, 1979.

Wilkinson, John. "The Incident of the Blood and Water in John 19.34." *The Scottish Journal of Theology* 28 (1975): 149–72.

Wilson, Luke. "William Harvey's *Prelectiones*: The Performance of the Body in the Renaissance Theater of Anatomy." *Representations* 17 (1987): 62–95.

Wolfson, Elliot R. "Images of the Divine Feet: Some Observations on the Divine Body in Judaism." In *People of the Body: Jews and Judaism from an Embodied Perspective*, edited by Howard Eilberg-Schwartz, 143–82. SUNY Series on the Body in Culture, History, and Religion. Albany: State University of New York Press, 1992.

Yarbro Collins, Adela. *The Combat Myth in the Book of Revelation*. Harvard Dissertations in Religion 9. Missoula, MT: Scholars Press, 1976.

———. *Crisis and Catharsis: The Power of the Apocalypse*. Philadelphia: The Westminster Press, 1984.

Young, Frances M. *The Use of Sacrificial Ideas in Greek Christian Writers from the New Testament to John Chrysostom*. Patristic Monograph Series 5. Cambridge, MA: The Philadelphia Patristic Foundation, 1979.

Zane, Frank. "Train with Zane: Bodybuilding in Future-World." *Muscle & Fitness* (June 1994): 247.

general index

108, 111–13, 116; phallic nature of,
133–34, 135; popularity of, 75–76;
posing in, xii, 100, 113–15, 121–23,
133–34, 135, 137–38; as purity
system, 76–82, 107–108; as quest for
wholeness, 77, 107–108; and
Revelation, 121–23, 134–38; symbolic
universe of, 81–82, 114–15; training
methods in, 104, 110; women's, 77n9,
93n76. *See also* Gold's Gym
Boff, Leonardo, 11–12
Bolin, Anne, 75n2
Borg, Marcus J., 110n151
Boring, M. Eugene, 121n190, 123n203,
124, 126–27, 128n219, 136n264
Boyarin, Daniel, 23n97, 85n34, 89n58,
91n67
Brainum, Jerry, 97n95
Bronner, Leila Leah, 89n58, 101n114
Brown, Joanne Carlson, 12
Brown, Peter, 25n109
Brown, Raymond E., 3n2, 8nn15–16,
38n1, 60n107, 61n108, 61n111, 62n114,
67, 69, 111nn155–56, 113n163, 116n171
Bultmann, Rudolf, xi, 61n111, 112n159,
139; and anti–Semitism, 23n97; on
Pauline soteriology, 17–23; on
Revelation, 18n71
Butler, George, 75n2, 81, 95n85,
117n174, 122n198, 133n243, 134n251
Bynum, Caroline Walker, 38n3

Caird, G. B., 114n168, 122n196,
136n264, 137n267
Caligula, 130
Calvin, John, 84n31
Cassuto, Umberto, 84n29, 114n168,
136n265
Castelli, Elizabeth A., 10n21, 25,
27n120, 30n127
Castiglioni, Arturo, 44n27, 46nn35–36,
49n44, 71n142
Catherine of Siena, 38n3
Charles, R. H., 120n186, 124n206
Chatman, Seymour, 51n50, 57, 59
Cherbonnier, E. LaB., 83n22, 91n70
Childs, Brevard, 92–93
Christensen, Duane L., 83n21
Chrysostom, John, 38n3, 83

Claudius, 130
Clement of Alexandria, 38n3, 53
Clines, David J. A., 99n102
Codex, 38
Cohen, Martin S., 86–87, 88, 98n98
Cohn, Norman, 114n167
Conway, Ronald, 113n164
Cranfield, C. E. B., 15–16, 26n115,
111n155
Cross, Frank Moore, 93n76
Crossan, John Dominic, 5n5, 41–42,
69, 110n151, 113n163
Crucifixion, xi, 3, 4, 5, 28; as
bodybuilding posing exhibition,
113–15; as disciplinary technology,
139; as divine child abuse, 12;
evangelists' restraint in describing,
6; and feminist theology, 12; and
liberation theology, 11–12; methods
of, 7–8, 62–63, 68–69; Paul's
interpretation of, 17–30; regarded
with horror in antiquity, 7;
responsibility for, 12; and sacrament
of penance, 31, 33; as slave's
punishment, 25. *See also* Atonement
(doctrine of)
Culpepper, R. Alan, 50–59, 70
Cuss, Dominique, 124n206, 125–26,
130n226, 132n242

Da Carpi, Berengario, 115
Daly, Robert J., 13n39
Damiens, Robert-François, 8–9, 20, 72
David, 85
Davidson, Robert, 83n25
Davies, W. D., 21, 66
Da Vinci, Leonardo, 54
Dead Sea Scrolls, 76, 98n99
Deissman, Adolf, 132n238
Denzinger, Heinrich, 31n135
Derrida, Jacques, 119
De Vaux, Roland, 95n82
Dodd, C. H., 15–16, 59n104
Domitian, 124–25, 126n213, 130–38
Donfried, Karl P., 29n124
Douglas Mary, 76–77, 81n17
Downing, F. Gerald, 110n151
Dreyfus, Hubert L., 14n45
DuBois, Page, 4, 10

index of ancient sources

II. Pagan Sources

Apocryphal Gospels, Acts, Apocalypses and Related Literature

PATRISTIC AND RELATED LITERATURE